Coveteur

noun | Cov·et·eur | \ˈkə-vət-ər\

: the celebration of inspiring, influential people with good taste,
a unique point of view, and a lot of shoes

: uncovering the closets, drawers, shelves, and private spaces
of individuals around the world

— **Cov·et·eur'd** \-tərd\; **Cov·et·eur·ing** \-tiŋ\ *transitive verb*

the/COVETEUR

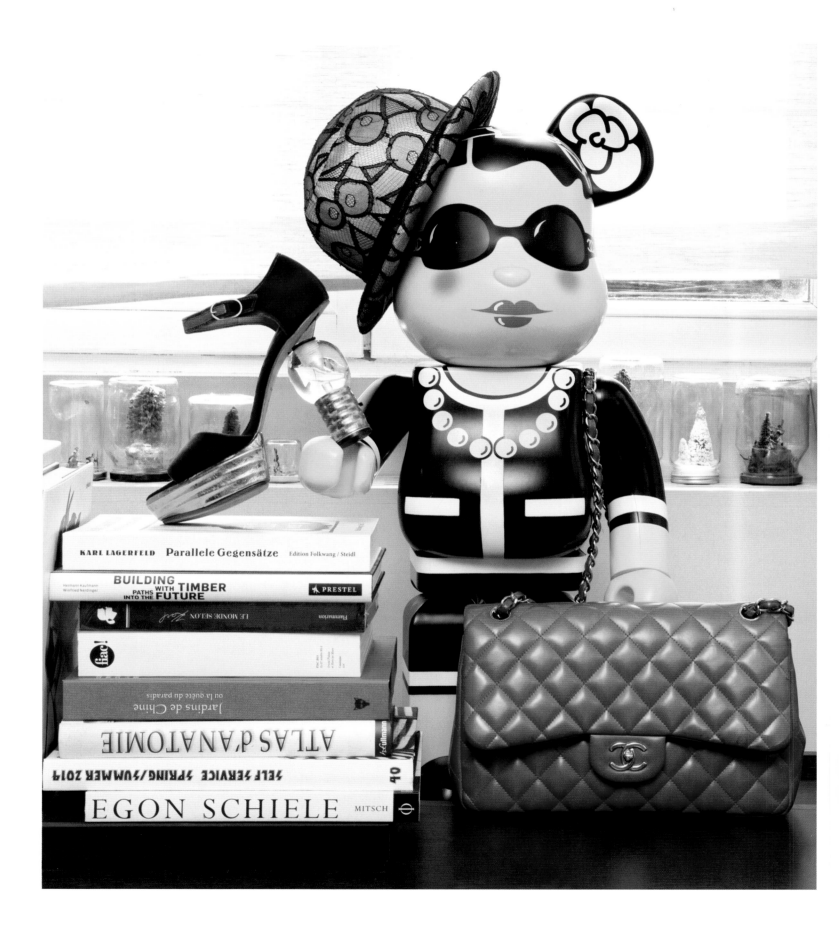

the COVETEUR

Private Spaces, Personal Style

By STEPHANIE MARK and JAKE ROSENBERG

ABRAMS, NEW YORK

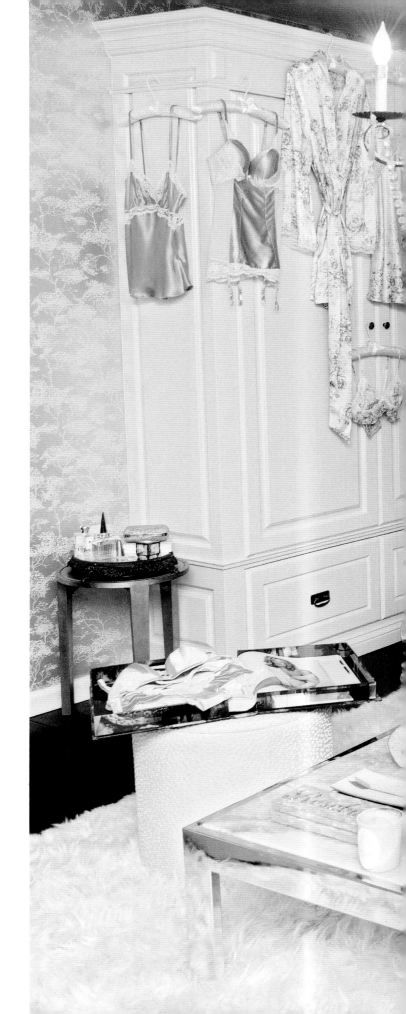

the
COVETEUR

Editor: *DAVID CASHION*
Designer: *EMILY WARDWELL*
Production Manager: *DENISE LACONGO*

Library of Congress Control Number: 2015955672

ISBN: 978-1-4197-2199-1

Text and photographs copyright © 2016 The Coveteur Inc.

Printed and bound in China
10 9 8 7 6 5 4 3 2 1

Abrams books are available at special discounts when purchased in quantity
for premiums and promotions as well as fundraising or educational use.
Special editions can also be created to specification. For details, contact
specialsales@abramsbooks.com or the address below.

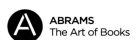

ABRAMS
The Art of Books

115 West 18th Street
New York, NY 10011
abramsbooks.com

Table of Contents

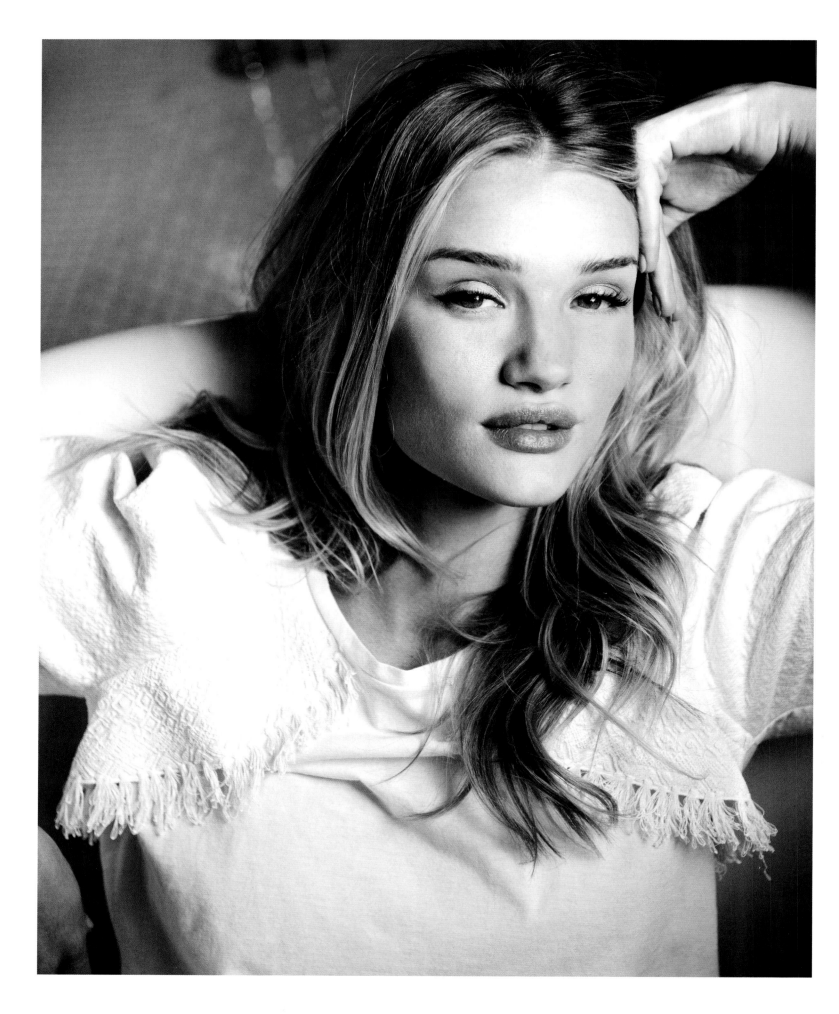

Foreword

I don't recall how I first discovered The Coveteur, but what I do remember is that when I landed on the site about three years ago, it immediately went into the Favorites bar on my computer. I have always loved the Internet as a great source of inspiration and for gathering knowledge on just about anything. New blogs, sites, apps, and video channels pop up almost every time we log on, overwhelming us with maybe too many choices when it comes to looking for our daily dose of information and ideas. To me, The Coveteur stood out straightaway because its concept is simple: From style icons to top tastemakers, new girl crushes, and just the people we admire—The Coveteur allows us to peek into their most intimate spaces.

It actually takes us along on the journey: from the wardrobes of movie stars and musicians in Los Angeles and Sydney to the closets of our favorite It Girls in Paris and Japan and the dressing rooms of superstar social media icons and top celebrity stylists; behind the scenes at supermodel lingerie photo shoots; inside the studios of the world's most celebrated designers; from backstage at the most glittering fashion shows to the inspirational work spaces of multibillion-dollar brands and startup-company headquarters. With a flair for eye-popping photography, everything The Coveteur presents is captivating, desirable, and enticing. There's also a great sense of humor and wit running through every aspect of the site, especially in the tone and voice of the writing—reading it feels like catching up with your funniest friend, like reuniting with that same familiar person. To say it's got a lot of personality would frankly be an understatement!

The Coveteur gives me this voyeuristic feeling, similar to the fluttering pleasure I experienced as a young girl when my mother allowed me to go into her wardrobe to borrow one of her best purses for my first date, or the excitement I felt rifling through my granny's jewelry box at age five, adorning myself with every piece I could, hoping that maybe, just maybe, she would give me a little brooch or locket. (She did, and I still hold it dear today.) The Coveteur grants us an exclusive look into someone else's very personal world, drawing back the imaginary curtain so we can step inside and have a good old rummage around. There is just something about peering inside somebody's private spaces that fires the imagination.

When it came to actually being featured in The Coveteur, I was a little hesitant about having a team of people arrive, hijack my house, and poke about in my closet and dressing room—deep down, I'm a private person. But the team and I worked together, adorning my home with shoes, scarves, and handbags; styling outfits; and pulling together all my favorite pieces and the special items I have collected over the course of my life. From beloved accessories and pieces of jewelry to unique vintage jackets that I scoured the globe for, prized books, and designer shoes—in just a few hours we pulled apart my whole closet to photograph and display my most treasured possessions. The whole experience was completely collaborative and truly authentic. Jake and I edited the photographs, as well as the layout, together, and I wrote stories and descriptions to go with every shot. The final piece is a true reflection of who I am, which isn't always the case with this kind of coverage.

At the heart of The Coveteur's success is its authenticity and sense of fun—that's what keeps people like you and me coming back time and time again, completely infatuated.

—ROSIE HUNTINGTON-WHITELEY

Based in New York City, stylist Stephanie Mark and photographer Jake Rosenberg are cofounders of TheCoveteur.com.

Introduction

When the idea for The Coveteur came about in 2010, the premise was not to build an online business, create a reason to travel the world, or even meet and spend time with some of this generation's most impactful and inspiring personalities—as glam as that all sounds. The website was created to showcase the personal style and ethos of, what was then, the behind-the-scenes and often unrecognized personalities in the fashion industry. Acknowledgment of street style was at its height, and while we enjoyed looking at (i.e., obsessing about) the impeccably dressed just as much as the next person, we knew there was more to it. Now, remember, this was a time before Instagram, and we wanted to feature the people we considered to be the unsung heroes of the industry: Hairstylists, makeup artists, casting directors, designers, and editors—they not only dictated the direction of fashion, but infiltrated our lives in a way that was not outright celebrated at that point. And we wanted to change that.

TheCoveteur.com went live on January 21, 2011, at nine o'clock in the morning. It launched with just six profiles. When the site crashed before the end of the day, due to overwhelming traffic, we knew we were onto something. We continued to profile the people whose careers and influence inspired us, but we realized we were also offering something more: We were giving our audience unfiltered and unretouched access that they didn't have before; we wanted them to come along for the ride! At the same time, we were also documenting the rise of the (then) rare species known as the "influencer"—a person whose background, lifestyle, authority, and general badass-ness make them celebrities for a new age.

Fast-forward about five years, and The Coveteur has evolved from a small website updated only three times a week into a full-blown media company. We have (literally) been to the top of the Burj Khalifa—the tallest skyscraper in the world—with Dubai royalty, only to later attend a Christian Dior fashion show in Tokyo. We have sat in Coco Chanel's apartment, and we've chatted with Christian Louboutin in his beautiful Parisian home on a sunny afternoon. The most important goal of these adventures has been to provide the best access and content possible, and this book is a new extension of our efforts.

While our work might seem very glamorous (and it is), it hasn't been easy: We have spent endless days and all-nighters on airplanes, in nonstop photo shoots, and tied up in rounds and rounds of phone calls in order to make The Coveteur what it is today. None of this could have been achieved without a tremendous amount of hard work and dedication from our team, along with support from our family and friends. They are the ones who allow us to do what we love and help make our vision and dream come to life.

We are pleased to offer this look into the lives of people who truly inspire and motivate us and whom we are honored to have gotten to know. We hope you will feel the same.

—STEPHANIE and JAKE

WHEN
September 24, 2013

WHERE
Alba's sprawling
Beverly Hills home

WHY
She single-handedly
kicked off the
whole actor-turned-
eco-conscious-entrepreneur
thing. That, and
she's Jessica Alba.

JESSICA ALBA

ACTOR; COFOUNDER, THE HONEST COMPANY

This one can only be described as a long time in the making.

The very first time we had the chance to meet with Jessica Alba (over champagne and cupcakes) to celebrate her book launch in early 2013, we mutually vowed that we'd give the superhuman actress/entrepreneur/mom the Coveteur treatment before the year was out. And guess who kept their promise? And then some?

Let us put it this way: We essentially spent the better part of a day hanging with Alba, first touring her Beverly Hills home and closet before heading over to The Honest Company's headquarters. Welcoming us at her door while her kids were away at swimming lessons, she got right to the goods, immediately leading us to the pièce de résistance: her closet. "Who doesn't love shoes?!" Alba exclaimed while showing us the countless shelves upon shelves of color-coordinated Louboutins, Saint Laurents, and Brian Atwoods. Oh, and it turns out that running in Alba's circle comes with its perks: "[My shoes] don't mind being shared with my friends." We won't lie—our first thought was whether our day together qualified us for borrowing privileges. Too soon?!

And for the girl whose "fashion mishaps" at one time included "deliberately mismatched socks, hair scrunchies, hightops," and "tomboy meets Prince [yes, the musician] outfits," she's certainly come a long way. Except for this one time . . . because wardrobe

malfunctions only happen to the best of us. "Once I wore a dress backward because I couldn't tell which way was front. I've also had seams split, zippers burst . . . it's all happened. So, the lesson I've carried forward? Pay special attention to your undergarments." Duly noted.

Our peek inside Alba's home only proved the point that attempting to go the all-natural-everything route doesn't necessarily mean sacrificing your Giuseppes for granola. That said, Alba and her business partners hit up Craigslist and even went dumpster diving to outfit Honest's offices. The same savvy approach to decor extends to Alba's home, as well, "I love wallpaper and upcycling flea-market finds," she confessed to us. Alba even allowed us to take a peek inside little Honor's and Haven's (that would be her two adorable daughters') closets. "My oldest daughter, Honor, has a distinct sense of style and likes to pick out her own clothes!" Starting 'em young: We approve.

And though her walk-in won our hearts, it was her magical, kid-friendly backyard that instantly had us plotting our move to the West Coast. From the rainbow-bright pillows scattered across the yard (souvenirs from Alba's travels) to the enormous gnome (which, in our eyes, juuuust wasn't complete without a white Chanel bag slung across it), every inch of her veritable playground had her signature touch. And after a long day's work, we couldn't help but retreat to the mini black-and-white striped teepee, where we kicked it with the actress at the end of the shoot. Work hard, play hard, right?

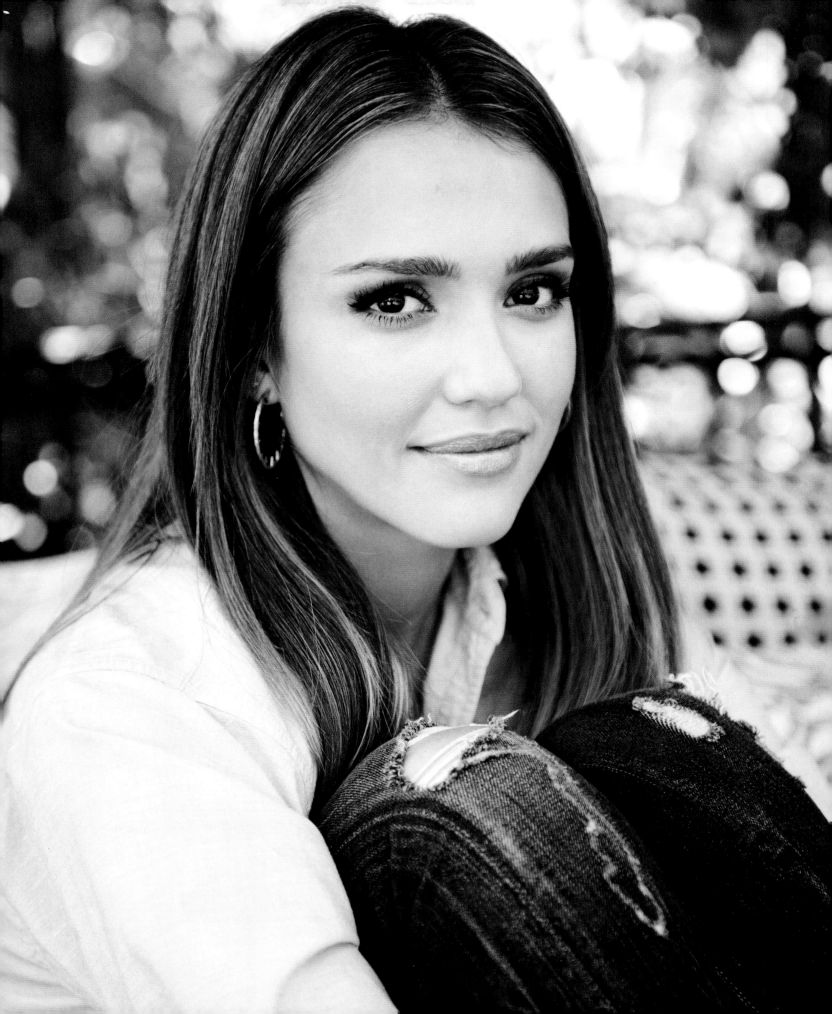

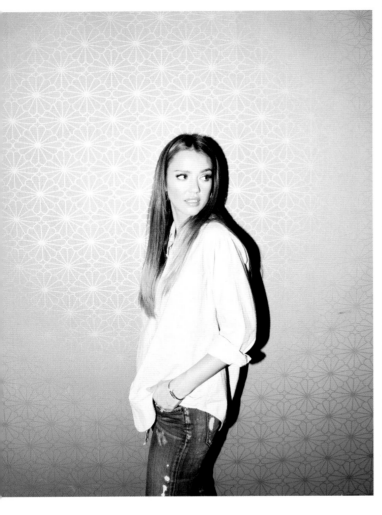

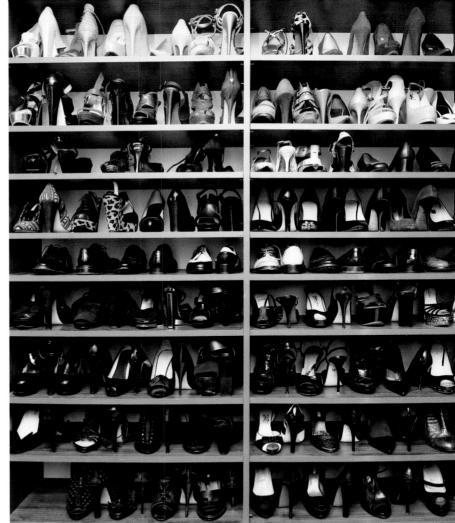

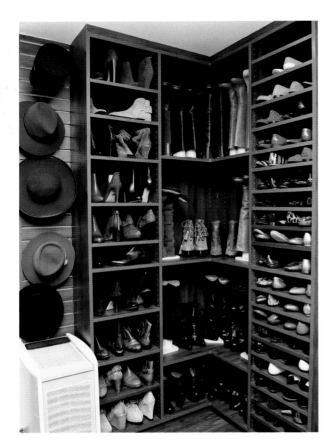

"If my shoes could talk, they'd let you know how much I love to wear them again and again. We go a lot of places together, and I certainly put them to the test because I'm not the most delicate when I wear them out and about. And they don't mind being shared with my friends."

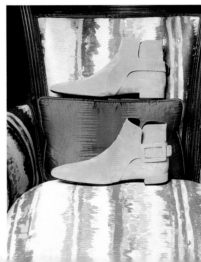

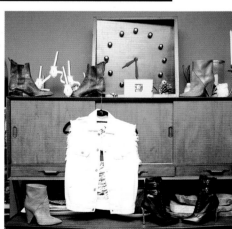

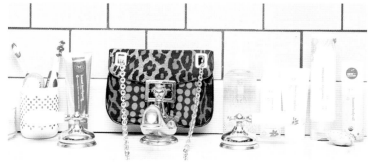

ANNE MICHAELS

FUGITIVE PIECES

Elizabeth Wurtzel

BITCH

M&S

OXFORD
NYPI

CHARL... MPIA

TOM BINNS

CHARL... MPIA

TOM BINNS

...IQUE Does YATE

WARNER BOOKS

FICTION

THE SALT ROADS NALO HOPKINSON

READING GROUP Guide Inside

THE COLLECTED PLAYS OF The People's Playwright Volume 1

david e talbert

THE GREAT GATSBY F. SCOTT FITZGERALD

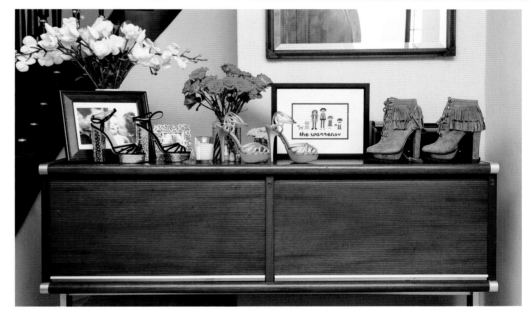

"I have experienced my fair share of red-carpet blunders. Once I wore a dress backward because I couldn't tell which way was front."

WHEN
January 15, 2013

WHERE
Her New York
Midtown high-rise

WHY
She basically
styled every iconic
1990s and early
2000s hip-hop video.

JUNE AMBROSE

CELEBRITY STYLIST; DESIGNER

We've made it our mission to find everyone and anyone who's made historic sartorial decisions. You know, the ones who practically define an era? Whether it's their own personal styles, or the styles in which they dress others, we ultimately need to get into their spaces. And no one quite fits the aforementioned criterion quite like June Ambrose. In case you're unaware (to be fair, we didn't know for an entire decade either), Ambrose is responsible for establishing the collective fashion standard for practically every single nineties hip-hop artist back in the day, from Jay Z to Missy Elliott to P. Diddy (then known as Puff Daddy) and R. Kelly. Since then, she's been styling and reinventing (cue the comeback) the sartorial identities of some of the biggest celebrities in the industry (she works as Jay's personal stylist to this day). Suffice it to say, she's a big deal.

As we pulled up to her Midtown East high-rise and made our way up the elevator, we had an inkling we were about to walk into a pretty epic scenario. And to kick off the entire shoot, Ambrose swung open the door in a robe-esque dress and her ubiquitous head-dress and seriously sky-high Louboutins. It was just a precursor to the closet we were about to raid.

Let's just say Ambrose's collection of Yves Saint Laurent Tribtoos, Christian Louboutin Altas, and DSquared2 skate shoes was only the tip of the proverbial iceberg. There were pony-hair Alaïas that we couldn't help but pick up and pet (. . . and try not to shove into our Louis Vuitton Neverfulls) and jacquard gold Rodartes that were almost too pretty to wear. And the clothing—from Proenza Schouler to Dries van Noten to Prada—was all impeccably organized. "My closet is designed by color and hanging items by silhouette," she explained. Not to mention, the cornucopia of sunglasses she hoards in her dressing room—think pink-tinted lenses, thick black frames, mirrored aviators, and even cat-eye pairs. Yeah, we can kind of get behind that.

Just as we were about to wrap up, Ambrose threw out this little anecdote as she fingered one of her many Hermès *collier de chien* cuffs, "I bought my first cuff thirteen years ago, and it was actually in Canada! When they refused to ship it to me because it was an exotic skin, I flew over to buy it. I love the edgy-yet-classy feeling of the cuffs and brand. It used to be an understated status symbol, but now that I have so many, it's far from understated." When someone is as dedicated to fashion as we are, well, we know we're going to be friends for a long, long time.

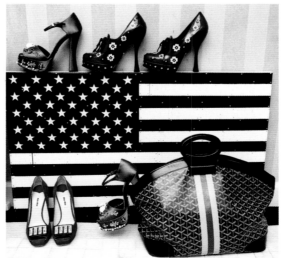

"I have to admit I was out of my mind in the nineties, when I was styling some of today's most iconic music videos. Missy Elliott, Puffy, Busta Rhymes, and Jay Z were among the brave who gave me creative freedom to do whatever I wanted."

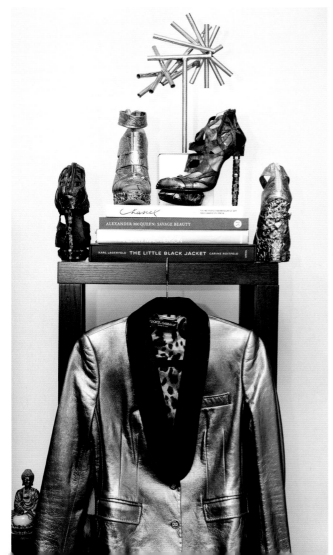

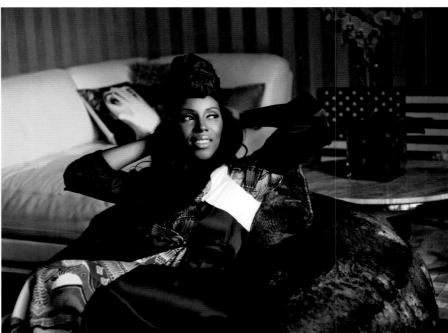

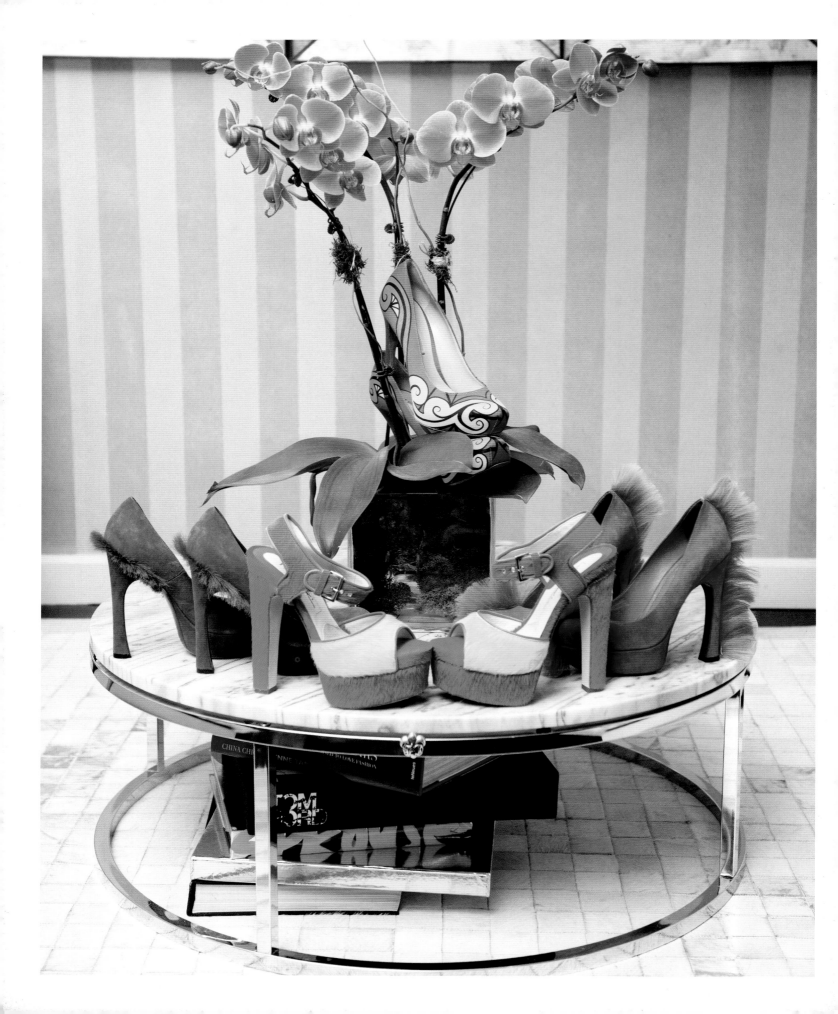

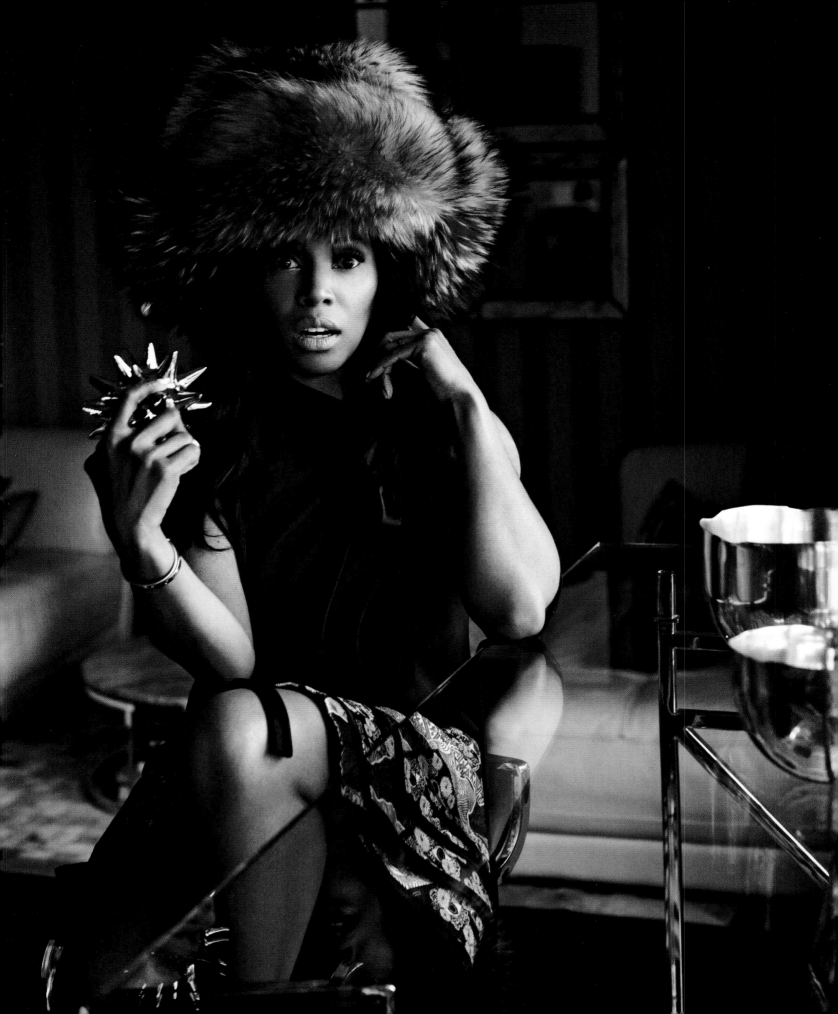

WHEN
October 17, 2015

WHERE
The airy and art-filled uptown Manhattan apartment Baque shares with his girlfriend

WHY
He's helped Supreme transcend the streetwear world to become one of the most in-demand brands while avoiding overexposure (and certain death). Plus he's maintained a certain air of mystery, so our urge to barge in on his home is kind of a given.

ANGELO BAQUE

BRAND DIRECTOR, SUPREME

Supreme is a label that so perfectly gets the post-Internet, social media–driven fashion thing, that, even if the streetwear brand isn't your style and you don't own a stitch of it, you can't help but be a fan. Maybe because it somehow distills "iconicity" without being too serious about it—think of those Terry Richardson–lensed Kate Moss and Keith Richards posters. If those aren't sealed into your mind's eye, where have you been living?

Either way, anyone in charge of such a company becomes a kind of moving target for us (we have a nose for these things), which was exactly the case with Baque. Thing is, the man isn't exactly the most accessible—not only does he pride himself on subtlety and mystery, he's also just extremely busy. When we finally got in touch with him (email is a magical thing), it took a few tries before we made it to his front (and closet) door. (No blame here, though—a book project with David Sims and a collaboration with Air Jordan will do that to a person. Again: busy.)

When we arrived, he was all graciousness dressed up in a born-and-bred New York accent, allowing us the run of his extensive Hawaiian shirt and vintage T-shirt collections while offering us iced green teas (there are ways to our hearts and these are most definitely workable routes). This is a guy who has very exacting taste and style, from eighties-era Polo Ralph Lauren to well-worn straight-leg denim and loafers. (For any guy who wears the latter footwear, he claims credit is due.) But despite his obvious mastery of the streetwear market, his personal style is decidedly more of the old-school, sentimental variety (see his large collection of Morrissey memorabilia should you have any doubt of his emotional connection to his stuff).

One thing that he most certainly brings to Supreme is his intimidating—inherent, really—coolness. It sounds lame when you say it out loud, but with him, more than anyone, it's true. Just trust us. Baque is a guy who can make a sweat suit and Jon Buscemi white leather slides work as well as a flannel shirt and cuffed denim (a Supreme-made classic if there every was one). Best of all, he offers no explanation. Loafers simply are cooler than boots; straight-leg better than skinny. Why? Because Baque said so.

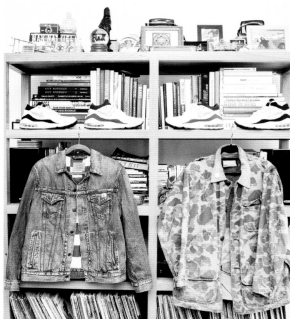

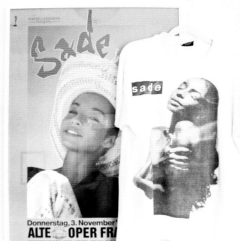

"I'm an old man disguised in the body of a thirty-eight-year-old. I'm just waiting for when I can wear a short-sleeve rayon shirt, unbuttoned, with shorts and loafers every day on a beach somewhere. I've been working on my dad status for the last decade."

29

WHEN
November 12, 2014

WHERE
*Brown's family home in
Montclair, New Jersey*

WHY
*As if we even need
to say this, but if there's
such a thing as a
beauty godmother, Bobbi
Brown is it.*

BOBBI BROWN

FOUNDER, BOBBI BROWN COSMETICS;
EDITOR-IN-CHIEF, YAHOO BEAUTY

Apologies ahead of time if we get a little sentimental here. Just bear with us.

A lot of what we do when we're considering whom to photograph is about inspiration—what's the special thing or person or moment that has us excited now, but also in the long term? A lot of the time, quite honestly, this looks like stumbling across a person or trend when we're down a deep Instagram black hole sometime north of midnight. But then there are those luminaries we've grown up with—who have seemingly been a constant presence in our lives by way of advice given in nineties-era issues of *Seventeen* or even a book or two still residing on our present-day bedside shelves. And there's no one who really epitomizes the endlessly inspiring, yet totally relatable power woman quite like Bobbi Brown. What can we say? The woman has been our personally appointed cheerleader ever since *Teenage Beauty: Everything You Need to Look Pretty, Natural, Sexy and Awesome*. (And, not coincidentally, that book title is still very much our mantra when we look in the bathroom mirror every morning.)

So when we finally got the go-ahead to get into her closet (and

beauty cabinet, because we couldn't not), the prospect of meeting the woman who taught us that there is, in fact, a perfect blush color for each person–("To find your ideal blush color, pinch your cheeks or look in the mirror after a workout. The color they turn is your ideal shade.")–became a game of minimizing our obvious fan status.

Showing up at her suburban New Jersey home, it didn't take us long to get digging through her prodigious collection of Céline, Saint Laurent, and Chanel. And, honestly, it wasn't so hard to feel at home with the makeup mogul, especially when she plied us with food and coffee— unquestionably the surest way to our hearts. Then again, that could be because we're still reading up on everything she has to teach us via Yahoo Beauty, which, when it comes to empowering women (rather than encouraging insecurities) pretty much nails it on the digital head.

"I built my brand on empowering women to celebrate their natural beauty and be their best, most confident selves," she told us. "I have worked with actresses, models, and celebrities my entire career, and have learned that they share all the same beauty concerns that everyday women have. So shedding light on those issues that nobody talks about is important to me. I will talk about them and tell you the truth." And there she goes again: our cheerleader.

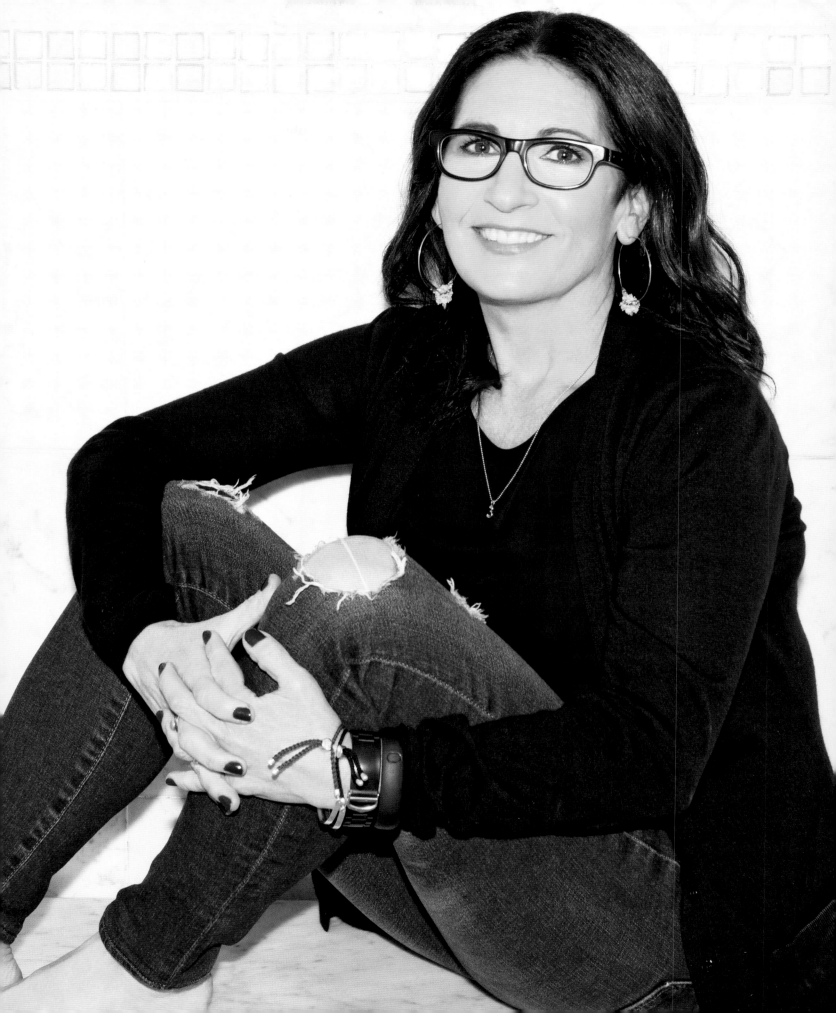

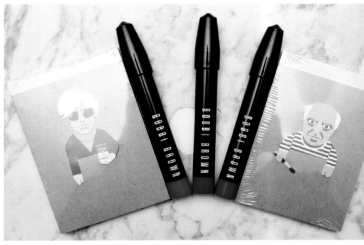

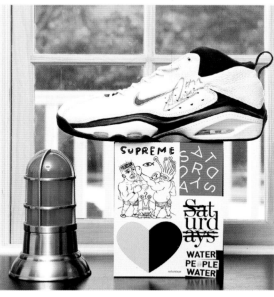

*"Sometimes
it's okay to break
the rules and
create your own."*

WHEN
September 29, 2015

WHERE
*Crawford's ocean-side
Malibu estate*

WHY
*She's the most iconic
supermodel in the world
with a career spanning
over thirty years.
We mean, it's Cindy.*

CINDY CRAWFORD

SUPERMODEL; ENTREPRENEUR; AUTHOR

Since the inception of The Coveteur, cataloguing and documenting legacies has been a big part of our MO. But we'll admit, when we booked this particular Coveteur shoot, there was something extra special about it, in that the subject was Cindy Crawford (!!!), who has been at the top of our proverbial bucket list, well, since before our company's existence.

We suppose it's glaringly obvious: She's the ultimate supermodel whose transcendent thirty-four-year long career shows no signs of slowing down. And you'd think that with over three decades of being lauded the most beautiful woman on this planet, walking the most memorable runways (yes, that Versace walk), and fronting major campaigns, that she'd have some semblance of impudence. Au contraire, friends. From the moment she invited us to her oceanfront Malibu estate (the view almost brought us to tears), Crawford proved to be one of the sweetest humans whose door we ever knocked on—affable and soft-spoken, almost shy. She knew that the way to our hearts (okay, so she's had prime real estate there since, well, forever) was an expansive table of kale salad, salmon, chips, and guacamole to feast on before we got down to ransacking her floor-to-ceiling custom-built closet.

It was, as we're almost positive you can imagine, pretty epic. As in, there were shelves upon shelves of Jimmy Choo, Saint Laurent, and Gianvito Rossi heels, while utilitarian Veronica Beard jackets and IRO leather bombers hung from seemingly endless racks. Billowing silk Chloé blouses in every shade of neutral and the odd Zimmermann jumpsuit made up the rest of her IRL Malibu Barbie wardrobe. With, you know, a cache of floral-embroidered and leather-stitched Fendi baguettes.

And while we bonded over our mutual love for Canadian cottage country, we talked about that iconic Versace runway she stalked with three other supermodel greats, how she always manages to squeeze in a morning Jacuzzi, and the sage advice (and archival Chanel) she's passing down to her daughter, Kaia. Guys, we're etching this one on our tombstones.

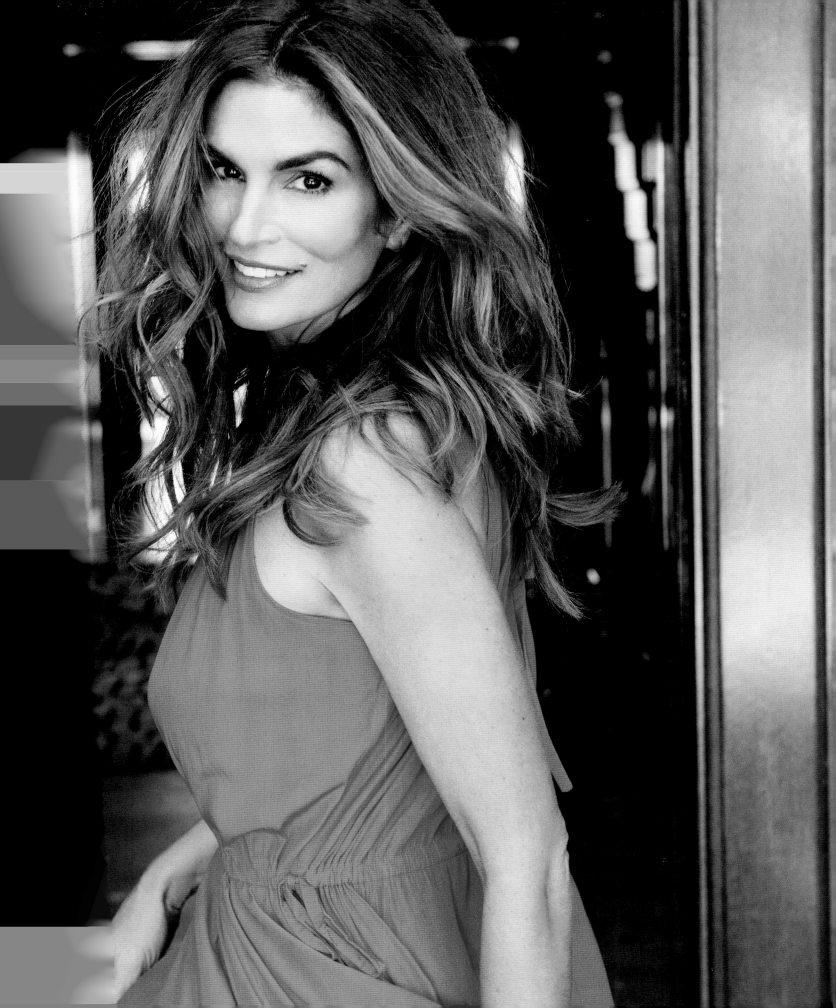

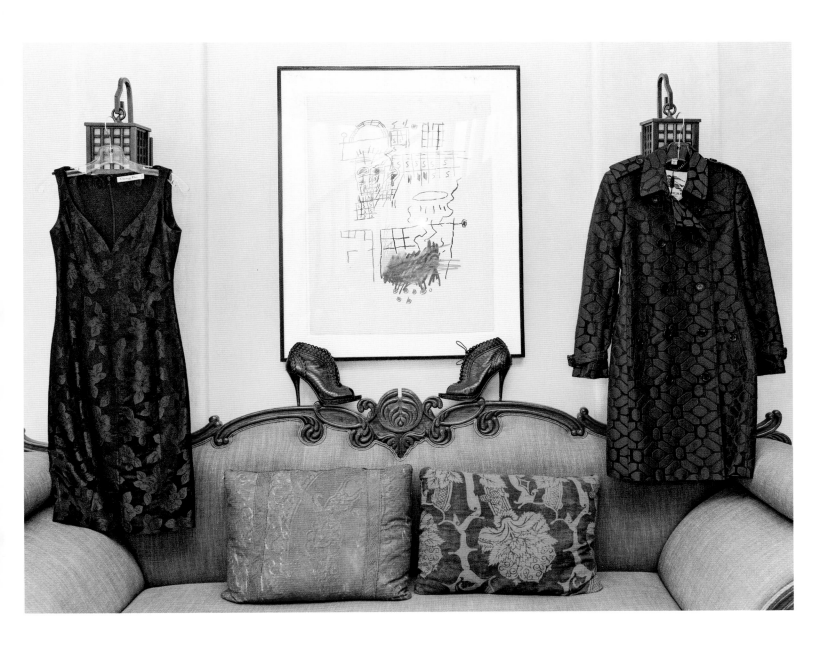

"I think the most surreal [moment in my career] was walking down that Versace runway with Christy, Linda, and Naomi to the George Michael song and the video. That one moment became bigger than any one of us, it was just amplified by the fact that we were all together."

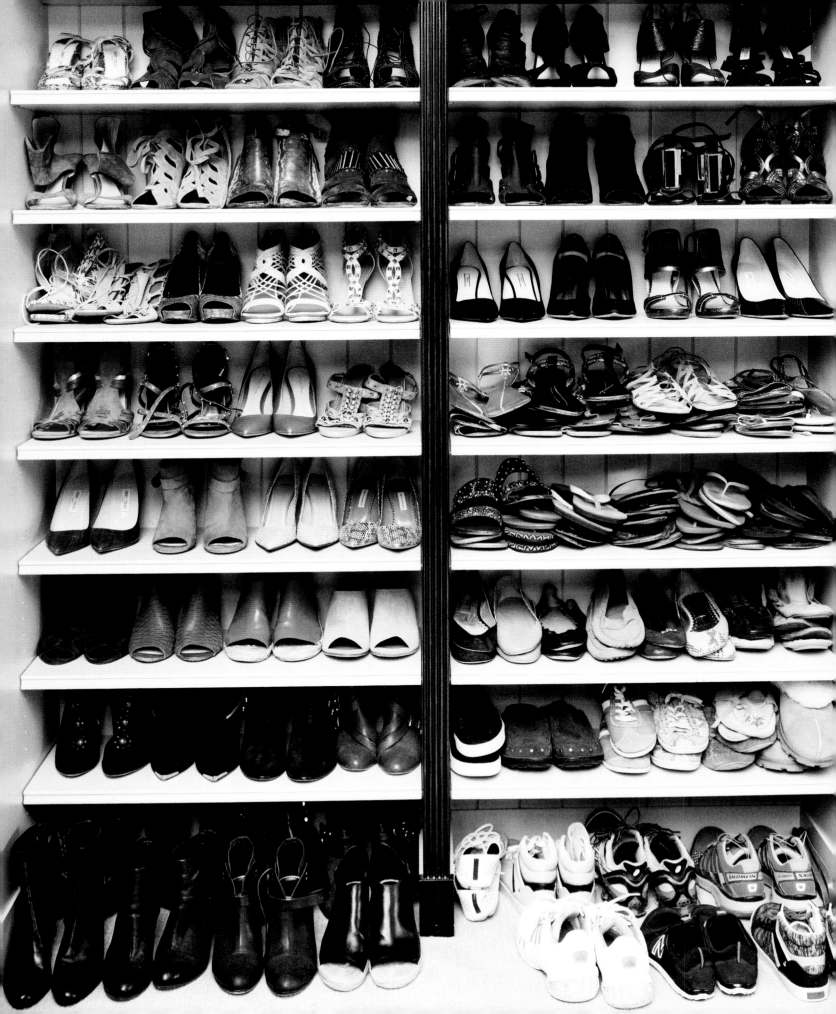

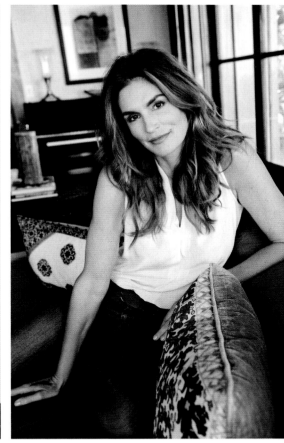

"Treat [modeling] like a job and be professional. Sometimes in fashion, you're so young going into it, you forget it's a business. Show up prepared, on time, and ready to work. Don't be on your phone, don't be distracted, and don't be tired."

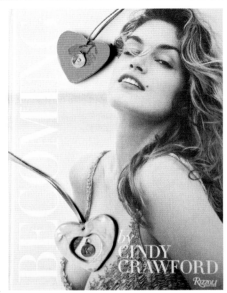

"I just like jeans,
a good leather jacket,
and cute boots—
'off-duty supermodel,'
that's kind
of my thing."

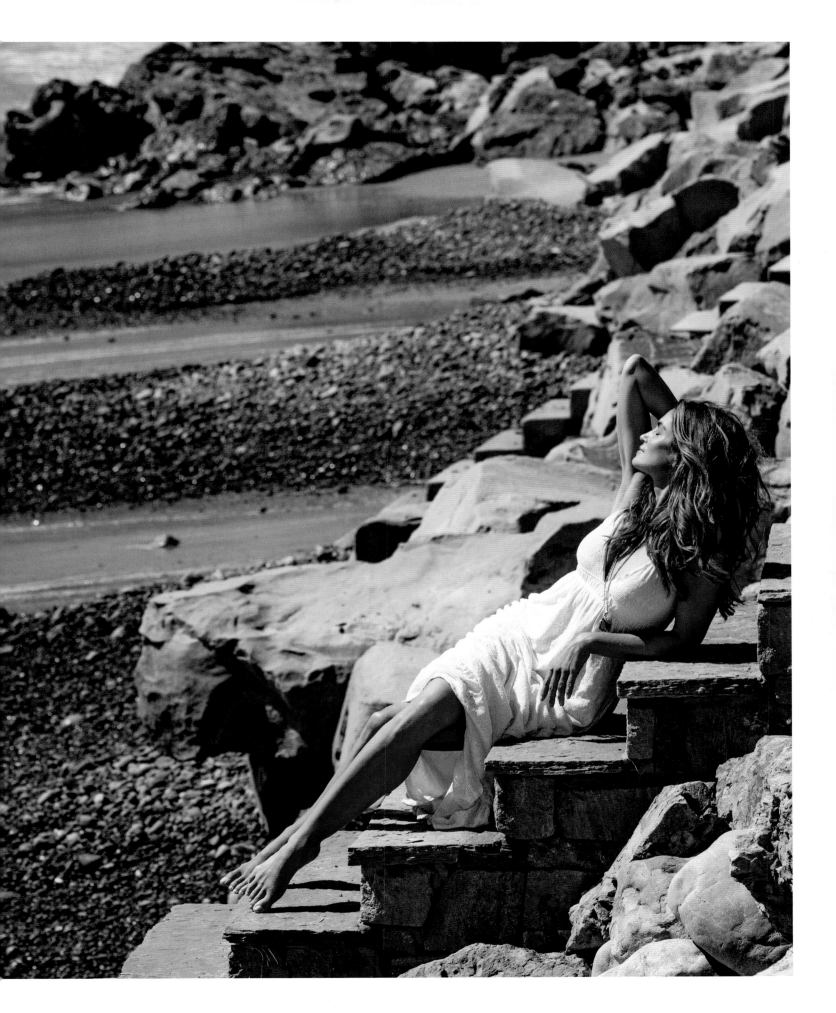

WHEN
February 26, 2015

WHERE
*The Crawley family's
first Los Angeles home*

WHY
*She mixes streetwear and
couture like no one else.*

KRISTEN NOEL CRAWLEY

JEWELRY DESIGNER, KDIA

Our apologies to the late, truly great *Cosmo* editor-in-chief Helen Gurley Brown, but by now we've (hopefully) established that the notion of "having it all" is a tired, if not unduly limiting, myth for women. But if balancing family, social life, a thriving career, and personal development–type perks, such as jet-setting around the world and, oh, we don't know, rubbing shoulders with Mr. Alaïa and building a considerable collection of Dior, isn't pretty damn close to making that myth a reality, we don't know what is. And given that this pretty much describes the day-to-day of Kristen Noel Crawley—née Gipson—the Chicago-born-and-bred jewelry designer, when we heard that she was (finally!) settled into her new home in Los Angeles, we jumped at the chance to come over for an afternoon and get acquainted with the, ahem, finer points of her wardrobe.

Crawley welcomed us clad in a white tee and slim-cut trousers by The Row (a staple of hers—so much so that she owns eight pairs) and sporting her new blunt crop (think Audrey Hepburn, if she lived among four-foot-tall Bearbrick statues and wore fine jewelry inspired by emojis), with her son, Baby Don, at her side. After giving us the full tour of her place (right down to Baby Don's Takashi Murakami–filled room), we quickly got busy in her closet. Immaculately organized, with each item on pristine

white hangers, her wardrobe was comprised of the sort of standout staples that make up her signature: one part straight-from-the-racks-of-Colette cartoonish whimsy, one part pulled-together *Vogue* Paris editor, one part avid Hypebeast subscriber.

And despite all of this, she still has the same mortal concerns about "saving" her very best pieces that we do—though the origins of said pieces differ just a tad from our own. "Kanye gave me those Giuseppe Zanotti x Kanye West beaded heels, and not only will I never get rid of them, but I will also never wear them. I'm so afraid that a little pearl is going to pop off, and that would just kill me." (Crawley's husband goes way back with West.) She has a serious thing for novelty pieces, too: a leather-bound Chanel bible, Louis Vuitton pumps with Perspex acrylic wedges, blue rubber-like Dior sneakers. You see how we want to be her now, right?

While we pretty much exhausted the ins and outs of Crawley's wardrobe during our shoot, nothing quite nailed Crawley's aesthetic like her last look of the day. She changed out of a well-worn Def Leppard–concert tee and teal Balmain miniskirt and into Off-White boyfriend jeans, a khaki-hued Fear of God bomber, and a floral Céline bra top. After adding a few finishing touches (a blue Kansas City snapback, nude Manolos, and a fistful of her namesake KDIA jewelry), we strolled with Crawley down her palm tree–lined street with just one question in mind: How the hell did she not move here sooner?

"When I was twenty years old, I was living in L.A., going to school, and waitressing, so money was really tight. I saw this white Chanel bag that had this sparkle in it. It was $3,000 and I remember thinking, 'Okay, I could pay my rent for six months, or I could buy this bag.' I decided to buy the bag! Even though it put me in a tight financial spot, I cherished it. I was so happy that I bought it."

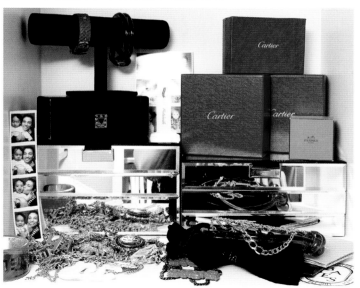

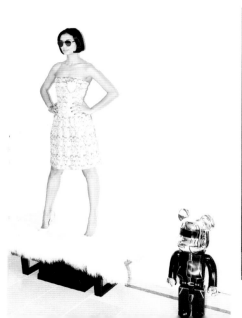

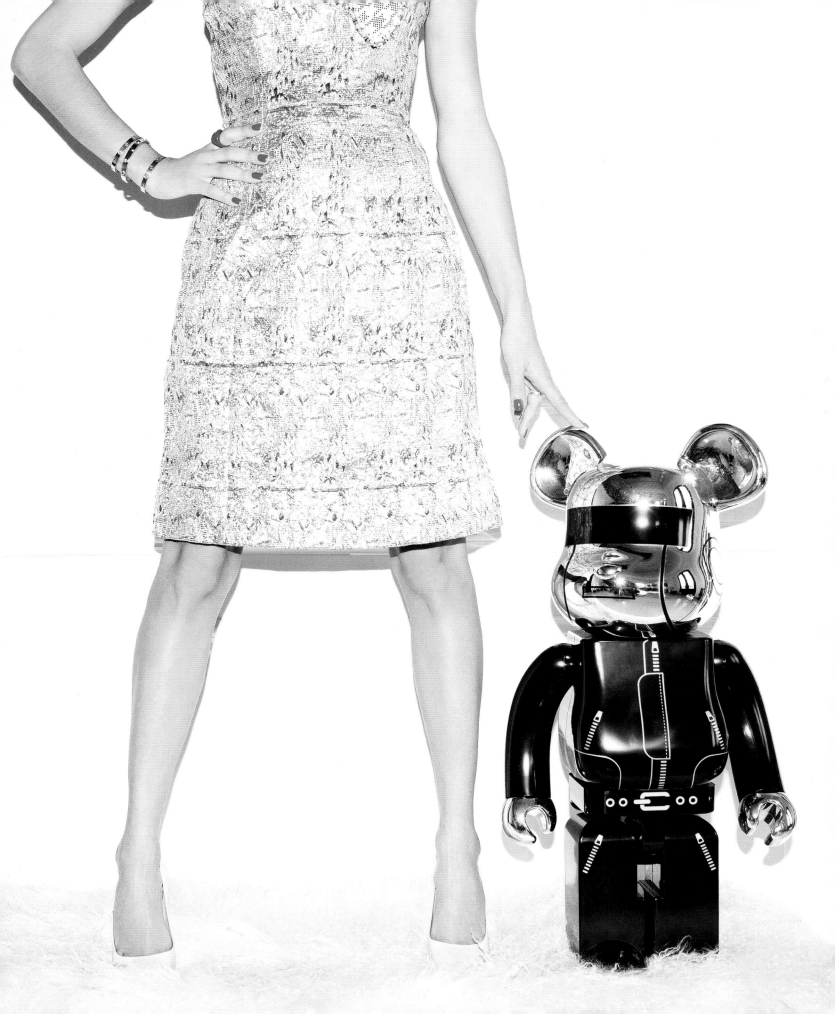

WHEN
July 23, 2015

WHERE
*The designer's houseboat
on the Seine,
just outside of Paris*

WHY
*She designs some of
our favorite footwear in
the game. See: her
namesake label. Oh, and
her work with Chanel.*

LAURENCE DACADE

SHOE DESIGNER FOR HER NAMESAKE LABEL, LAURENCE DACADE,
AS WELL AS CHANEL

We consider ourselves lucky enough to call Paris one of our semi-regular haunts, from our biannual expeditions for Paris Fashion Week to spontaneous outings to visit French designers like Olympia Le-Tan or Aurélie Bidermann. And thus, we've become relatively familiar with the city (or as familiar as you can be when you don't quite speak the language, nor can you pull off actually looking like you belong in that inimitable, Parisian way). But then, we'd never visited Laurence Dacade before.

It's not for lack of trying, however. We've been following Dacade ever since we woke up to the fact that she has a large hand in the creation of every piece of Chanel footwear we've ever

coveted. Those chain-strapped patent boots? The quilted combats? The cap-toed kitten heels? All her. Seriously. That and the undeniable truth that a solid percentage of the shoes on our online wishlists bear her name. It's a cliché, but just like every other fashion person out there, we're shoe obsessed. Therefore Dacade = a must-shoot.

But then—wild card!—we learned that Dacade lives with her husband and next door to her best friend (also her publicist and our new pen pal) in a houseboat on the Seine. A closet full of Chanel in a home unlike anything we've ever seen before? This, friends, is what we call Coveteur catnip. Flight to Paris booked,

and we found ourselves onboard in the middle of July. And, yes, there was an extraordinarily tight edit of both Chanel and shoes on hand. We mean, who needs a summer vacation when this is your everyday?

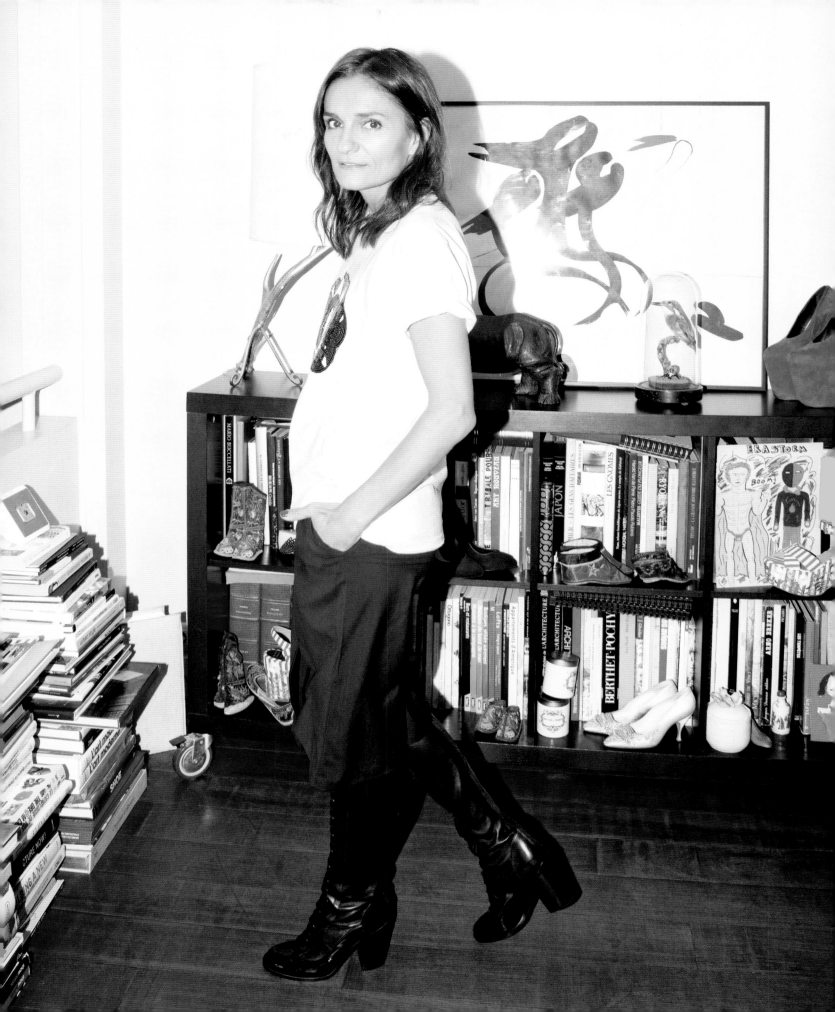

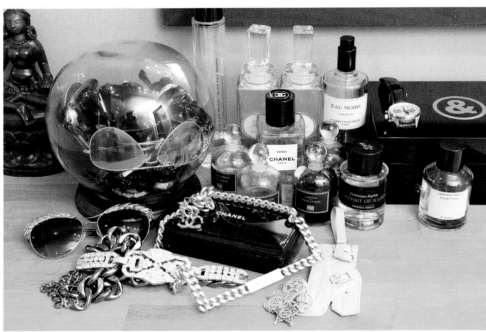

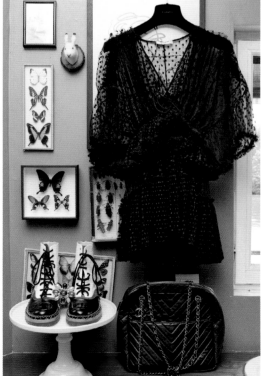

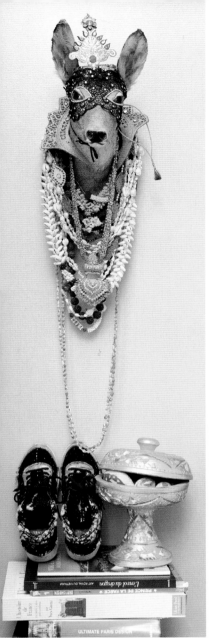

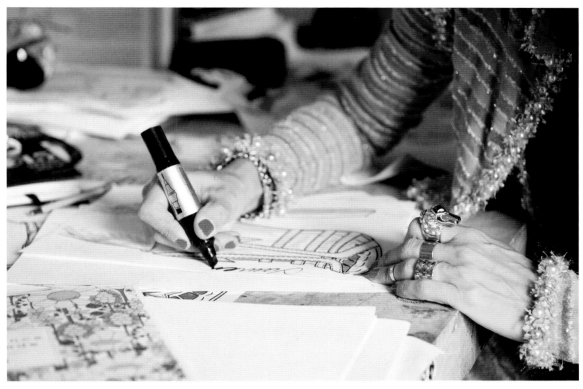

"I have lived on a houseboat for years now! I love the view, the light, and the feeling of being on holiday and traveling; it gives me a sensation of freedom. I would not feel the same living in an apartment or house."

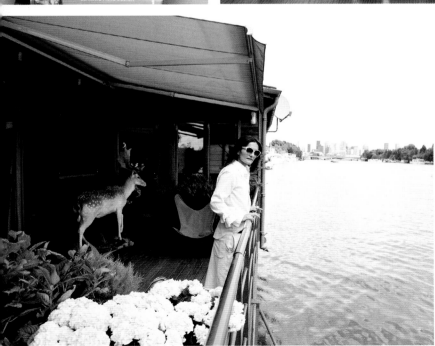

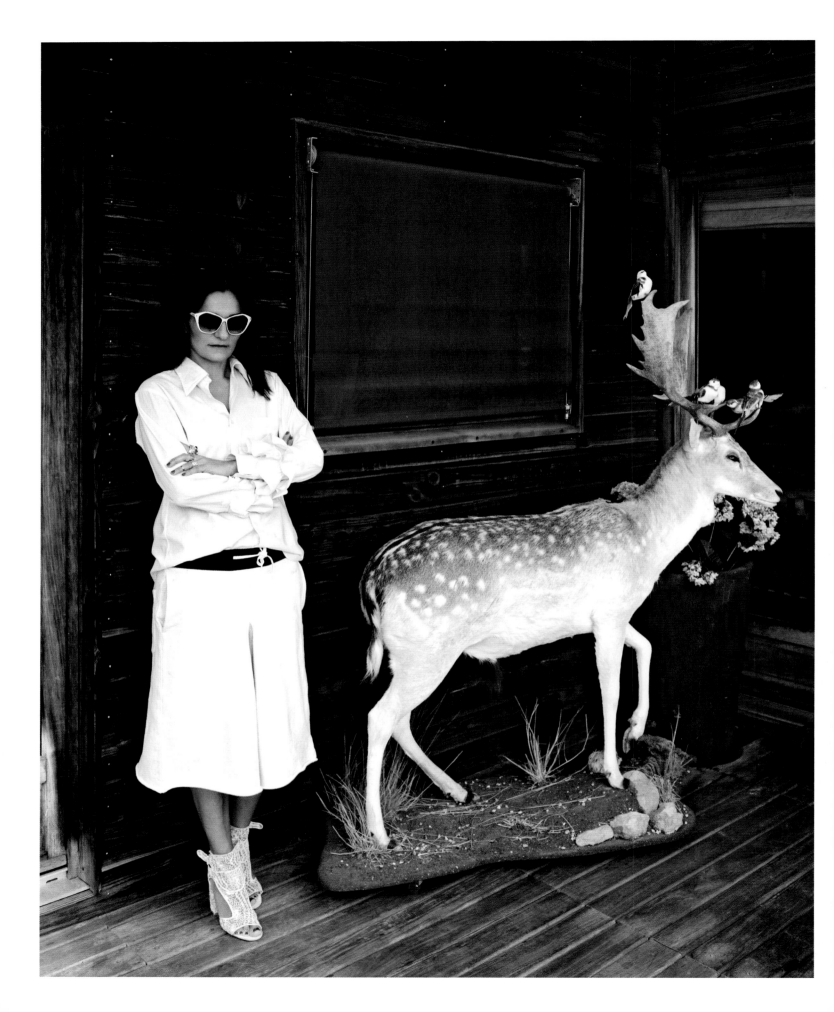

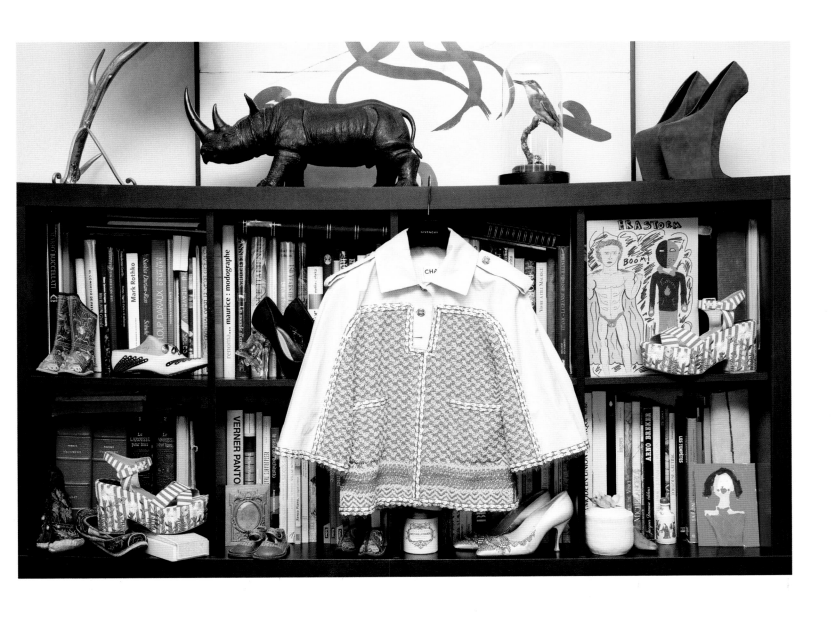

"As long as I can remember,
I have always been obsessed with shoes."

WHEN
September 18, 2014

WHERE
Her classic London townhouse in Ladbroke Grove

WHY
She's the genius mind behind the madcap accessories label Charlotte Olympia and wears retro unlike anyone else.

CHARLOTTE OLYMPIA DELLAL

CEO & CREATIVE DIRECTOR, CHARLOTTE OLYMPIA, LONDON

Pre-2008 was a simpler time, footwear wise. Basic, even. The platforms of our pumps rarely exceeded a few millimeters, and we didn't dare dream of carved poodle heels or glossy pink filmstrip ankle straps. Then again, our presence hadn't yet been graced by the inimitable Charlotte Olympia Dellal and her namesake accessories line—and our bank accounts, medial arches, and overall happiness levels haven't been the same since. (Look at those feline faces embroidered on her namesake flats.)

Dellal greeted us bright and early at her Ladbroke Grove home in London (we were playing Milan Fashion Week hooky at the time—the possibility of viewing the designer's personal footwear trumps pretty much everything), which, for lack of a less hackneyed turn of phrase, couldn't have been more, well, on brand. As in, there's probably no better advertisement for all things Charlotte Olympia than Dellal herself and her very (very) extensive wardrobe. Despite having recently-ish given birth to her third child, she greeted us with immaculately coiffed blonde waves and ruby-red matte lips, in a pair of her ubiquitous sky-high heels (house slippers are not a thing here), which were only

the first of many pairs she'd wear during our shoot (but you already saw that one coming).

Suddenly, our jet-lagged excuse of an outfit felt a little, um, out of place. See, Dellal is one person who truly has a signature. Never, no matter how casual the occasion (hosting a couple of schlubby photographers *chez elle* comes to mind), will you spot Dellal out of her retro signatures. And for that, well, we are impressed. Hers is certainly more imaginative than our black jeans–white tee "signature."

Dellal's longtime go-to hair guy made a few minor touch-ups while we virtually ran wild in her home (think less kids in a candy store and more perfectly grown adults with zero self-control). Her shoe closet was thoroughly raided, as was her stash of Isa Arfen separates, Yazbukey jewelry, and cheeky (as in, borderline-NSFW cheeky) Piers Atkinson hats. We chatted everything from the *Rio II* soundtrack (it's a long story) to Dellal's penchant for naming her accessories after icons (a word we don't use too lightly around these parts) of Old Hollywood. Does Dean, Bogart, Gable, or Astaire ring a bell? Also, all the shoes. "When I started making shoes it was literally five and a half inches or nothing," she said with a laugh. Oh, and just as we were about to head out the door, we convinced Dellal to hop inside her clawfoot tub for one last shot. Then again, if we were Dellal, we'd be kicking up our heels, too.

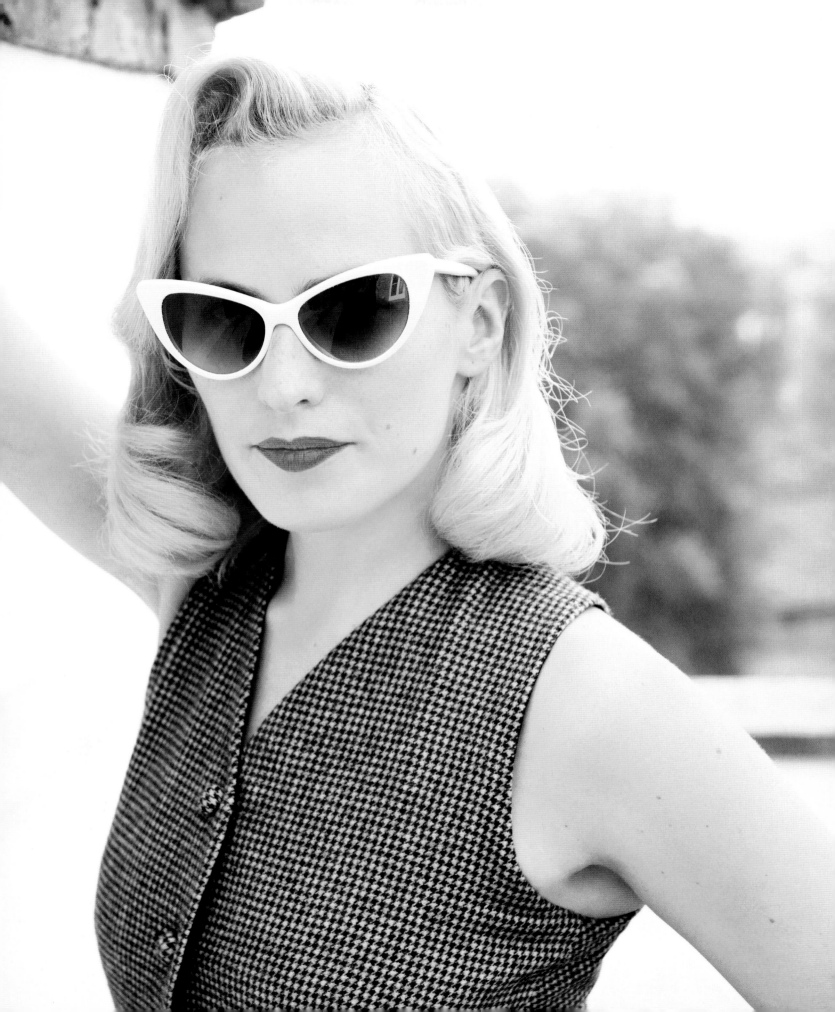

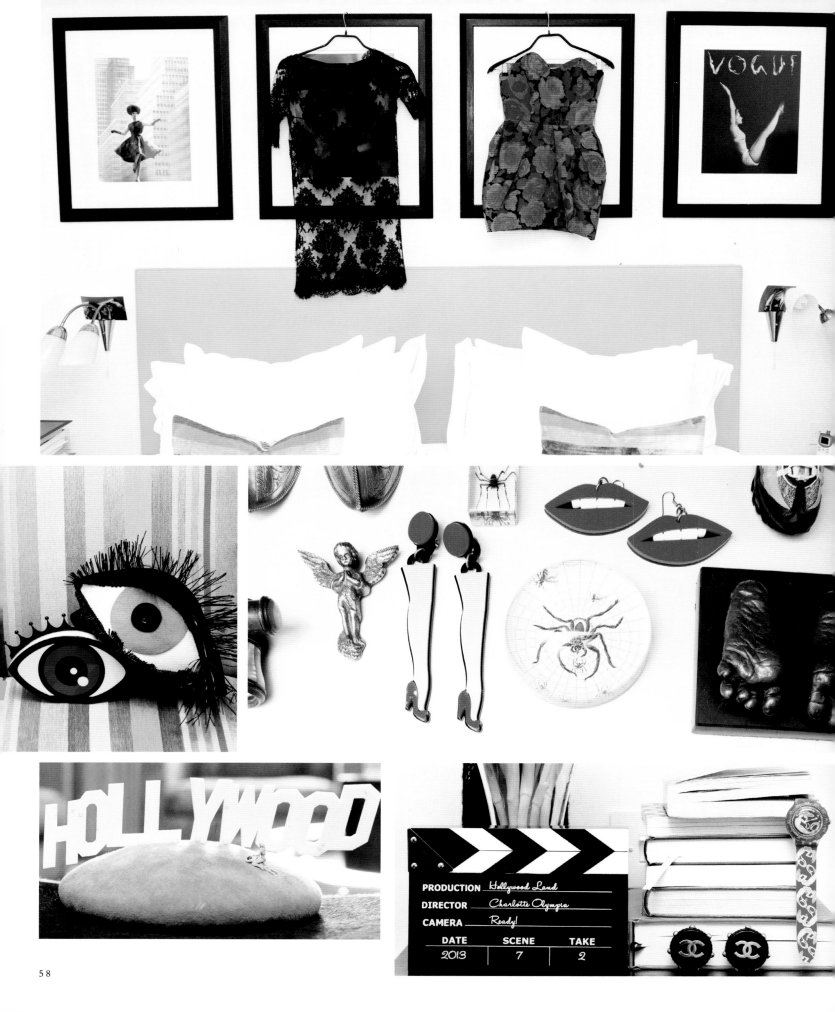

PRODUCTION *Hollywood Land*
DIRECTOR *Charlotte Olympia*
CAMERA *Ready!*
DATE | SCENE | TAKE
2013 | 7 | 2

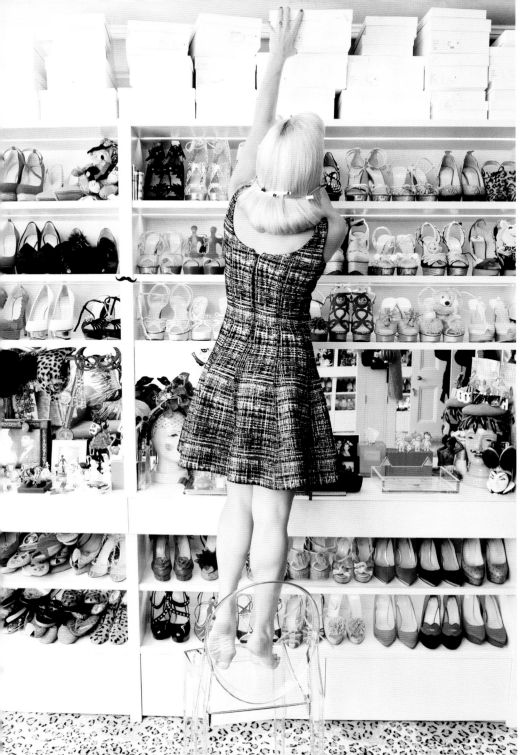

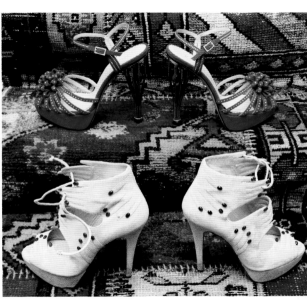

"*I love the glamour, but I love to have a little bit of humor. If [my shoes] would say something, I guess it would be 'Take me dancing!'*"

"I've always loved the 1930s, forties, and fifties, from a young age. I used to watch lots of old movies with my mom, so I think I get it from her. She loves glamour, and my grandmother was very glamorous. I get it from the women in my life."

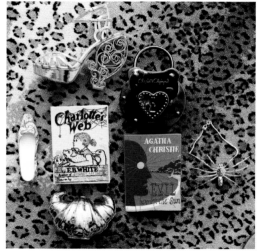

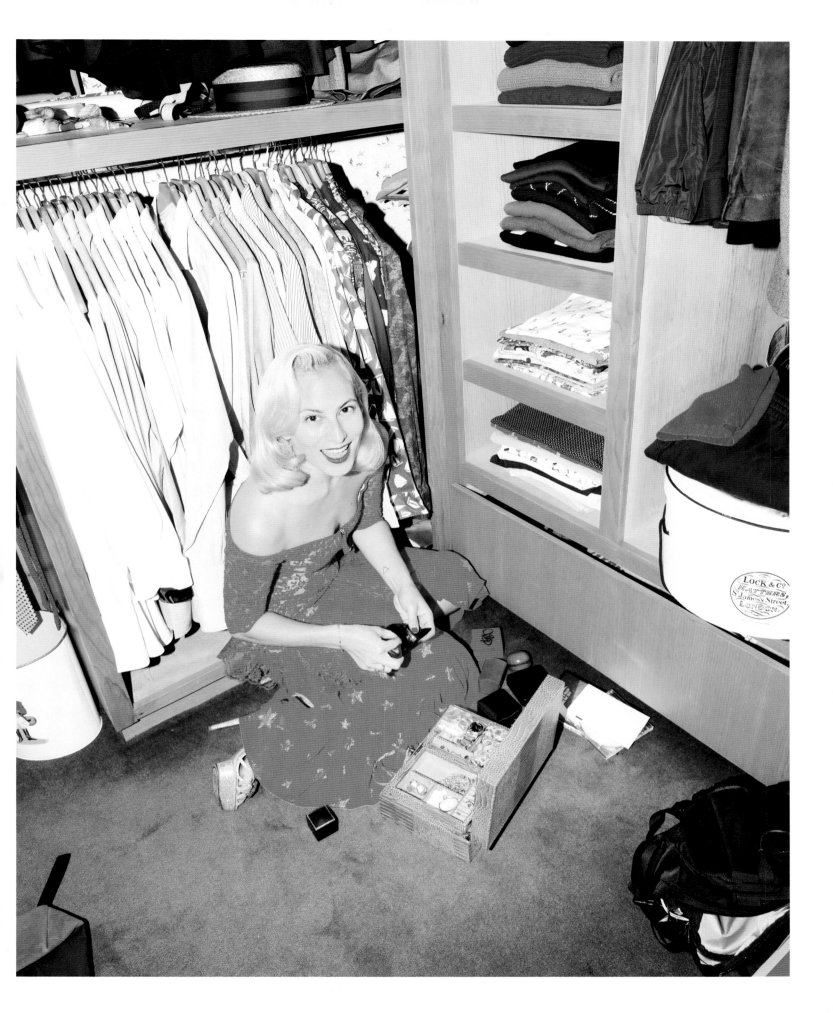

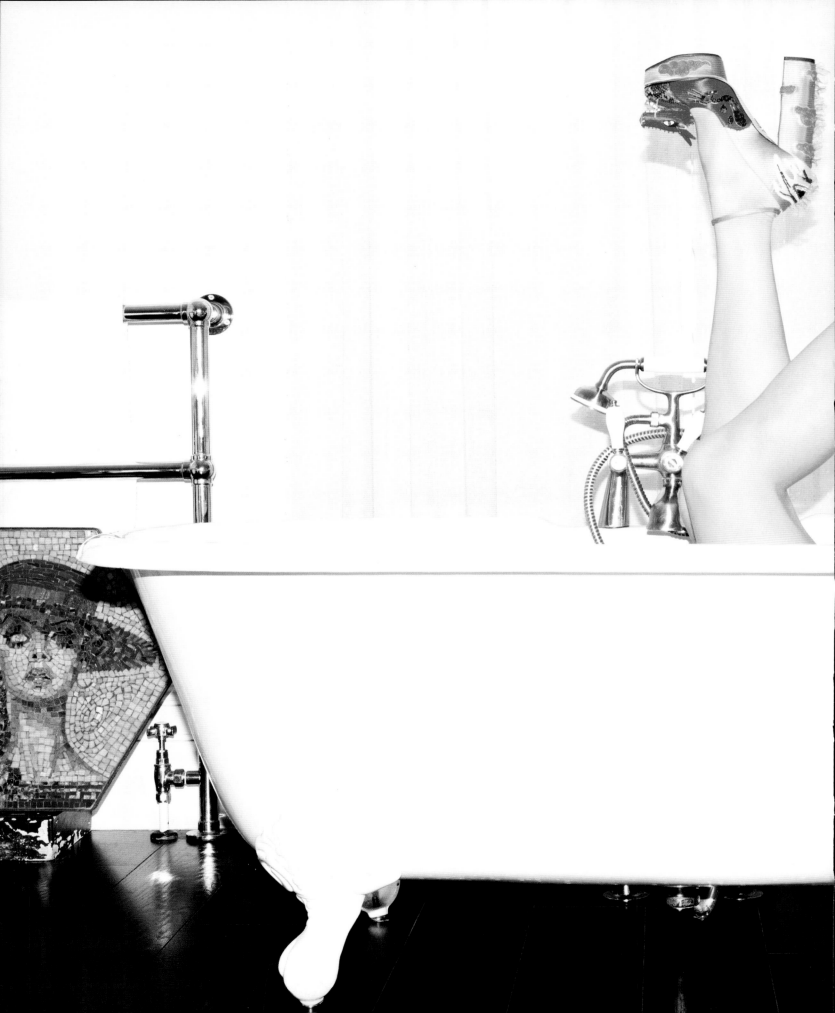

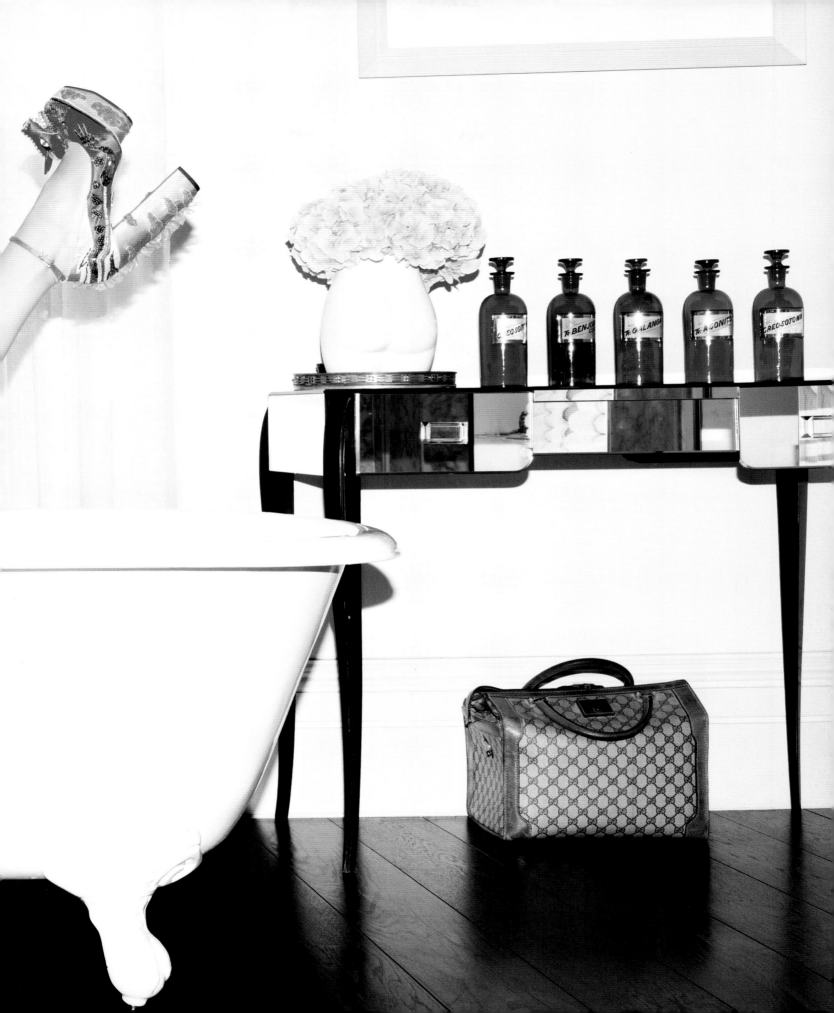

WHEN
February 18, 2014

WHERE
*Eldridge's central
London home*

WHY
*Vogue and Kate Moss
call her out for her
handiness with a blush
brush. Oh, and her
YouTube channel,
where she breaks down
makeup techniques for
even the most amateur
among us, has racked
up millions and millions
of views to date.*

LISA ELDRIDGE

MAKEUP ARTIST; BLOGGER; CREATIVE DIRECTOR

Before meeting makeup artist Lisa Eldridge in the flesh, we thought we knew exactly what we'd find in her home. A seriously extensive beauty cabinet? You could say we saw that coming—and, no, we weren't disappointed. You would have thought we'd never seen an eyeshadow palette in our lives the way we were mooning over her (admittedly outrageous) collection of skincare and makeup.

But if we're being completely honest, what we didn't expect was the home and closet that Eldridge welcomed us into. We suppose when the woman who has countless international *Vogue* covers under her makeup belt and big-name clients that include all four Kates (those would be Beckinsale, Bosworth, Winslet, and yes, Moss), not to mention one hundred million views on her YouTube channel (no big deal!), we should have seen it all coming.

After all, having spent more than a few hours watching her tutorials (we swear we're *this* close to mastering her "no makeup" makeup and "meeting the ex" looks), meeting Eldridge in living color was a bit like seeing a long-lost friend—but one with a seriously enviable London home. Simply put: In line with her chosen profession, Eldridge has an appreciation for beautiful things that she perfected long ago. We mean, her collection of deco lamps and arty objects is second to none, and she's managed to curate the next-to-impossible-to-achieve gallery wall, with vintage *Vogue* covers as a key ingredient.

When it comes to fashion, though, Eldridge covers all her sartorial bases, from goth-like Christopher Kane and a pop art–inspired Lulu Guinness lip clutch, to strings of pearls (Chanel, *bien sûr*) and Miu Miu sparkle booties. It was the kind of mixed bag we can appreciate, and one she pulled off without breaking a sweat in front of our lens. Jury's still out on whether we've pulled together her cat-eye technique in quite the same way.

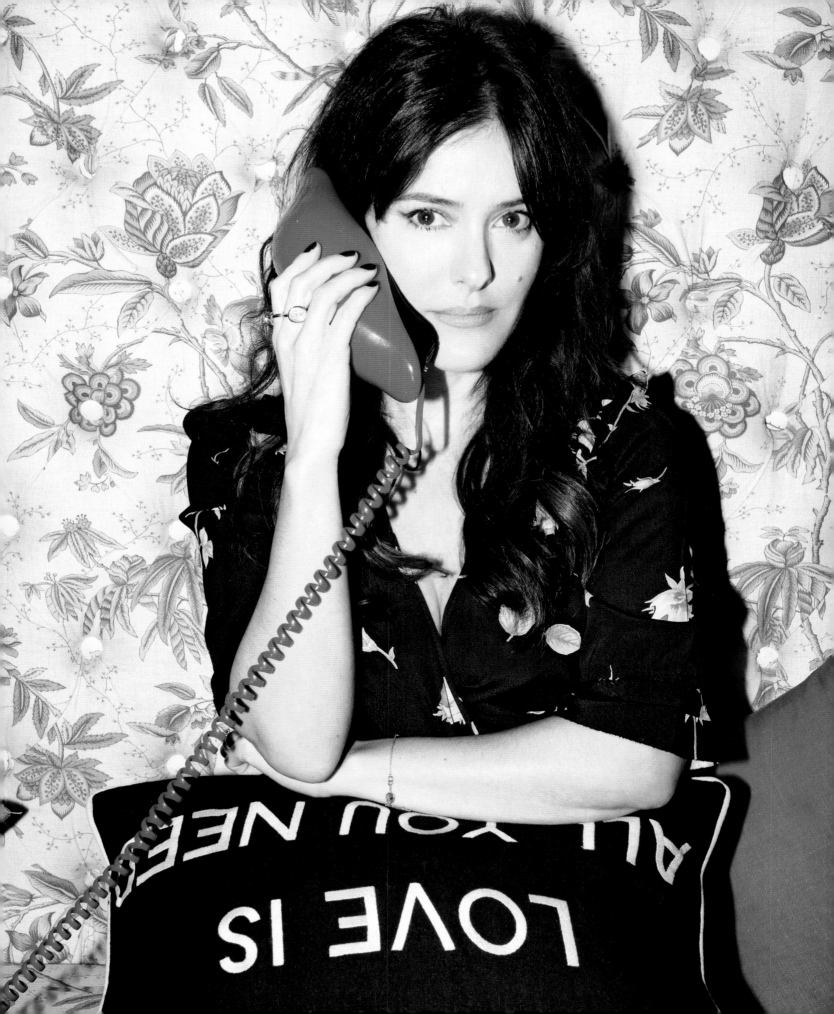

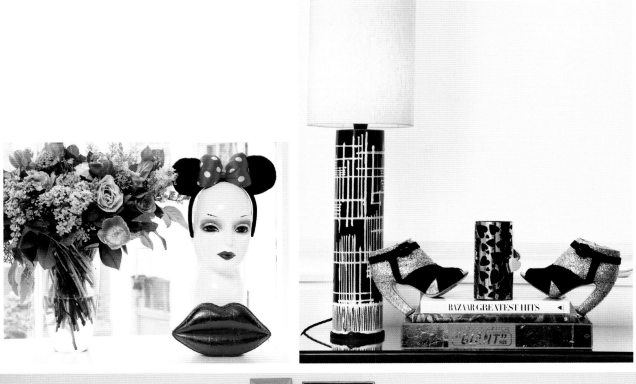

"I love the variety of my job; one day I'm in France shooting for Vogue Paris, the next I'm launching a new product for a brand, and on another, I'm helping an A-lister perfect her look for the red carpet."

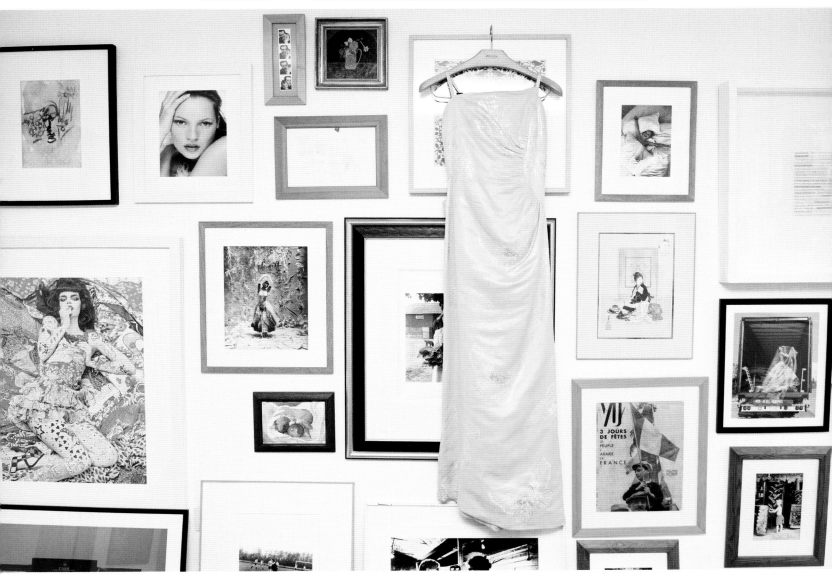

WHEN
November 19, 2015

WHERE
*Elie's family home in
Cologne, Germany*

WHY
*Ever found yourself in
a Comme des Garçons
outpost wondering, Who
actually wears this stuff?
Elie does.*

MICHELLE ELIE

DESIGNER

I f the street-style photos of Michelle Elie making her way through the Tuileries in her very best Rodarte gowns and sculptural Comme des Garçons coats haven't made their way to your computer screens, allow us to explain her appeal thusly. Elie's the kind of woman who rolls up to greet you in those oversize, patchwork Junya Watanabe jeans (the ones every fashion editor, everywhere, is desperate to get their hands on) the same way you might greet a friend with a bottle of wine in sweatpants. We arrived at Elie's Cologne home early one morning, trudging up a few flights of stairs before being greeted by the woman herself, who had espressos and fresh croissants with raspberry jam at the ready. We managed to catch our first few peeks at the Damien Hirst pieces that dot her entryway, just out of full view. While we ate, we caught up on the details of her latest New York birthday trip (she skipped shopping—waiting for sale season—and instead stopped by the Gagosian and the Whitney to take in Jeff Koons and Frank Stella), the quality of croissants in Cologne versus Paris (let's put it this way: Paris, watch your back), and the preparations for her son's upcoming birthday party. And then? It was time for the closet.

Elie lead us up flight after flight of stairs—touring us through her bathroom, sauna (!), meditation room (!!), children's rooms, her

incredible bedroom adjacent to a reading-cum-loungey space, her husband's black marble bathroom, and finally, her closet (!!!). Sliding doors revealed archival Balenciaga, Junya Watanabe, printed Prada, and of course, Elie's favorite, Comme des Garçons. After taking our first browse through Elie's main closet, we were led up a set of white stairs to her attic atelier, which doubles as a home for her more conceptual CdG pieces. In short, it was a little overwhelming. In the very best way possible.

Born in Haiti, and having lived everywhere from Paris (where she put in time at Le Cordon Bleu) to New York and Miami, Elie is a real renaissance woman. Her Cologne residence provided no shortage of interior details for us to style our shoot around—Michelle and her husband, art director Mike Meiré, really make it a point to incorporate art into their everyday lives. A Joseph Beuys sat atop the fridge, a Tracey Emin light installation above their pots and pans, a massive pink Hirst valentine in their dining room (a wedding gift to the couple . . . from themselves). Oh, and you think you have a magazine-buying problem? Elie's collection should more than justify your future purchases. We pretty much had to stop ourselves from poring over her stacks of *032c* (the biannual glossy is one of her husband's clients), international editions of *Vogue*, and archival issues of *Artforum*. In other words, it was decidedly one for the books. Namely, this one.

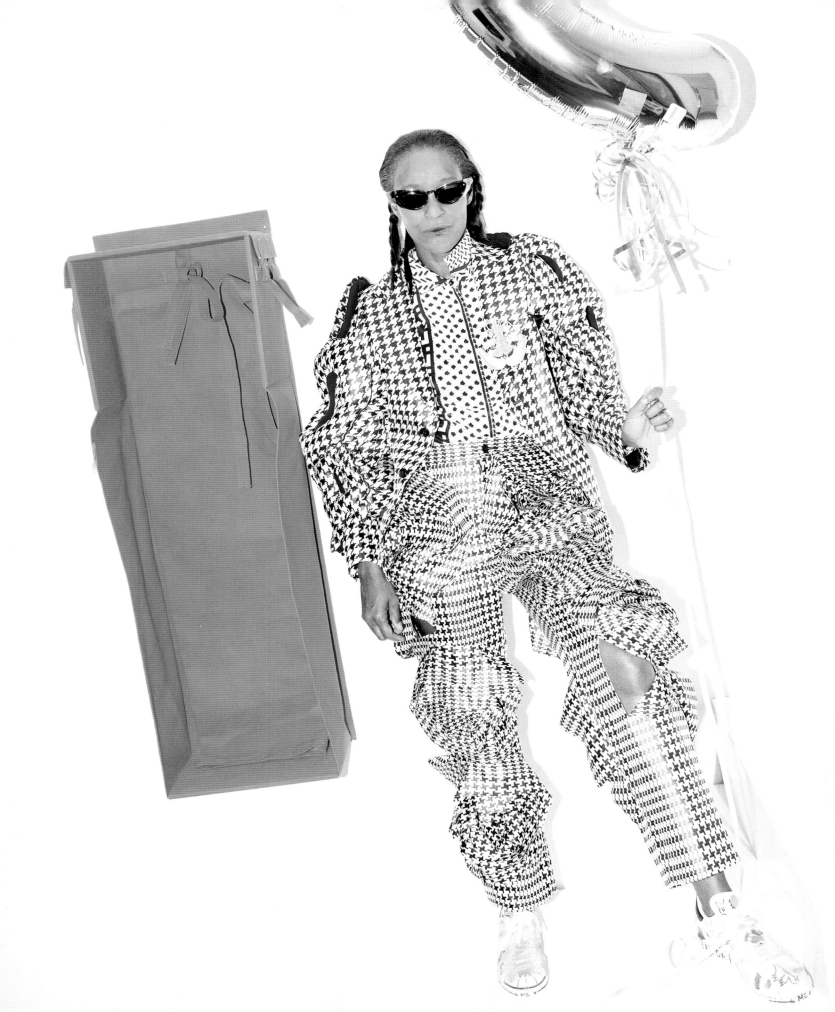

"I love all the very forward-thinking designers. I won't say 'avant-garde' because that term is quite boring. When no one understands anything, they say, 'Oh, it's avant-garde.'"

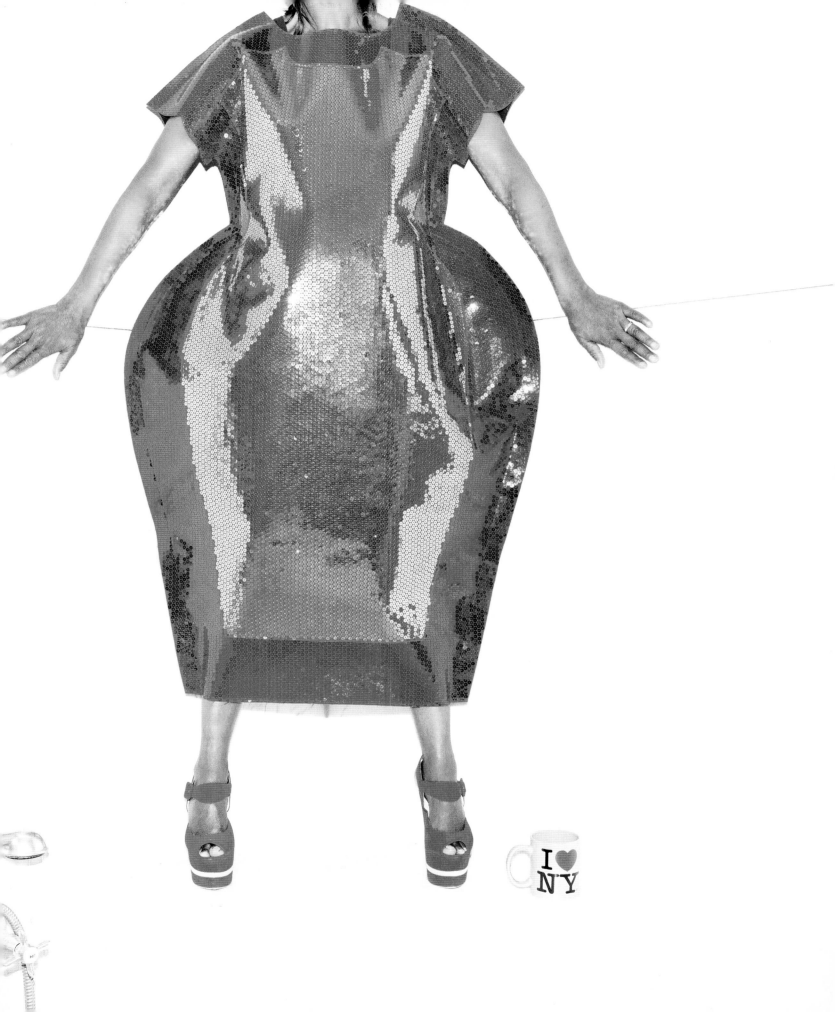

WHEN
June 15, 2015

WHERE
*A walk-up in New York's
Lower East Side*

WHY
*Other than the fact
that a good percentage
of her wardrobe is
hand-me-downs by
way of Stevie Nicks?
Tavi rose to the
front-row ranks and
proceeded to fall in
and out of love with
the fashion industry
before starting her own
magazine for girls in
their teen years and
beyond (and managing
the staffers that
came with it), all
before she graduated
from high school.*

TAVI GEVINSON

FOUNDER, *ROOKIE*

A quick disclaimer: We hate to idealize. No, really: Even though we have the tendency to wax prolific on everything from the mundane (grilled cheese) to the extravagant (hand-beaded couture that requires upward of ten thousand hours of work), we understand—it's a crushing amount of pressure to live up to.

But when someone's résumé ranges from traveling to Tokyo to interview (the notoriously press shy) Rei Kawakubo of Comme des Garçons at age fifteen, to penning *Elle* cover stories with Taylor Swift and Miley Cyrus at eighteen (oh, and founding, running, and publishing her own online magazine with an annual print yearbook while still in high school), it's hard not to take notice and consequently feel really bad about how you spent the better part of junior year. For the record, it was reading *YM* and stealing our parents' liquor. Naturally.

When Tavi Gevinson first captured the rapt, undivided attention of the fashion industry (yes, said attention included requisite front-row snaps alongside Karl Lagerfeld and Anna Wintour) with her *Style Rookie* blog before even graduating from middle school, it would have been way too easy to just sort of . . . ride things out. And then, the inevitable backlash started. Editors complaining that Gevinson's work was ghostwritten; her whole enterprise orchestrated by her parents; her words without meaning and she without the requisite years spent

in the journo-trenches. Her solution? Gevinson traded front-row seats (save for her biannual appearance at Rodarte) to pursue a passion project that was all her own (literally—she eschewed big-name publishers in favor of help from Anaheed Alani and Ira Glass). The result? Rookiemag.com, on which Gevinson and her team have covered everything from collecting vinyl and cult films to panic attacks and masturbation—and attracted a cult following of adults, too. Despite every alarmist article in the *New York Times* conflating this generation's preoccupation with something as innocuous as selfies with the apocalypse, we're pretty sure that, if Tavi's any indication, they're going to be just fine.

Meeting us at her Lower East Side apartment one afternoon before a performance of the Broadway show *This Is Our Youth*, Gevinson gave us the grand tour of her place, which she shares with photographer Petra Collins. We sorted through her wardrobe together, including what Tavi described as a "wonderfully corny assortment of Susan Sontag items" and a Miu Miu purchase fueled by its print's resemblance to the Gevinson family dog. And then came the hand-me-downs. True to form, Tavi's secondhand pieces weren't quite the ones we scavenged from the thrift store. Instead, we found pleated lip-print skirts gifted to her by Miuccia Prada, leather gloves handed down by Winona Ryder (who, in turn, received them from Audrey Hepburn), and gold Chanel boots that were a present from Stevie Nicks. "I owe so much of my brain to so many people," Gevinson explained as we picked through the piles of tchotchkes. Friends, high places, you know the deal.

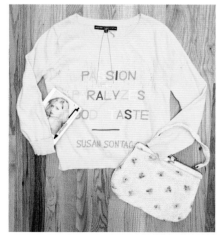

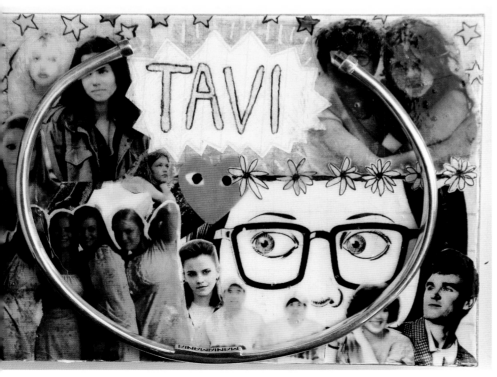

"Winona Ryder gave me a pair
of gloves on my eighteenth birthday—
Audrey Hepburn gave them
to her when she turned eighteen."

WHEN
April 22, 2014

WHERE
*Ghandour's palatial
home on one of Dubai's
famous palm fronds*

WHY
*The boutique owner
and designer has
one of the most over-
the-top collections
of avant-garde fashion
and contemporary
art we've ever seen.*

ZAYAN GHANDOUR

COFOUNDER AND CREATIVE DIRECTOR, S*UCE

O ur day jobs come with some perks: exploring the deeper corners of some truly exceptional closets, going backstage at a couple major fashion shows, hanging out with one or two Victoria's Secret supermodels—not that we like to brag. One of our favorites, however, is spontaneously jumping on flights to new cities around the world—like to Dubai, for instance. And while we're definitely a fan of the many, um, public attractions—a mall featuring a ski hill and a couple thousand square feet of shoes—it's getting a peek inside private homes that really gives us an indication of how the natives live. We'll say this: All that shiny extravagance that Dubai is known for really doesn't let up once you get to the inside. Like, at all.

Luckily for us, our first stop in the Middle Eastern capital of glitz was the home of Zayan Ghandour, designer of her own eponymous label and cofounder and creative director of the concept boutique S*uce. We've never met a local ambassador with quite so much Sophia Webster, custom Chanel, and contemporary art. Arriving at her home wasn't unlike stepping into a fantasy world where a Pepto-pink toy soldier (it's art, guys!) is your personal mascot and everyone has his or her own aerie swimming pool sanctuary. Welcome to Dubai!

Ghandour is known for her eccentric, totally out-there style. (We'll put it this way: The designer is Dubai's model citizen, sartorially speaking.) We mean, when she welcomed us into her home decked out in that Simone Rocha pearl-encrusted dress, we knew we were into the big time, Middle East–style. After munching on a traditional spread of hummus and pita (Whole Foods has nothing on the real thing) and sipping coffee, we got down to the serious business of evaluating Ghandour's closet. Lets just say the designer gets the A-grade when it comes to incorporating art into fashion. Even her Chanel and Louis Vuitton bags were graffiti-adorned (her favorite is a ten-year-old collectible from Takashi Murakami's collaboration with LV). And her shoe game? Next level. We dare you to look through her closet and not want to throw out all your black boots in favor of Ghandour's

hot-pink, lacy Marc Jacobs pumps or spiky Christian Louboutin sandals. Then again, we're pretty sure even the most accurate mimicry couldn't get us to her mix-mastery level—it's clearly a Dubai thing.

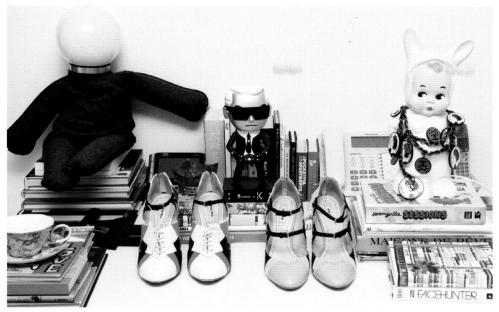

"People in this part of the world are nuts about colors and over-the-top details. They love to show off their pretty things; it's apparent in their extravagant and colorful clothing, living quarters, and art."

WHEN
August 28, 2013

WHERE
*His iconic, John
Lautner–designed Los
Angeles home*

WHY
*A fixture at just about
every fashion week and
basketball game, he's
still as enigmatic as
his business card reads:
"Fashion, architecture,
and basketball."*

JAMES GOLDSTEIN

ENTREPRENEUR AND ARCHITECT;
FASHION AND BASKETBALL ENTHUSIAST

There's a certain mystery that follows James Goldstein wherever he goes; yet, there's no extravagant event that can overshadow him—he's kind of hard to miss. Whether he's lensed by street-style photographers outside fashion week tents in Paris, Milan, New York, or London (or the more obscure weeks in Moscow and Copenhagen), sitting front row at John Galliano's Maison Margiela shows (the two go way back), or courtside at every. single. Lakers game, you can't help but wonder: "Who is that guy?" The truth is, Goldstein's story is shrouded in secrecy. But something tells us he likes it that way. And so do we.

In addition to his aura of mystery, Goldstein's accouterments have become legendary in and of themselves: exotic-skinned wide-brimmed hats, flashy embellished blazers, leather jackets festooned in chains or sequins, cigarette jeans (often slashed and frayed), a printed neckerchief knotted just so—a sort of cowboy in Versace, if you will. But aside from his obvious sartorial eccentricities, it's his signature silvery hair and icy baby blues that will lure you in. But we'll admit it: As much as we were dying to uncover the most OTT pieces in his wardrobe, his home itself was the thing we couldn't wait to see in real life.

You see, for someone who basks in the ambiguity that surrounds him, he's pretty public about his home (a man of contradictions, there's no mistaking it), which means it's become just about as legendary as the man who lives within its John Lautner–designed walls. Like Goldstein, you've seen his highly striking house just about everywhere (maybe without even knowing it): in *The Big Lebowski*, *Charlie's Angels: Full Throttle*, and more than one Snoop Dogg music video. Hell, the place even has its own Wikipedia page.

As for our venture into the Hollywood Hills, well, it wasn't without its detours. But when we finally found the place, jutting out cliff-side like shards of glass and overlooking what seemed to be the entirety of 90210, the man himself greeted us, clad in his usual hard-rock garb. After giving us the grand tour (because you know we insisted on seeing it all) and exchanging pleasantries, he led us to the bedroom, which housed a bespoke revolving closet of his archival Gaultier, Saint Laurent, and Balmain. It was pretty clear that Goldstein shares the same excitement for fashion as we do. "I just picked this up the other day," he said as he unwrapped a fur-vested Saint Laurent leather jacket. And friends, for our lens, there's nothing better than floor-length tiger-printed furs set in front of sprawling verdure.

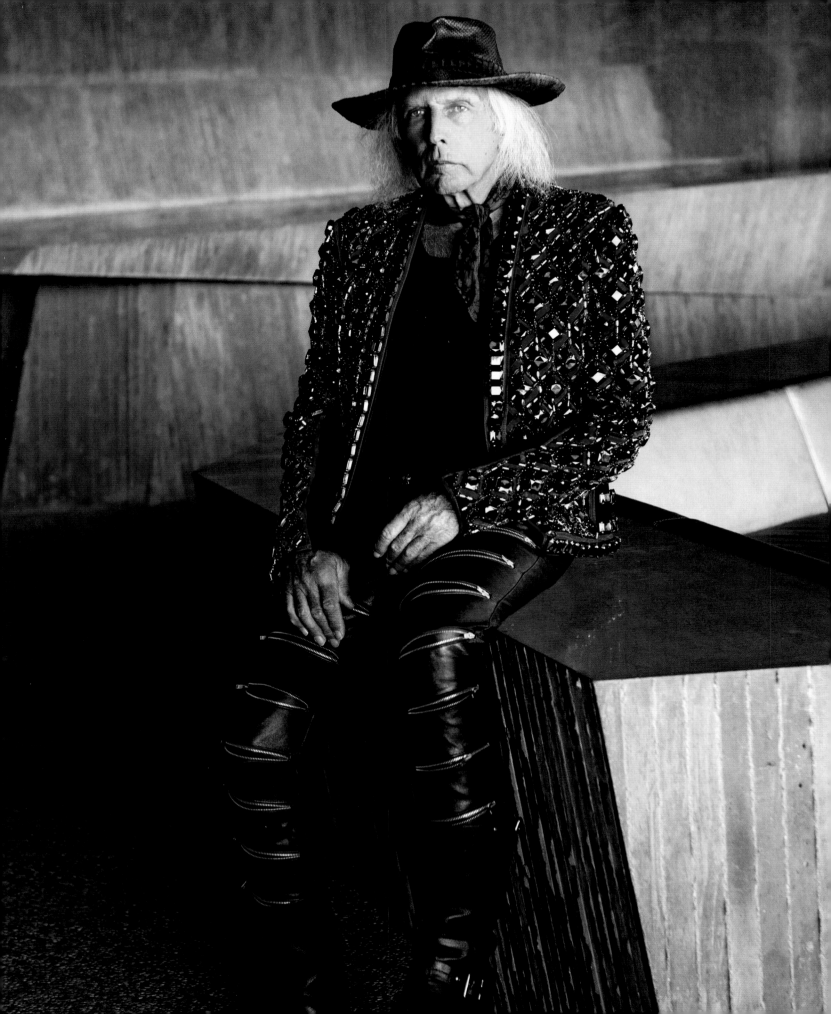

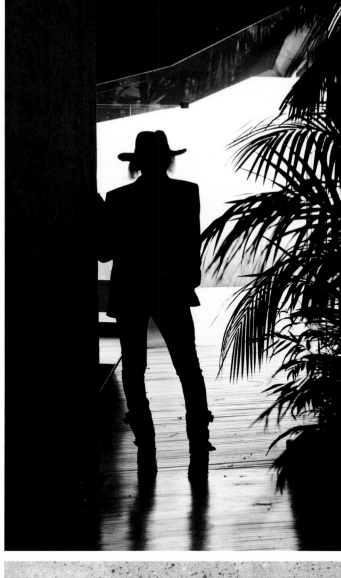

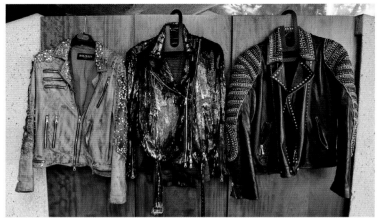

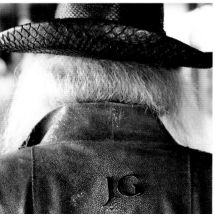

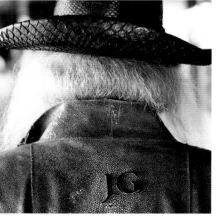

"I'm a little bit taken aback by all these sports announcers on television wearing these three-piece suits, which I think are completely ridiculous. [It's] not only out of fashion, but this is a sports event—why do they feel they have to get so dressed up? I don't get it."

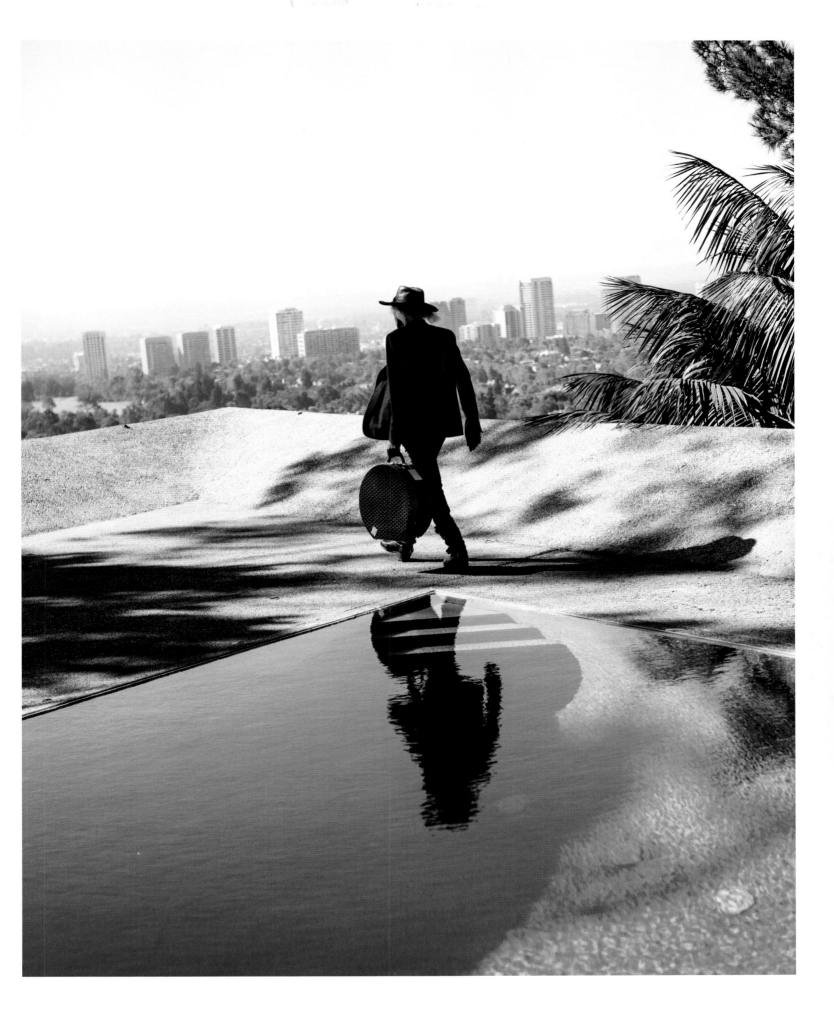

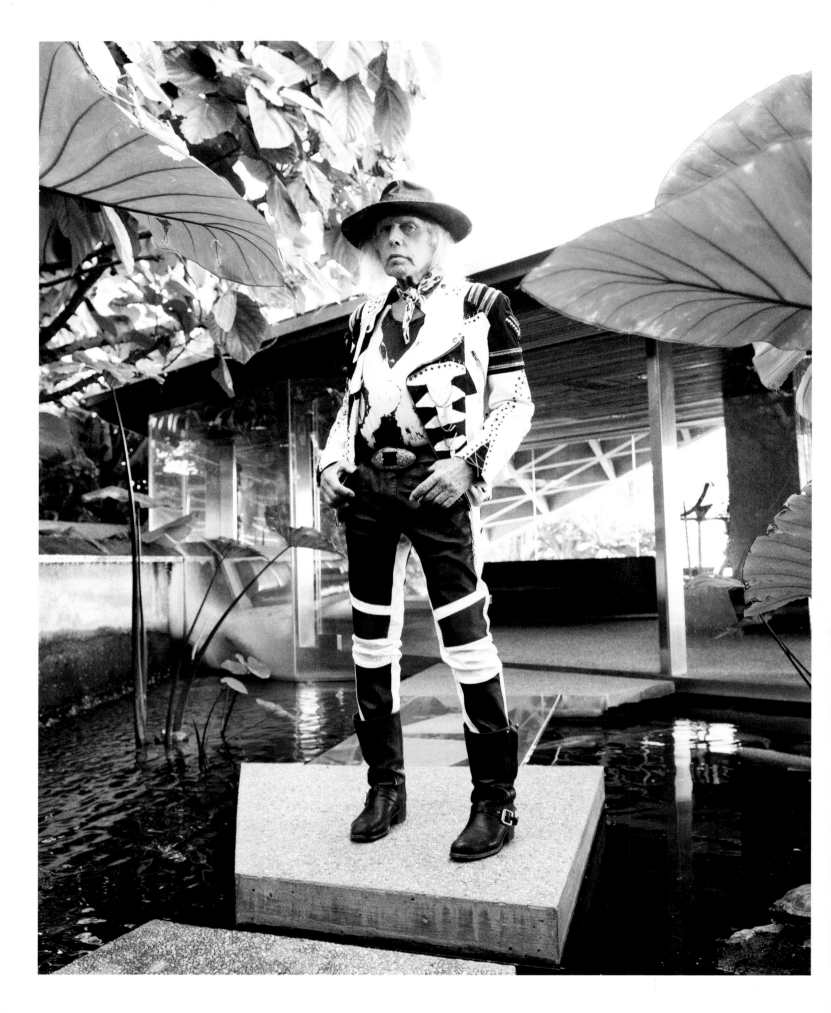

"I try to look good when I'm courtside. I try not to wear the same thing very often. Especially with a particular team—I like to have them see me in a different look every time."

WHEN
November 27, 2015

WHERE
*At his Scandinavian
modern flat in Stockholm*

WHY
*He's a master perfumer
whose candles and scents
dot the shelves of every
woman in the fashion
universe (and beyond).*

BEN GORHAM

CREATIVE DIRECTOR AND FOUNDER, BYREDO PARFUMS

We have our fair share of vices. But what you'll most consistently find on the desks of the editors of The Coveteur (that's us!) are lit candles. Burning the midnight oil, so to speak. Because when you can breathe in air that smells like plums and peonies, with base notes of leather and patchouli, during your nine-to-five, well, it kind of changes everything. Same goes for winter, when we're cooped up in our apartments for eight long months (thanks, East Coast living!), and the only thing that makes our hibernation somewhat bearable (and simultaneously ramps up the coziness factor) is candles that fill our living rooms with the smell of "fresh soil, deep forests, and campfires," according to their literature (Byredo knows us well).

But if you know anything about buying scented candles—or fragrances full stop, for that matter—you know that tracking one down that doesn't smell like your aunt's powder room is something of a Holy Grail. That's why when we got our first whiff of Byredo's assemblage of musky yet floral scents, well, we practically started stockpiling the stuff. And, inevitably, when we find a line of products we fall in love with, we *must* meet the person behind it. Especially when a precursory Google search lands us on the tall drink of water that is Ben Gorham—the expert nose and creative mind behind the cult fragrance Gypsy Water, which has earned a permanent place on our desks (and probably yours, too).

After a few emails back and forth that landed us on a plane straight to the former-pro-basketball-player-turned-master-perfumer's native Stockholm, we found ourselves climbing the marble steps up to his Scandinavian-style digs. Upon entering, Gorham, who was holding his youngest daughter in his arms, gave us the grand tour of his office/library and his living room, all laden with custom Scandinavian furniture (think sleek, ingenious design) and massive Indian paintings (a homage to Gorham's heritage)—a kind of culmination of the aesthetics that inform his scents.

Before sifting through his myriad leather and Saint Laurent coats (more on that later), we sat on Gorham's mammoth tufted couch to talk about how far Byredo has come since conjuring up its first scent in 2006. As in, a recent collaboration with Oliver Peoples to create a set of complementary shades and scents (yeah, we want them all) and Byredo's venture into leather goods—think tumbled calf wallets and stingray skin–embossed travel cases—all of which Gorham pulled out to show us.

Found among his wardrobe: piles of A.P.C. denim, seemingly endless bespoke suits (he has a thing for them, that much we've come to know), printed scarves, and rugged motorcycle boots, along with a small helping of oversize leather Hermès and Goyard bags (essentials for his travels), a Rolex watch close to his heart, and those furry Gucci loafers we've been dying to get our hands on—all of which hammered home the whole reason for us traveling to Stockholm to begin with.

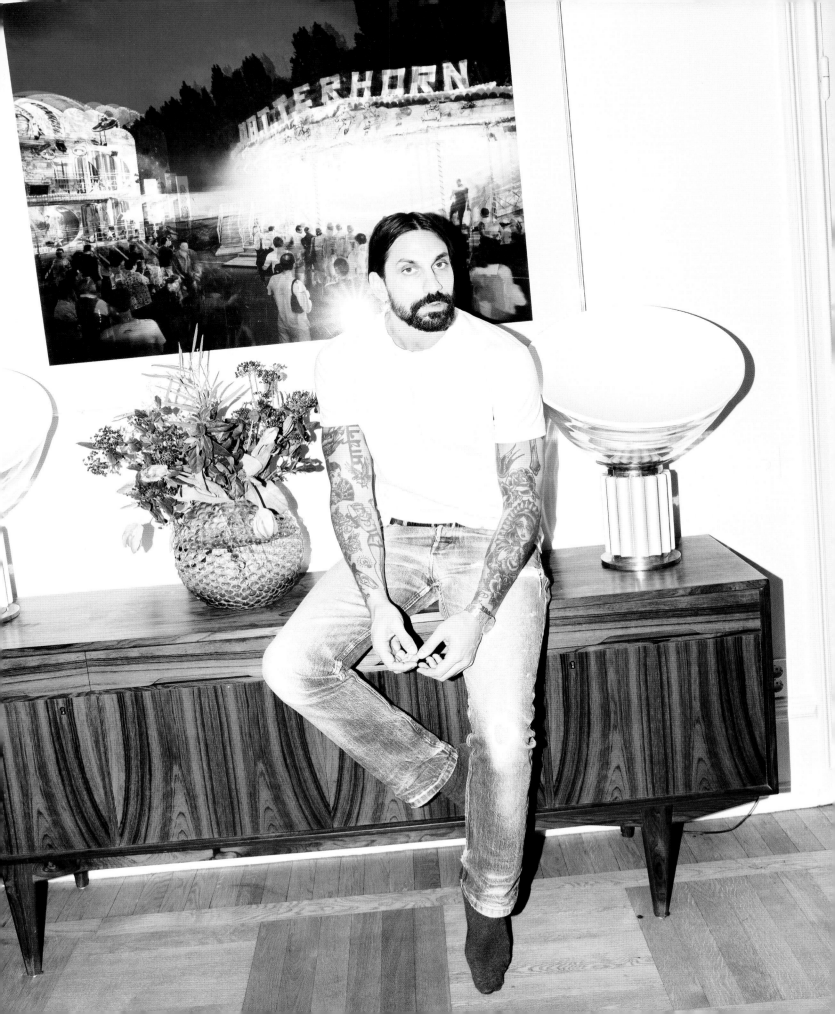

> *"I have a gold watch that I inherited from my grandfather, who worked for twenty-five years in a Canadian paper mill. I strive for that level of dedication, and it's always a great reminder."*

WHEN
July 28, 2014

WHERE
*Hastreiter's art- and
collectible-filled
apartment in New York's
Greenwich Village*

WHY
*Because no one inspires
more admiration
for her ability to quite
literally ensure that
her publication "keeps
up with the times"
than Hastreiter; it's
stayed relevant for more
than thirty years.*

KIM HASTREITER

COFOUNDER AND EDITOR-IN-CHIEF, *PAPER*

We're just going to put it out there: The Coveteur hearts *Paper*. It's one magazine that has embraced us since the beginning; they even had us collaborate on an issue and photograph Nicole Richie at home for their cover. But enough about us; this is about Kim Hastreiter, the magazine's cofounder and long-reigning editor, who has managed to make an entirely independent magazine about style (and all that word implies—fashion, art, culture, music), launched in the eighties, one of the most influential and relevant media ventures in the country. We like to think of Hastreiter this way: If she gives you her blessing, you're officially part of the industry's cool club. Just look at what *Paper* did for Kim Kardashian when it had photographer Jean-Paul Goude exaggerate her most famous, ahem, asset on the cover. Internet = broken.

To put it mildly, Hastreiter herself is a serious presence, in part because of very specific signatures. Like, say, her red glasses. And her skirt-suit uniform that she seems to have in every single color. How many exactly? Let's just say it was part of our mission to find out when we got the invite to Hastreiter's Greenwich Village apartment one hot summer morning. It didn't take us long to realize, though, that the editor isn't just a woman with a uniform (this is a no jeans, T-shirt, leather jacket situation). As specific as her signatures are, there's an even more specific reason.

So, while Hastreiter watered her abundant balcony garden overlooking Washington Square Park (it was a New York moment, people), she told us about her near twenty-years-strong go-tos. "I always dressed wild," she said. "As you get older, you can be one of those kinds of people that wear crazy shit on the street and they're like seventy years old. But I didn't want to be that person, I decided." She proceeded to outline her jewelry (Ted Muehling earrings); her sneakers (Vans); and her suit (a custom pattern based on a beloved Isaac Mizrahi jacket and a silhouette inspired by a Mao uniform mixed with a Yohji Yamamoto skirt). Her staples are not exactly boring, though, because she owns maybe a thousand versions of each—as you might have guessed, we were unsuccessful in the survey aspect of the mission.

But that she has a copious collection of other clothing items and, just, stuff that essentially reads as the most important moments in the past thirty-odd years of fashion and culture history is a testament to Hastreiter's instinctual ability to have her finger constantly on the proverbial pulse. Like her custom Stephen Sprouse, made by the man himself. Or T-shirts painted by Keith Haring. And the fact that she has all of that and continues to fall in love with the new as well (there was a particular Burberry mint bag she was mooning over) is pretty indicative of how she's maintained *Paper*'s roots as an underground style magazine, while remaking it into a digital-age powerhouse that doubles as a creative agency. She may not be the mature woman dressed in (totally) crazy shit, but she's definitely not fading into the background, either.

"When I find something that I love, I buy a lot of it—I'm just one of those people. That's why I have a million Ted Muehling earrings."

WHEN
August 14, 2012

WHERE
*The Playboy Mansion in
Beverly Hills*

WHY
*We love nothing better
than a smoking jacket
paired with velvet
slippers, and we have
Hef to thank for it.*

HUGH HEFNER

FOUNDER, CHIEF CREATIVE OFFICER, PLAYBOY ENTERPRISES, INC.

Media tycoons in the traditional sense are a dying breed. Scratch that—those who can be called tycoons with a straight face and manage to not conjure images of Monopoly Man types instead are a dying breed. If there is anyone actually worthy of the title today, it's undoubtedly Hugh Hefner. Yes, that Hugh Hefner.

While Hefner's image in recent years may have been boiled down to a more slightly self-aware iteration—all pulled off with a knowing, in-on-the-joke wink—his influence on the state of everything from publishing to censorship in the media isn't to be underestimated. The early days of *Playboy*, which were accompanied by a chain of namesake nightclubs and resorts all over the world, made waves for its hiring practices, which gave a platform to African American musicians at the height of the civil rights movement, including Sammy Davis Jr. and Dizzy Gillespie. He also famously closed clubs in southern states that refused entrance to people of color, opposed the Vietnam War, and published the work of the literary world's most forward-thinking, avant-garde figures. Yes, this is where your dad's joke about reading *Playboy* for the articles comes from. Oh, and there's the whole thing where the magazine, at least initially, championed an entire range of female body types and encouraged unabashed sexual autonomy in all its forms. In other words, Hefner's brand and legacy has an incredibly inclusionary and downright feminist history. Mic drop.

With that in mind, after we were buzzed into the Mansion's drive (fun fact: When Hugh initially purchased the property in the seventies, it was the largest real-estate transaction in Los Angeles history), everything that occurred afterward can only be described as surreal. We found Hefner in his study, where the then-octogenarian was dressed in his trademark scarlet robe and silk pajama bottoms. Given that he's the originator of our default state of dress (it basically boils down to pajamas that are acceptable in public), it was pretty much everything we could have hoped for. The same applied to Hefner's closet, which we had full, unbridled access to and was stocked with all of his signatures: slinky PJs in every color of the rainbow, loafers, bunny cufflinks, velvet blazers, captain's hats, and even a few novelty keepsakes from the *Playboy* archives.

We spent a full day at the Mansion, getting the grand tour of the expansive grounds from Hefner and his team—yes, including the legendary grotto and re-creation of the founder's star on the Hollywood Walk of Fame—and even got to thumb through a selection of the *Playboy* founder's award-winning scrapbooks. (Did you know he holds the Guinness World Record for largest collection? Hefner told us it dates back to his high school days.) In short: Consider this one for the bucket list.

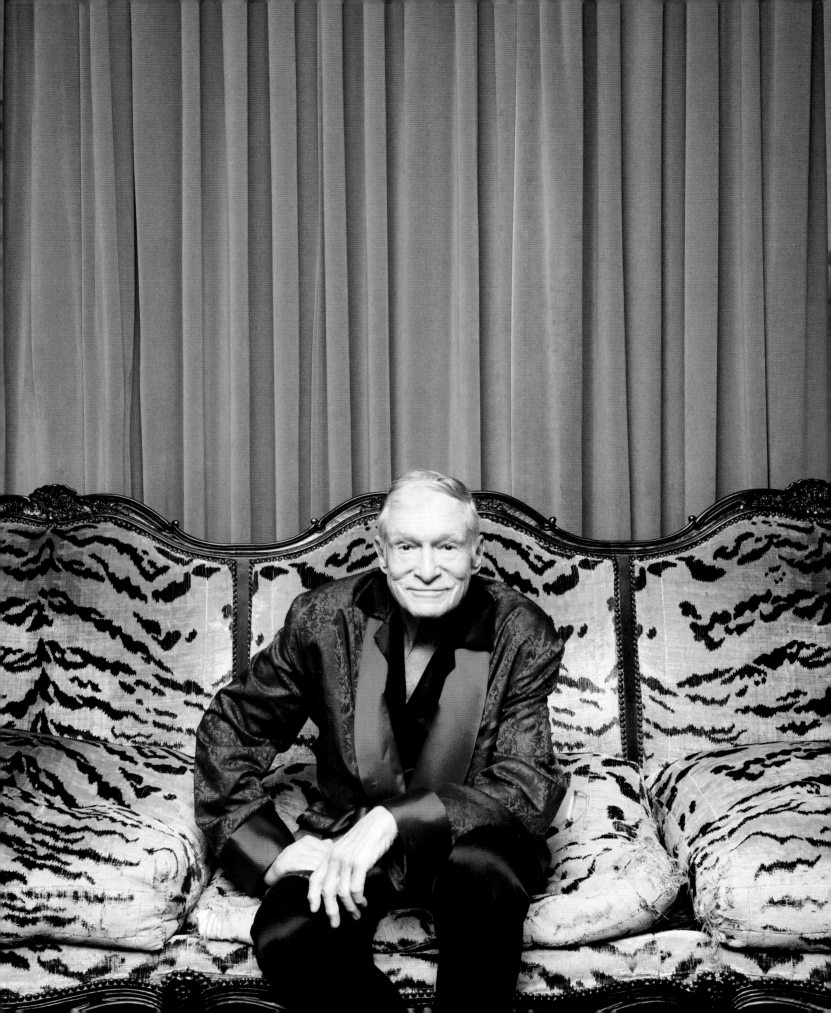

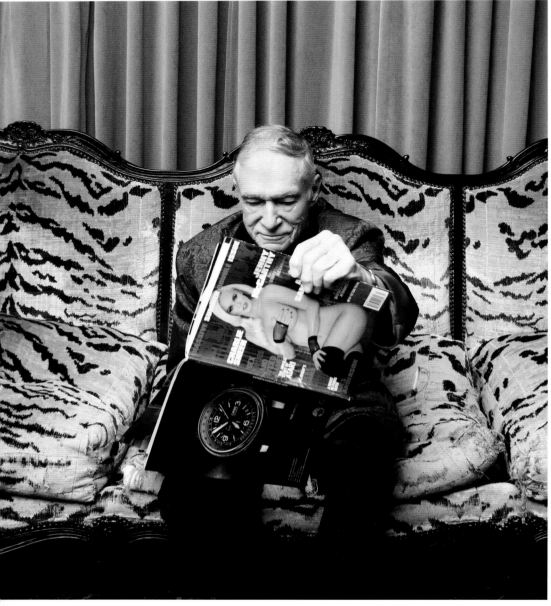

"The fact that I wear sleepwear evolved early on. I started the magazine in 1953 and found myself taking the work with me, home to the Mansion. I was working at night—around the clock—and it just became a natural kind of thing to wear the pajamas; they were comfortable."

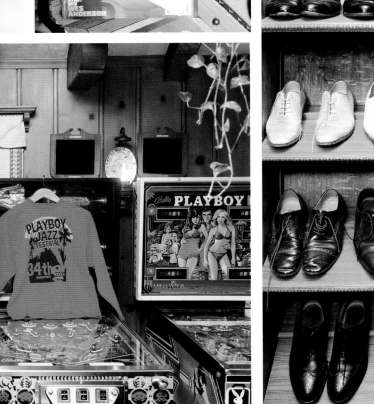

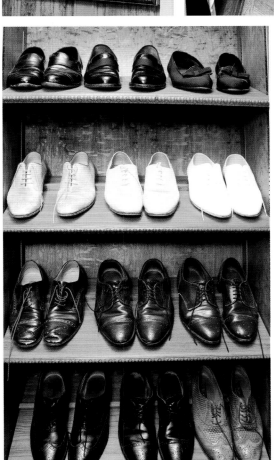

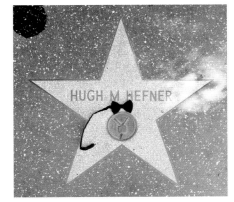

WHEN
July 24, 2015

WHERE
*The couple's
Berlin townhouse*

WHY
*Because, separately and
together, they dominate
the street-style scene and
the front row.*

VERONIKA HEILBRUNNER and JUSTIN O'SHEA

FOUNDER, HEY WOMAN!; CREATIVE DIRECTOR, BRIONI

There are some people in fashion whom those of us in the industry just can't get enough of. For The Coveteur, that translates into us asking them to pose for us, not once, not twice, but three times. Such is the case with Veronika Heilbrunner and boyfriend Justin O'Shea (okay, so he's only landed himself in front of our lens twice—still a feat). The two are more or less the honorary first couple of fashion, so you can't blame us (or anyone else) for our obsession.

And to be fair, it's warranted; it isn't as if Heilbrunner is toting around her non-fashion-understanding boyfriend to shows just for kicks, or vice versa. Fact is, they're both bona fide professionals (she with her much-loved website, Hey Woman! and former posts at *Vogue* and *Harper's Bazaar* Germany, and he as buying director at e-commerce mecca MyTheresa)—and, frankly, this industry loves nothing more than a good love story, all dressed up in Christopher Kane and Brioni. Especially when they're both this good-looking (can't deny it!).

So, as they say: Third time's a charm. And it really was. Mostly because instead of interrupting the couple at their Paris Fashion Week hotel-room-turned-love-nest

(you'll have to get yourself to TheCoveteur.com to see how we found them, ahem, in bed), we actually made it off our usual fashion capital circuit for a long overdue visit in Berlin, their hometown.

Of course, the trip was well worth it. Because home is where they keep their collectibles (a Chanel basketball; a limited edition Beefeater Gin bottle on which O'Shea is featured—yes, this is a real thing that was sold in stores—can you say epic?), as well as their painstakingly edited wardrobes. For O'Shea that meant multiple (and by multiple, we mean many, many) versions of his signature three-piece suit, plus endless sunglasses and evidence of an admitted weakness for silk shirts and polos (everyone needs an off-duty outfit, people). For Heilbrunner, it was feminine printed dresses, minaudières by the likes of Edie Parker and Prada, and a myriad of flats and sneakers (girl is tall!)—a look she coined four years ago when she started wearing Air Force 1s with her Erdem, way back when Stan Smiths were still something worn by our tennis-playing dads in the opinion of most women in the fashion industry.

And while, in our usual fashion, we had munched on coffee and cookies for the entirety of the shoot, we were still persuaded to join Heilbrunner and O'Shea for dinner (exhibit #57493 that we can't get enough of them). We hereby promise to give Berlin a permanent spot on our global circuit.

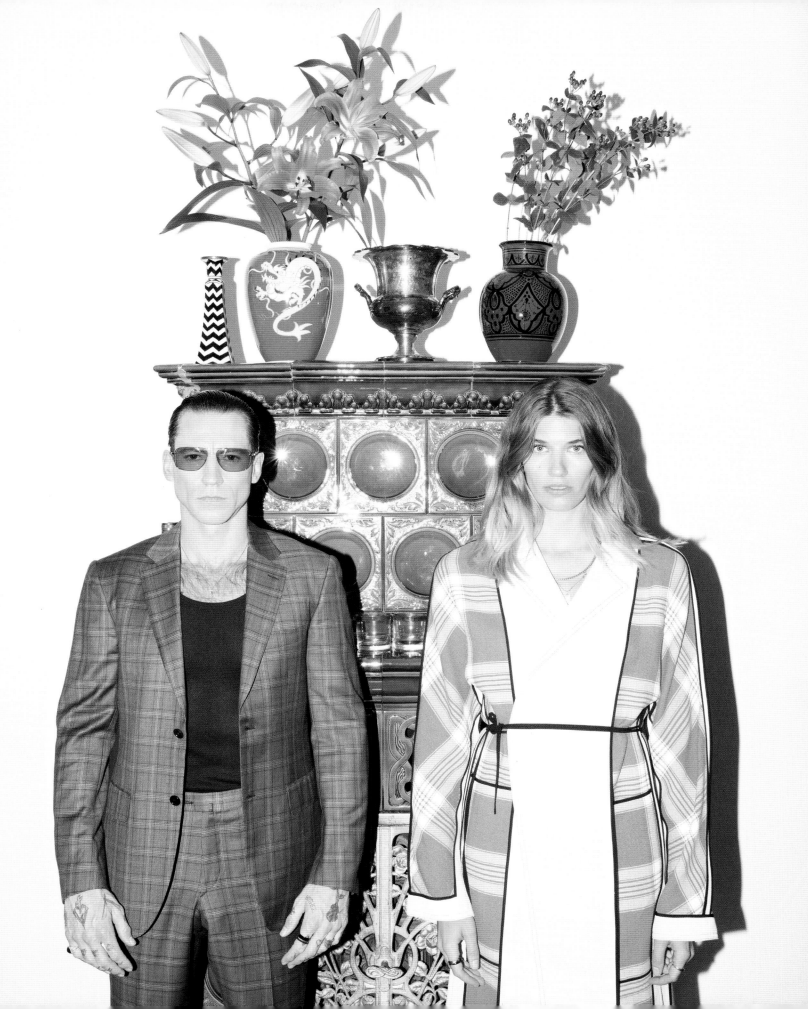

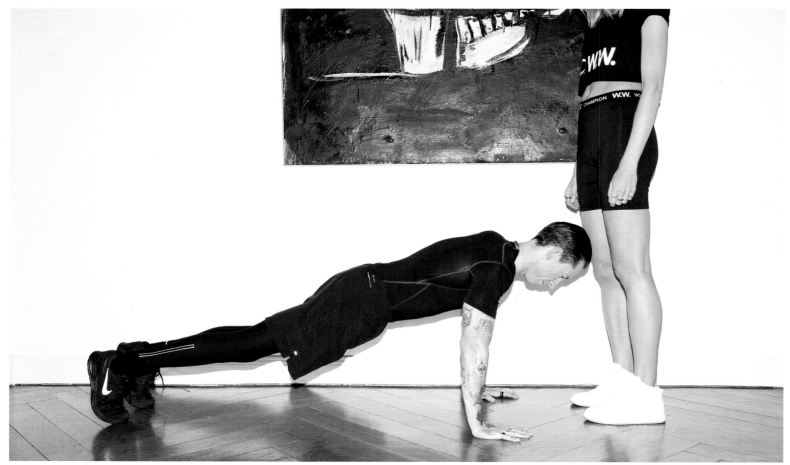

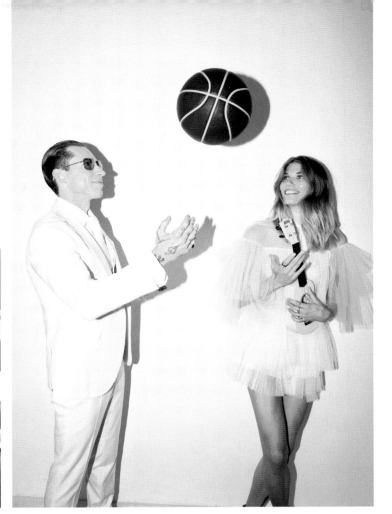

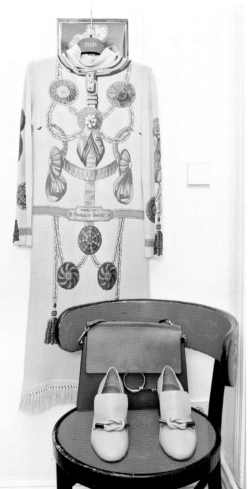

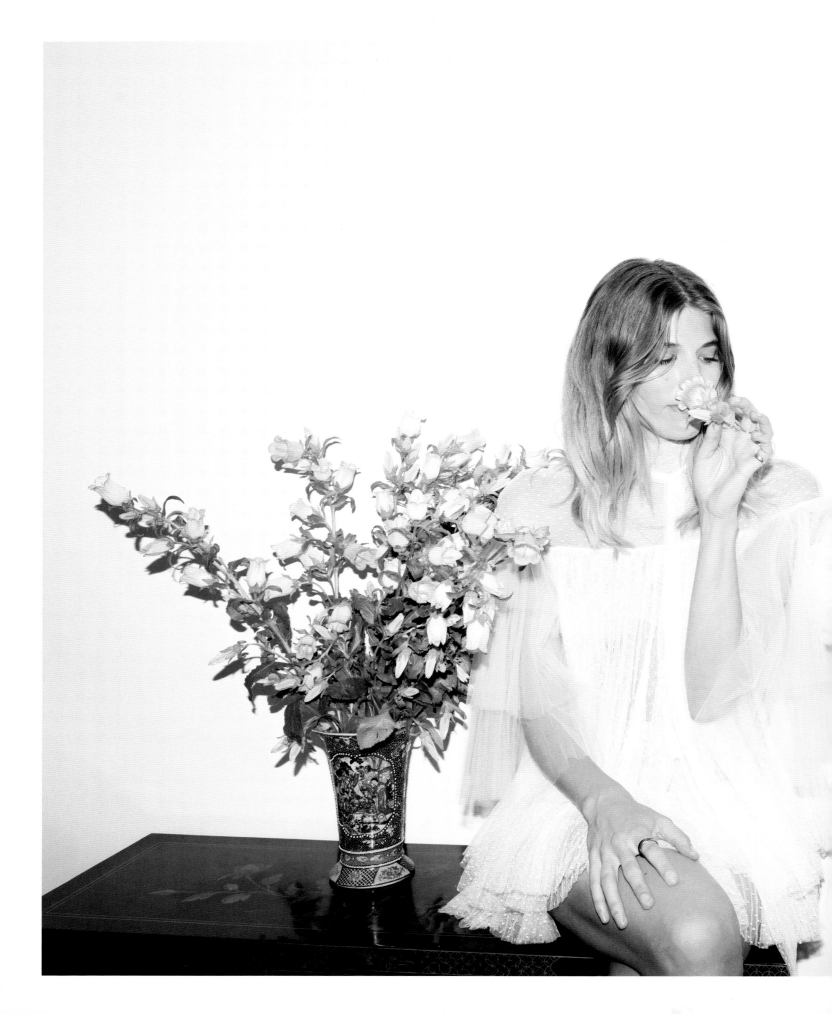

"My favorite is probably when she wears Valentino. And there is something so youthfully graceful and elegant about how she wears Pierpaolo Piccioli and Maria Grazia Chiuri's amazing creations. My least favorite is probably short, tight stuff. I can't believe that I am saying that, but it just doesn't seem like 'her.'"
—JUSTIN O'SHEA

WHEN
March 10, 2012

WHERE
*The couple's apartment
at the Plaza
Hotel in New York*

WHY
*Hilfiger is only the
long-reigning king
of American-sportswear-
meets-streetwear.*

DEE and TOMMY HILFIGER

FOUNDER, DEE OCLEPPO; FOUNDER, TOMMY HILFIGER

If ever one can use the word "icon"—a statement we try to shy away from, given its superfluous utilization in our industry—it's in reference to Tommy Hilfiger, who could very well claim to have defined modern, urban, street-aware Americana since founding his label in 1985. And if that seems a tad hyperbolic, there is a reason why his perfectly suited logo is red, white, and blue. It goes without saying that when his designer wife (Dee Hilfiger has her own line of handbags called Dee Ocleppo) invited us to their New York apartment, we knew without question this would be one for the books—quite literally.

For one thing, the Hilfigers live in what could rightly be considered the American version of a castle (we're going to run with the king theme here)—the Plaza Hotel. Again, the word "iconic" doesn't seem wrong here. And, of course, they have a room devoted to the Plaza princess herself, Eloise, because, really, why not?

While Tommy regaled us with stories about casting Britney Spears in his commercials (icon!) and dancing at Studio 54 (iconic!), we marveled at their collection of Warhol, Basquiat, Keith Haring, and Richard Prince (Icon! Icon! Icon! Icon!) and then got down to the not-so-dirty business of going through their extensive wardrobes. Take, for example, Tommy's veritable room of shoes—no word of a lie, his is a true racks-upon-racks situation—and Dee's similar collection of Pradas, Miu Mius, and Louboutins.

The whole shoot felt like what we imagined hanging out with fashion royalty would be like, right down to when we placed a pair of Tommy's Tom Ford glasses on a family portrait (with all seven kids—now that's a dynasty), only to find out it was photographed by Annie Leibovitz (we don't want to say it again, but ic—). The one grounding factor: The whole brood is in that undeniably all-American uniform of T-shirt and jeans. Remember what we said about that red, white, and blue?

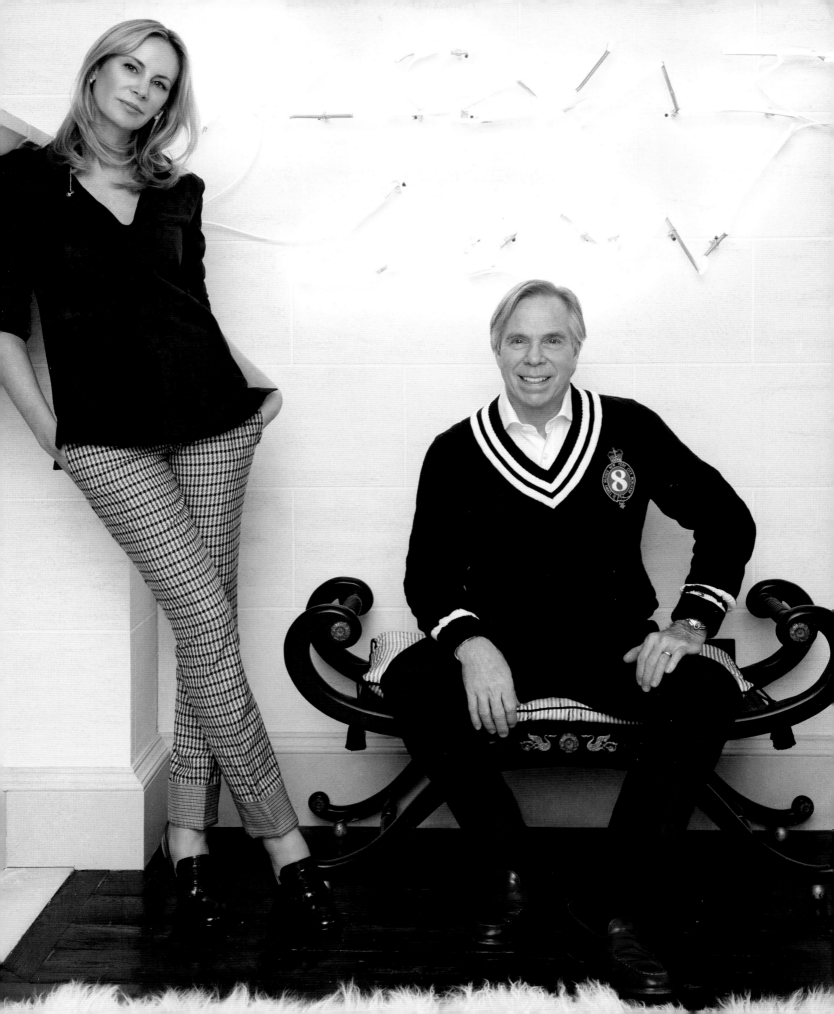

*"My Christian Louboutins were
a birthday gift from Dee.
If she can wear Loubs, so can I.
They are my favorite."*

—TOMMY HILFIGER

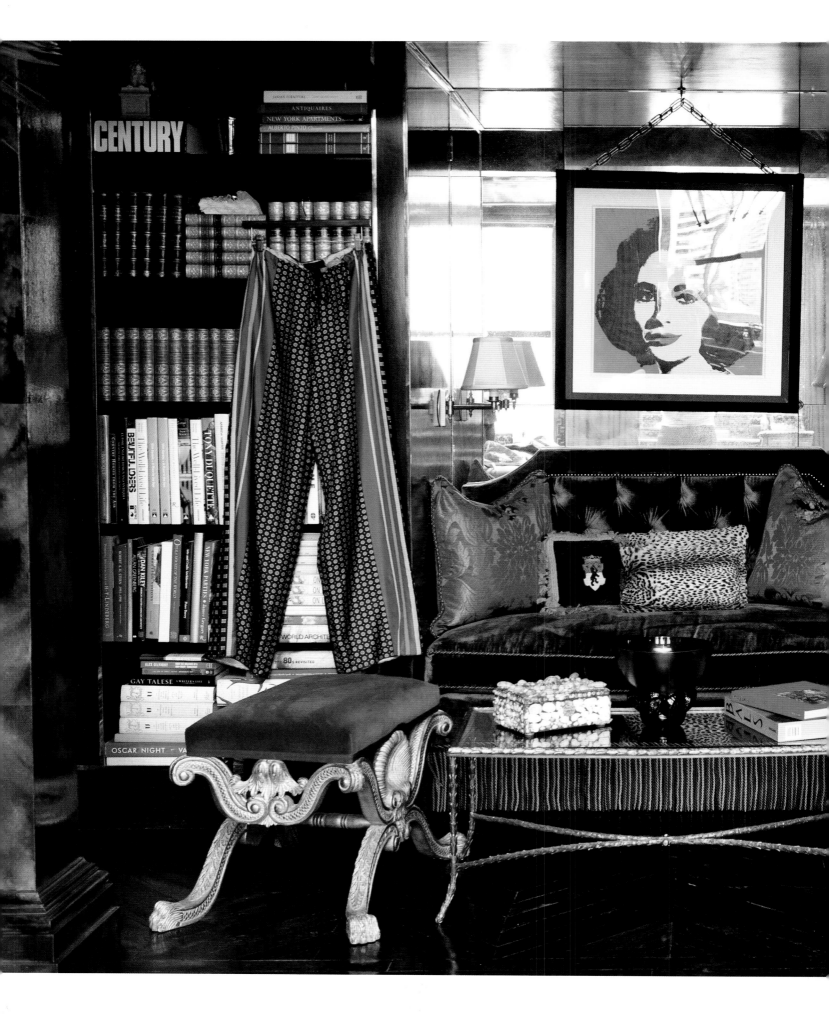

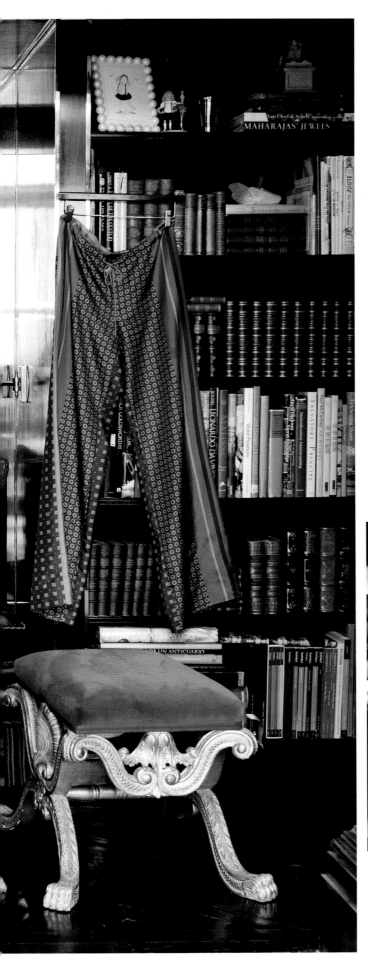

> *"Disorganization is not an option for me."*
>
> —TOMMY HILFIGER

WHEN
June 15, 2015

WHERE
*Huffington's SoHo
penthouse in New York*

WHY
*She's built a digital-
media empire within an
industry that, despite
being in its relative
infancy, is generally
considered a boys' club.
And she has a thing
for Saint Laurent and
sleeping in.*

ARIANNA HUFFINGTON

COFOUNDER, THE *HUFFINGTON POST*; AUTHOR, *THRIVE: THE THIRD METRIC TO REDEFINING
SUCCESS AND CREATING A LIFE OF WELL-BEING, WISDOM, AND WONDER*

For the record, the elevator ride through Arianna Huffington's building on your way up to her SoHo home seems like an especially long one—but it's not just having to hit the PH button that makes the trip feel longer than usual.

Unsurprisingly, it might have something to do with Huffington's role as the namesake cofounder of what is literally one of the most popular websites on the entire Internet (no small feat—we're talking three billion monthly page views), a digital media entity worth upward of $300 million dollars (at time of print), and the first ever to win a Pulitzer Prize. She single-handedly has the ability to rope in names as diverse as Larry David, Alice Waters, James Franco, and Nora Ephron to pen columns for free, and the aforementioned accomplishments only capture the last decade or so of her career. Contrary to what you might think (or more accurately, come to expect is required to achieve this kind of career path), she's also an evangelist for getting a solid eight hours of sleep. She even goes so far as to lock her work phone in the bathroom every night to accomplish it. In other words, that elevator ride left us wide open for a whole lot of "How the hell are we going to make small talk about Gucci bombers and Alexander McQueen shift dresses with Arianna Huffington?"

Turns out, that last part was a little easier than we'd anticipated. Aside from sleep, Huffington's also a flat-shoe advocate—a worthy wardrobe segue if we've ever heard of one. And because we know you're dying to know, her saving grace is a pair of Saint Laurents, which, if you ask us, could pretty much sway anyone over to the sturdy side. When Huffington wasn't schooling us with the signature aphorisms that have seen her through the boys' clubs of politics, media, journalism, and venture capital, she was doling out the names of her Manhattan must-sees and outlining the future of her namesake empire for us.

By the end of our shoot, we left on the kind of high that can only come from an afternoon with a media magnate. Because c'mon—anyone who encourages us to get liberal with the snooze button as part of ascending the path to career success is our kind of people.

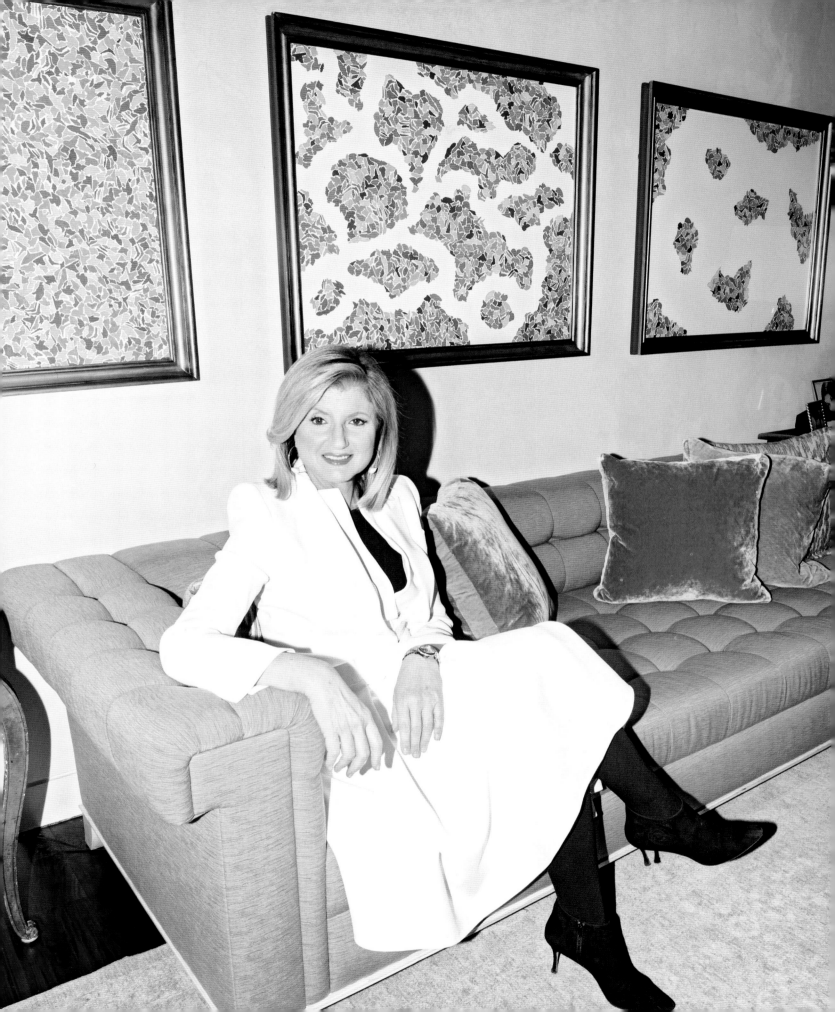

"I have a go-to outfit for a period of time. I wear a dress to death, until I can't look at it anymore. But I kind of like it, because I appreciate how men can just go put a suit on in the morning and they don't have to think about it."

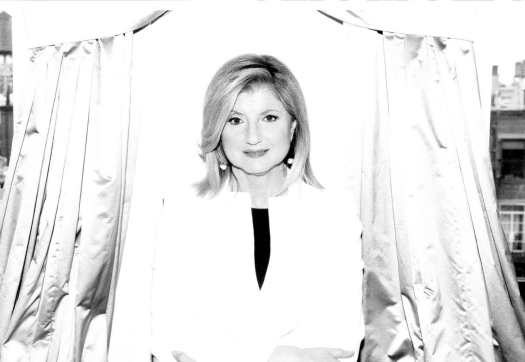

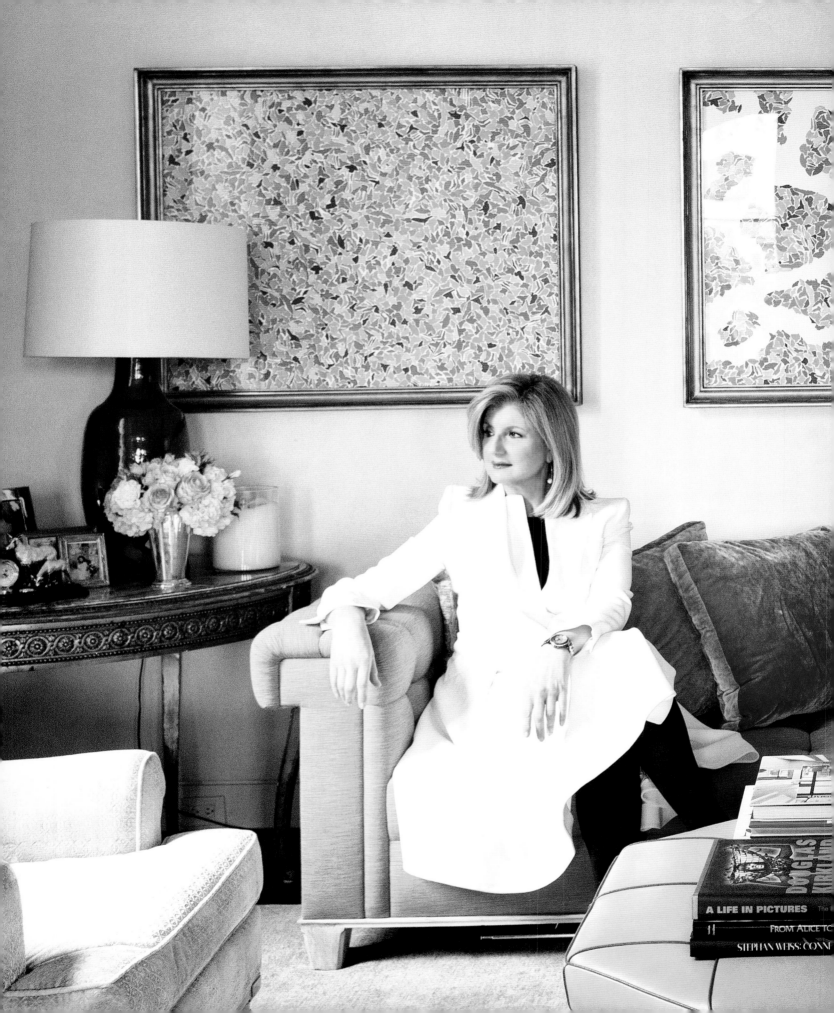

WHEN
November 18, 2015

WHERE
*Cranciunescu Huls's
Antwerp manse*

WHY
*The woman has an entire
room (the size of our
apartments, mind you)
dedicated to what seemed
to be only one-third of
her wardrobe.*

CAMELIA CRACIUNESCU HULS

ENTREPRENEUR

The five stages of seeing a truly overwhelming closet—whether it's overwhelming due to sheer volume alone or the culty collector's appeal—go a little something like this. Shock: "Holy (insert every expletive here)!" Denial: "This . . . this can't be real, right?" Anger: "I'm seriously supposed to rifle through all of this in just a couple of hours? What was I thinking?!" (Literal) bargaining: "I'll clean your house every day for a month in exchange for that magenta mink Saint Laurent." And, finally, acceptance: "Okay. Let's do this thing."

Based on the images here, you can probably understand that the above was our exact thought process when we showed up bright and early at Camilla Craciunescu Huls's Antwerp home to shoot her closet. And good thing we cleared our schedule entirely the day of, too: The images you see here are the result of four hours of running up and down her grand staircase with arms full of Birkins and Valentino shoes. It would have taken us a good two days to get through the whole thing.

Craciunescu Huls's home is a master class in contemporary decor; a very thorough how-to in adding a little life and color to what could easily feel like a stuffy, (very) grand manor. It was so immaculately outfitted that when we first walked in, we honestly thought there'd been some sort of communication error and Craciunescu Huls

had invited us to a boutique or storefront. Some corners were already dotted with Fendi bags and tchotchkes, alongside life-size horse lamps and pig side tables by the all-female Swedish design collective Front. There were more Fornasetti candles, trays, and plates than you'd find in the back stockroom at Barneys. Old-fashioned oil paintings and portraits in ornate gold frames were made modern and new hanging from neon walls with bright white crown molding. There were dozens of vases (one in the form of Frida Kahlo's face, by Lovestar) filled with the requisite fresh flowers; taxidermy; fur and Hermès throws (upon which her five cats cuddled up throughout the home); and bubblegum-pink Smeg appliances in the kitchen (along with boxes of macarons, massive bowls of fresh tropical fruit, and beyond). If there were ever a home made for Coveteuring, this was it.

When we finally made our way up to the last stop (the closet) on our tour of Craciunescu Huls's place, well, "dumbfounded" doesn't even come close to capturing our reaction. Bright, glossy white cabinetry showcased Camelia's fashion collection (among which we counted twenty-plus Hermès Birkin bags and pairs of Valentino Rockstuds), and a massive island in the middle housed her jewelry, sunglasses, and unmentionables. Much like her approach to her interiors, her wardrobe situation suggested that she doesn't take anything too seriously: After all, it's difficult to keep a straight face when you're wearing a black Fendi turtleneck covered in googly eyes and brightly hued fur eyebrows.

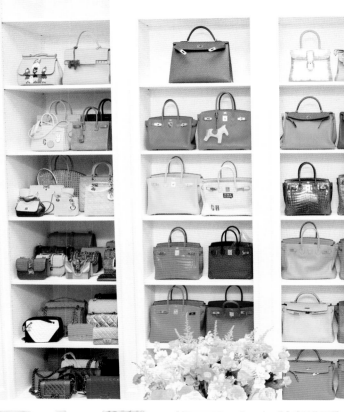

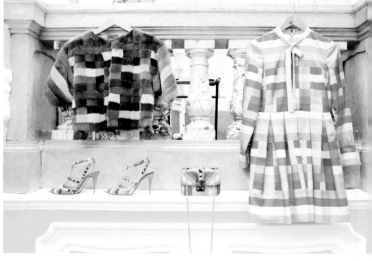

"A couple of years ago, neon was making a big comeback, and I found myself fitting in because I love all these bright colors—I couldn't get enough."

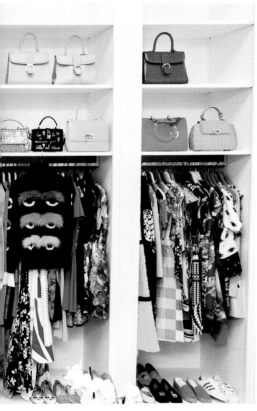

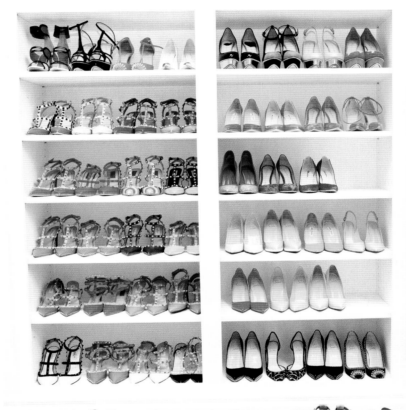

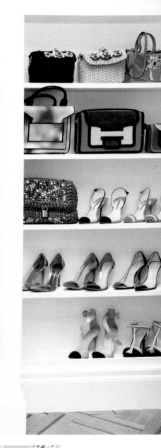

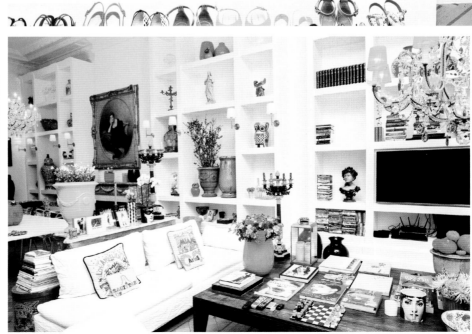

WHEN
January 20, 2014

WHERE
A terra-cotta-laden Spanish revivial estate, tucked among a sprawling tropical garden up in the Hollywood Hills

WHY
She's one of those beautiful people who's way more than just a beautiful person.

ROSIE HUNTINGTON-WHITELEY

MODEL; DESIGNER, ROSIE FOR AUTOGRAPH; CREATIVE DIRECTOR

In our line of work, there are those moments when we interrupt our regularly scheduled responsibilities to pursue a person that we absolutely need to feature, like, right now. That person often meets a whole list of criteria and must be somewhat of a unicorn. It's pretty clear that Rosie Huntington-Whiteley fits that bill spectacularly. Let's be real: Her unrivaled beauty is something that's likely to be worshipped for decades to come, plus she's a burgeoning designer, artfully overseeing every aspect of Rosie for Autograph, from ideation to modeling the pieces herself (it obviously doesn't hurt that her design area of choice is lingerie).

After months (and months) of playing email tag, we finally made our way through the palm-tree jungle that surrounds the Spanish residence Huntington-Whiteley shares with longtime beau, actor Jason Statham, and we didn't expect to be so excitedly greeted by the former Victoria's Secret model. Turns out, as much as we'd been preparing for this moment, Huntington-Whiteley had been, too (seriously shocking, we're aware)—she had already pulled her favorite pieces for us to play with, even organizing them in our signature, ahem, shoes-on-books style.

Picture this, though: a blush-pink dressing suite extending out from the main dwelling dedicated solely to all things Rosie and

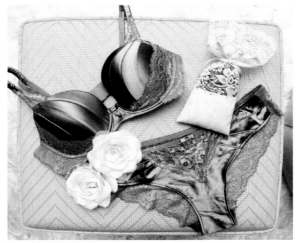

(appropriately) rose hued. Think immaculately organized furs peppered in among Isabel Marant and Dries Van Noten jacquard coats, silky draped lingerie pouring out of drawers and slung over plush hangers. From vintage floor-length satin robes with hand-painted roses climbing up the hem to delicate lace lingerie sets washed in jewel tones—to say that this was a Coveteur dream come true would be a complete understatement.

Don't even get us started on all the shoes: the Atwoods, Louboutins, Manolos, Givenchys, and Tom Fords—many of which, she told us, had been gifted by Statham—took up prime real estate on the cream-colored shelves. Or, for that matter, the dainty gold and diamond gems by the likes of Jacquie Aiche and Anita Ko strewn among porcelain dishes. They were practically begging to be photographed . . . and, well, we gave in.

Of course, it didn't stop there: Little mementos and antique tchotchkes, which we couldn't help but admire, were thoughtfully displayed center stage, perched atop stacks of fashion coffee-table books (much like this one) on her gilded table. "I love little antique trinkets and finds, they are so special and make lovely personal gifts," she said as she showed us a tiny hummingbird painting from her younger brother. You know when that perfect image you have of someone is ruined upon meeting them in person? Yeah, as you can probably guess, that didn't happen here. Huntington-Whiteley is still a total unicorn in our books.

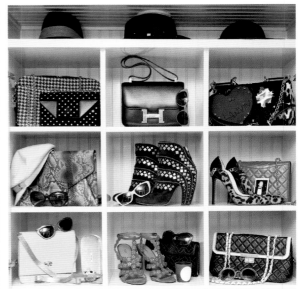
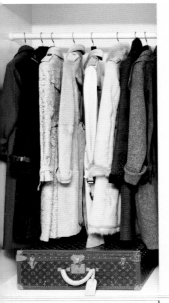
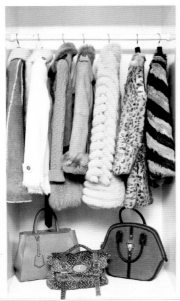
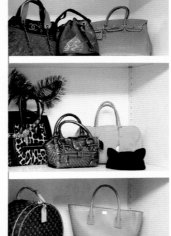

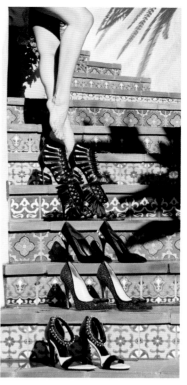

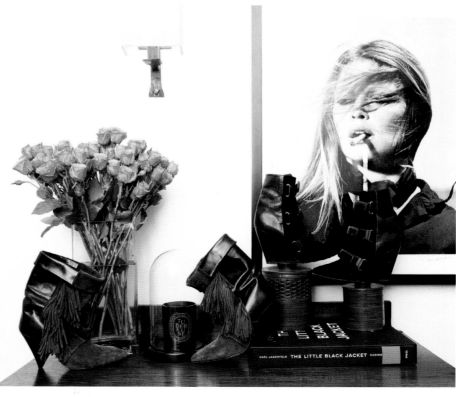

ALEXA CHUNG *it*

KATE MOSS STYLE

INEZ VAN LAMSWEERDE & VINOODH MATADIN
PRETTY MUCH EVERYTHING

TASCHEN

KARL LAGERFELD THE LITTLE BLACK JACKET CARINE

"I like to be very organized, in case you hadn't noticed! A good 'throw out' every couple of months helps to keep things in order. I donate most of my old clothes to Goodwill or give them to my girlfriends."

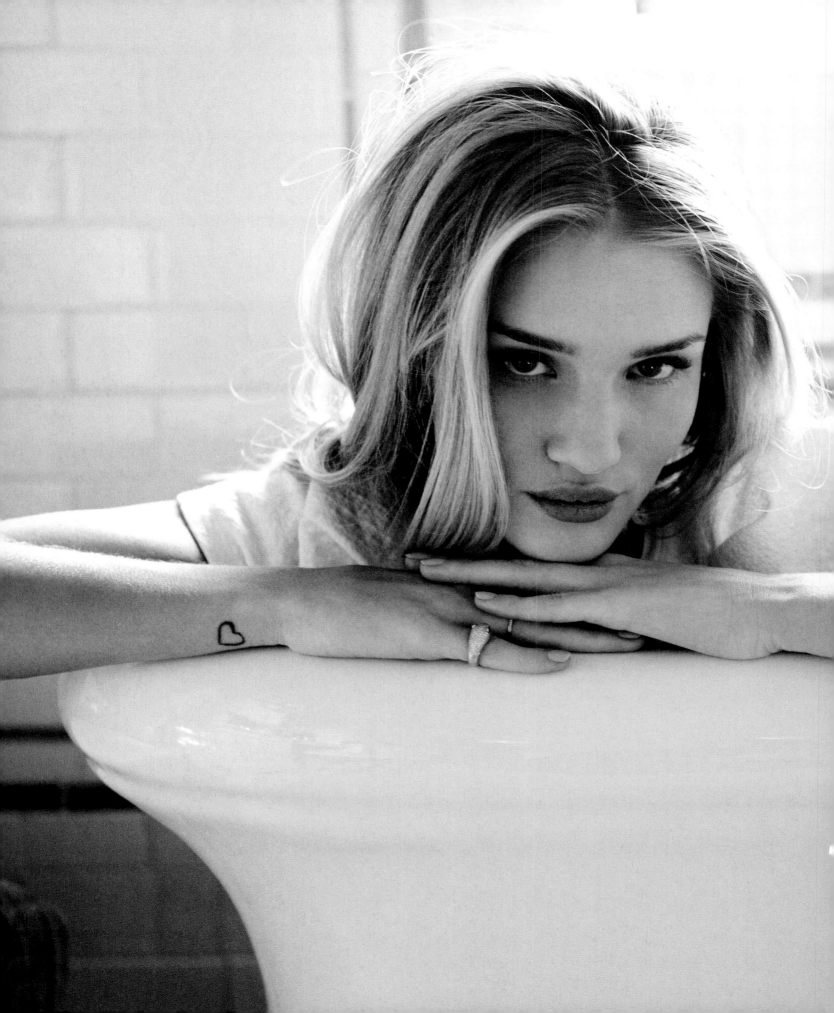

"*My first designer splurge was on a Chloé Silverado handbag when I was seventeen. I had never owned anything so expensive, so I saved for weeks. I still have that bag and I will never part with it!*"

WHEN
September 7, 2015

WHERE
*Issa's airy loft in
London's Marylebone
neighborhood*

WHY
*Hardly any profile
of Issa goes without a
mention of her being
at the exact intersection
of brainy and babely—
as if the presence of
one ever suggested the
absence of the other.
Oh, and she has a killer
coat game (the sort
that doesn't go unnoticed
by the fleets of street-
style photographers
trailing her every move).*

CAROLINE ISSA

EXECUTIVE FASHION DIRECTOR, *TANK*;
EDITOR-IN-CHIEF, *BECAUSE* MAGAZINE

Take one business degree from Wharton and add a multicultural upbringing, time advising for corporate clients ranging from Dr Pepper to Boots, and years living everywhere from Seattle to Singapore and Texas to Montreal. Now, throw in a return to working in the fashion industry (she had a brief stint as a teenage model) as both consultant and editor and the sort of idiosyncratic personal style that has brands breaking down your door to collaborate, and you might have something (or more precisely, someone) like Caroline Issa. Only after you wrap the whole thing in a traffic-stopping sky-blue peacoat, that is.

As the reigning fashion director of *Tank* and editor-in-chief of *Because* magazine, *Tank*'s digital sister publication, Issa juggles consulting for an entire range of brands while editing content on the daily. What we love most about Issa's work, though, is that she manages to intellectualize fashion without diminishing the elements of indulgence and fantasy that are so crucial to the whole thing. Fun fact: Because of her (and, admittedly, our) unrelenting schedule, after five years, despite collaborating a handful of times, we'd somehow never gotten the chance to actually see where the

magic happens—the "where" being Issa's closet—until we actually began to work on this book. Convenient, right?

The wait was worth it—Issa's place was precisely as we had imagined it would be. A collage of eccentric art and found images covered the entryway, which gave way to a largely open-concept, minimal loft (save for a sprawling dining table, and a cozy couch covered in blankets from Issa's travels). The whole thing was all exposed beams, glossy hardwood floors, and greenery dotting every corner, with a wall-to-wall bookshelf leading out to her balcony. In other words, it was the exact sort of space we'd want to call home, too, should we find ourselves ever calling London home. After catching up and trading fashion-month plans over a round of coffee with almond milk, Issa led us to her closet and we let the games begin.

If we're going to attempt to describe her wardrobe, we first need to acknowledge the sheer volume of it all—Issa has a closet occupying an entire wall of her bedroom, and a separate one in her storage-cum-dressing-room just to house her shoes. This also happens to be where we saw, firsthand, the real perks of designing your very own namesake collection (Issa's done so with both Nordstrom and L.K. Bennett). She has every single pair of shoes from the latter, with backups to spare tucked away for safekeeping, too. Call it Coveteur-approved hoarding.

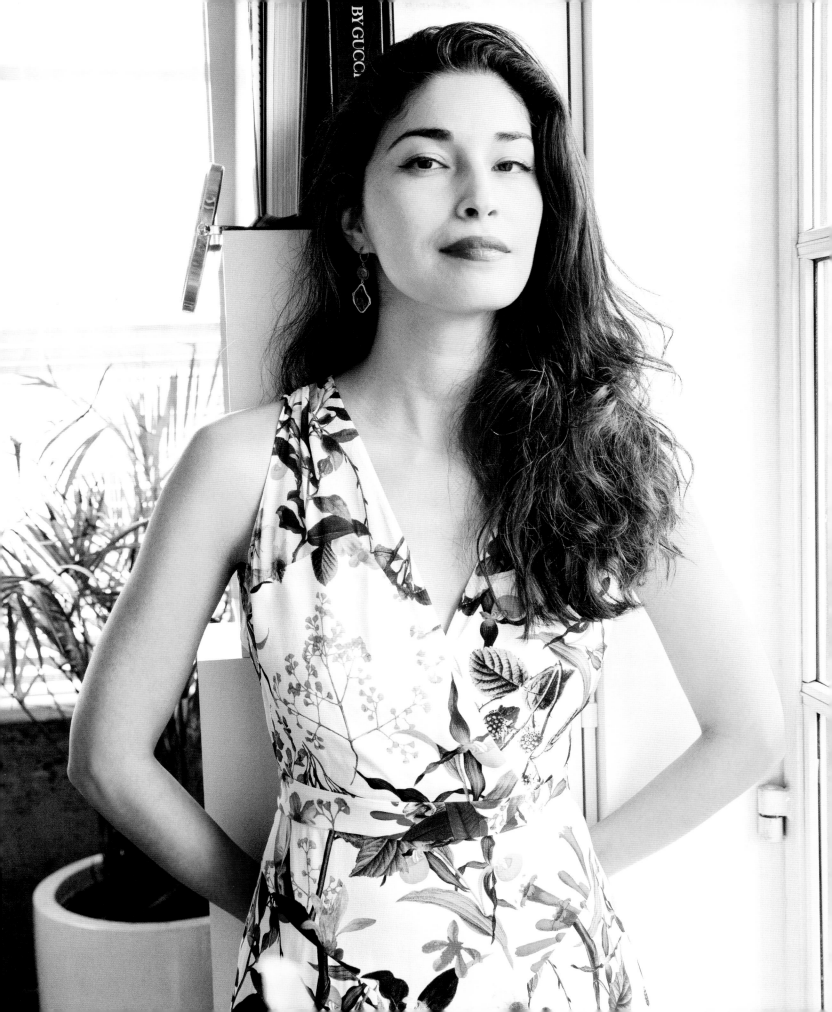

"My favorite project I've worked on? That's like asking who your favorite child is!"

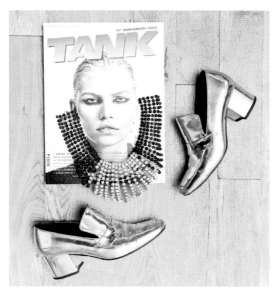

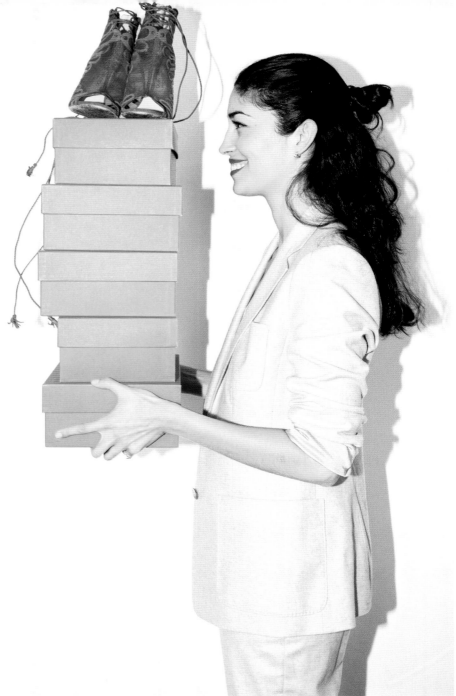

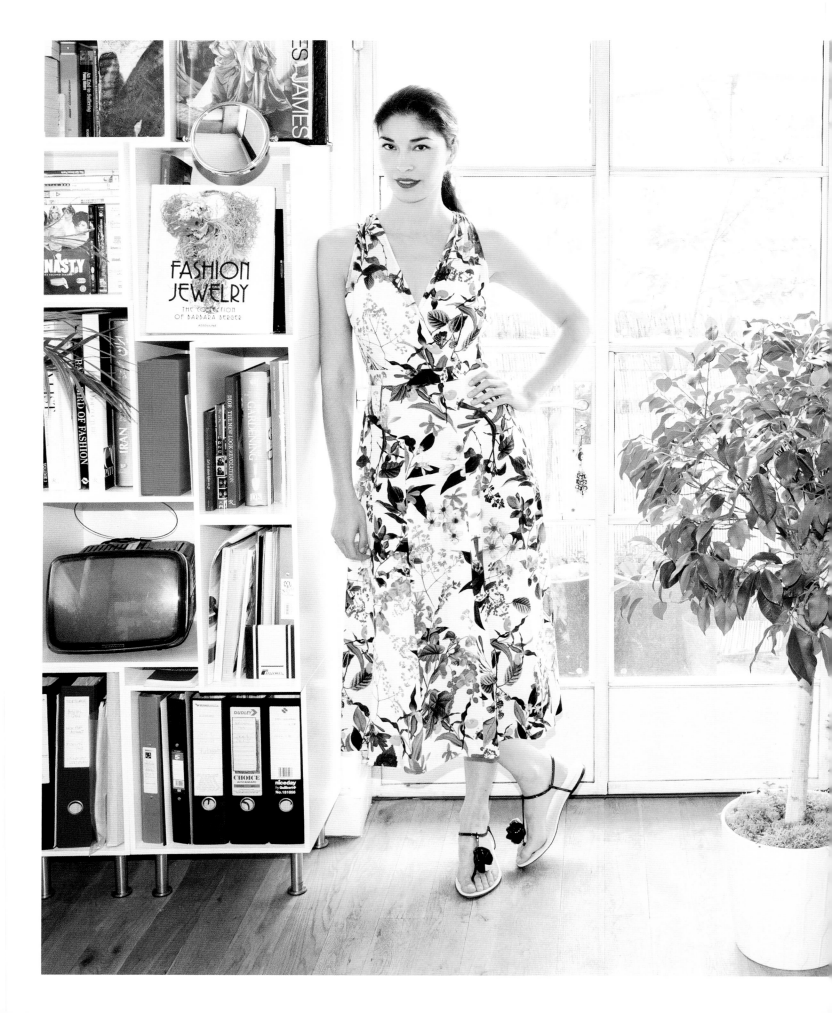

WHEN
November 13, 2015

WHERE
*Karput's central-
Moscow penthouse*

WHY
*Karput owns one of
Russia's most forward-
thinking boutiques
(selling the likes of
Christopher Kane,
Simone Rocha, and Hood
by Air). And surprise,
surprise: Her closet
is as well stocked as the
boutique itself.*

OLGA KARPUT

FOUNDER, KUZNETSKY MOST 20

We first met Olga Karput after, quite frankly, following her from afar during one Paris Fashion Week. She was wearing a men's Raf Simons graffitied lab coat and actually stood out from the rest of the street-style crowd—how could we not find out everything there was to know about her? Lucky for us, our stealth resulted in our photographing her inside her hotel room—and without a restraining order in hand. Suffice it to say, we left our first shoot promising to visit her in Moscow soon, wherein we would ravage her whole wardrobe and not just her suitcase(s).

And, just like that, a few weeks later, we actually did find ourselves in Moscow (isn't it funny how these things happen?), banking on Karput's promise that she would invite us over. And she did! (Did you see that one coming?) But let us first provide some context. Karput is the owner and creative mind behind of one of Moscow's most avant-garde boutiques, Kuznetsky Most 20 (that's KM20 to insiders). Pull a fashion-crazed kid from New York City's Lower East Side, London's Shoreditch, or Los Angeles's Silverlake—any "hip urban neighborhood," really—give them the run of KM20 and, well, they'd be in heaven. And so were we (it's only in our dreams that Marques'Almeida denim and bejeweled Rochas sandals are so readily available).

But back to Karput's home, because, in all seriousness, we've never seen an apartment quite like this. Actually, scratch that—a space like this can't really even properly be referred to as an apartment. It's a penthouse with 360-degree views of Moscow, an indoor pool, Turkish hammam, and gym complete with a ballet barre. Oh, and lots and lots of art. Then, there was the closet: a walk-in (obviously) with endless leather-lined cabinets filled with some very, very special things. Like, for example, an XXL collection of Meadham Kirchhoff, the eccentric, recently shuttered London label of which Karput was a huge fan and supporter. That and pieces from Simons's first collection for Dior, plus spangled, sparkly Ashish T-shirts, Prada platforms, and furry Simone Rocha slides. It was all there; the entire experience something akin to that old "kid in a candy store" adage. That's not even taking into account the fridge she keeps in her bathroom solely to house a French pharmacy's worth of specialized skincare products (it's now officially our life goal to have one of these, too).

We're guessing it's obvious by this point that Karput has anything but average taste—for one portrait she chose a Hood by Air T-shirt dress and a clashing brocade suit paired with precious jewels for another. And when we unearthed a classic Chanel bag, she flinched. We suppose it all goes back to Karput's innate ability to stand out in a crowd—especially a well-dressed one.

"[After the fall of the USSR] there was nothing in stores. You had to ask your friends who might have traveled somewhere to get you a pair of jeans, and then you'd buy something unusual in the street markets and customize it. In a way, that is what made me fall in love with fashion."

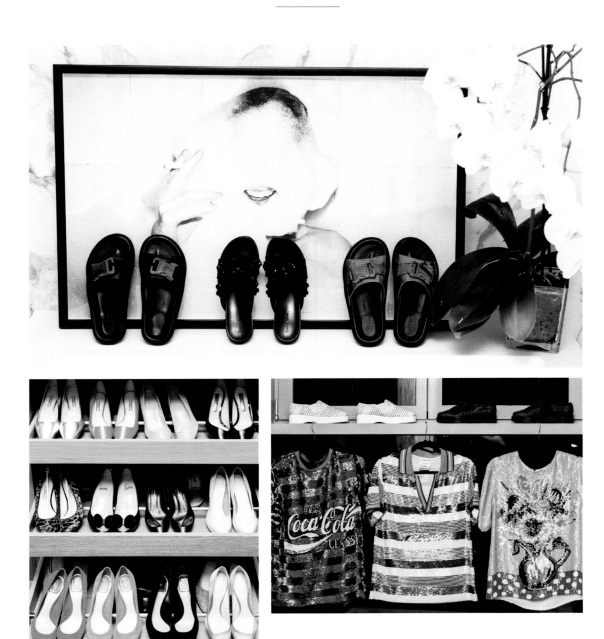

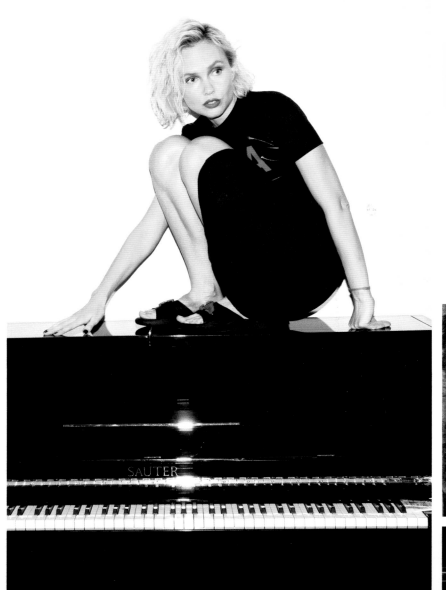

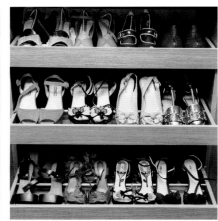

WHEN
October 9, 2015

WHERE
*Kennedy's East
London flat*

WHY
*Since founding Fashion
East, a nonprofit
that nurtures upcoming
designers and talent,
she's helped to explode
the careers of some of
London's most exciting
designers, from J.W.
Anderson and Jonathan
Saunders to Roksanda
Ilincic and House of
Holland. Think of her
as the fairy godmother of
English fashion.*

LULU KENNEDY

DIRECTOR, FASHION EAST; EDITOR-AT-LARGE, *LOVE* MAGAZINE;
CREATIVE CONSULTANT

This is what we love about the English: They respect fashion as an industry worth rewarding. See the honors given by the Most Excellent Order of the British Empire (chew on that) to people like Stella McCartney, Natalie Massenet, Christopher Kane, and Phoebe Philo. A name you might not recognize as belonging to the same club, however, that is suffixed with an MBE, too, is Lulu Kennedy. It might be true that she doesn't get the same spotlight afforded to her designer cohorts—but there's a good chance she put them in that spotlight.

Let us explain: Kennedy is one of those behind-the-scenes mavericks who everyone in fashion knows (or at the very least, knows of) and admires—see her close working relationship with the likes of Katie Grand, editor of *LOVE*, where Kennedy serves as editor-at-large. Yet, she remains largely unknown outside the industry, despite the fact that, through her nonprofit Fashion East, she's helped to build some of the country's most celebrated labels. And you get the feeling, when you visit her at her flat just around the corner from London's fabled Brick Lane, that she likes it that way.

When we finally got down to the business of going through her closet, we quickly realized that Kennedy is a woman who practices what she preaches—as in, she supports and wears the myriad of designers whom she's championed. Like Simone Rocha (neon yellow lace blouse), Bella Freud (tongue-in-cheek candles), House of Holland (cheeky sunglasses, natch), and Roksanda Ilincic (matching frocks for herself and her daughter, Rainbow—who, by the way, is no doubt the coolest kid in the playground). And as you might expect from someone who deals almost exclusively in Englishness (not that she doesn't also have a soft spot for Louboutins and Louis Vuitton), her style reads as resoundingly eccentric.

The fact is, we couldn't imagine it any other way. Especially when you consider her roots: growing up in Ibiza, working the nineties rave circuit in Italy, and then arriving in London to work at a vintage store, all before founding Fashion East in 2000. Since then, Kennedy's essentially been given credit for making London Fashion Week a major force again, pushing all that young, exciting, and, yes, eccentric talent into the spotlight. We might as well say it: She's the one responsible for making us fall in love with the English to begin with.

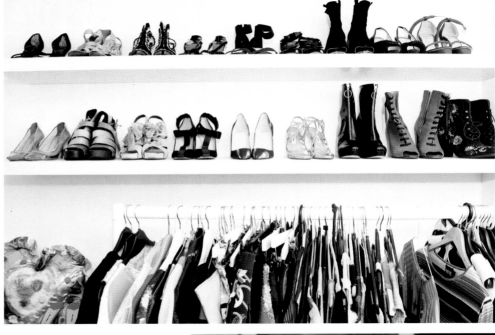

"[My style is] random, willful, and dependent on how I am feeling that day."

WHEN
July 10, 2013

WHERE
*Kerr's bright and airy
Upper East Side
townhouse in New York*

WHY
*The Australian was
one of the first of her
contemporaries to make
the move from model
to mogul. Oh, and she's
single-handedly raised
the stakes (and created
an entire category)
around airport street
style, too.*

MIRANDA KERR

MODEL; FOUNDER, KORA ORGANICS

There's nothing that does it in for the ol' self-esteem quite like an afternoon with a supermodel. Especially when said supermodel is Miranda Kerr. In case her face or baby blues somehow haven't peered out at you from a massive billboard, magazine campaign, or Instagram post sometime in the past, oh, ten-plus years, we'll elaborate. Kerr, a born-and-bred Aussie, made her name as a Victoria's Secret Angel (and the first ever hailing from Australia, too). But the girl is versatile—beyond the lingerie, she's also walked for Prada and Balenciaga, been photographed by Meisel for the September cover of *Vogue* Italia, and topped *Forbes*'s power list of high-earning models for a handful of years running. Hear that? That's Kerr laughing all the way to the bank. With a bouncy hair toss thrown in for good measure.

Back to the whole self-esteem thing: Aside from being otherworldly and jaw-droppingly stunning, Kerr just so happens to be all lovely and sunshiny in person, too. When she first met us at the door of her Upper East Side home, she gave us a quick tour before we got to playing around in her closet, which she told us was only the tip of the iceberg. "I'm living in New York. You make the best of the space that you have." Yeah, we're pretty sure this is the definition of doing just that. You'll see for yourself.

Beyond the closet, Kerr's abode has the whole pretty-as-a-Pinterest-board thing going on: clean, white walls and furniture; antique trays; and plenty of pink accents and blooming peonies from what feels like just about everywhere you turn. Virtually every surface is also littered with an assortment of candles, bundles of sage, and crystals—Kerr is big on all things organic, intuitive, and natural, hence the abundance of rose quartz. That very same approach to all-natural-everything extends to her beauty cabinet, too, leading her to launch her very own beauty and lifestyle line, KORA Organics. What, like you would say no to that supermodel skin and supernatural glow? See also: laughing all the way to the bank.

After cooing over son Flynn (who was then just a baby), it was back to that closet, where we couldn't help but gravitate toward, well . . . where do we begin? Her epic sunglasses collection, assortment of gorgeous golden nameplate necklaces (with one to match for little Flynn), and killer pieces from Céline, Louis Vuitton, Stella McCartney, and Tom Ford, too. Just to start, you know. We're magpies like that. And we were quickly reminded of what a true veteran-model-turned-beauty-boss really is when it came time to snap her portraits—clad in a pair of jeans and basic white tee, Kerr ran the entire shoot, taking sneak peeks and previews of shots in between setups, giving her direction on lighting and which angles were best to shoot. Lets just say a decade-plus of gigs worthy to those of her highest-earning contemporaries will do that to a person.

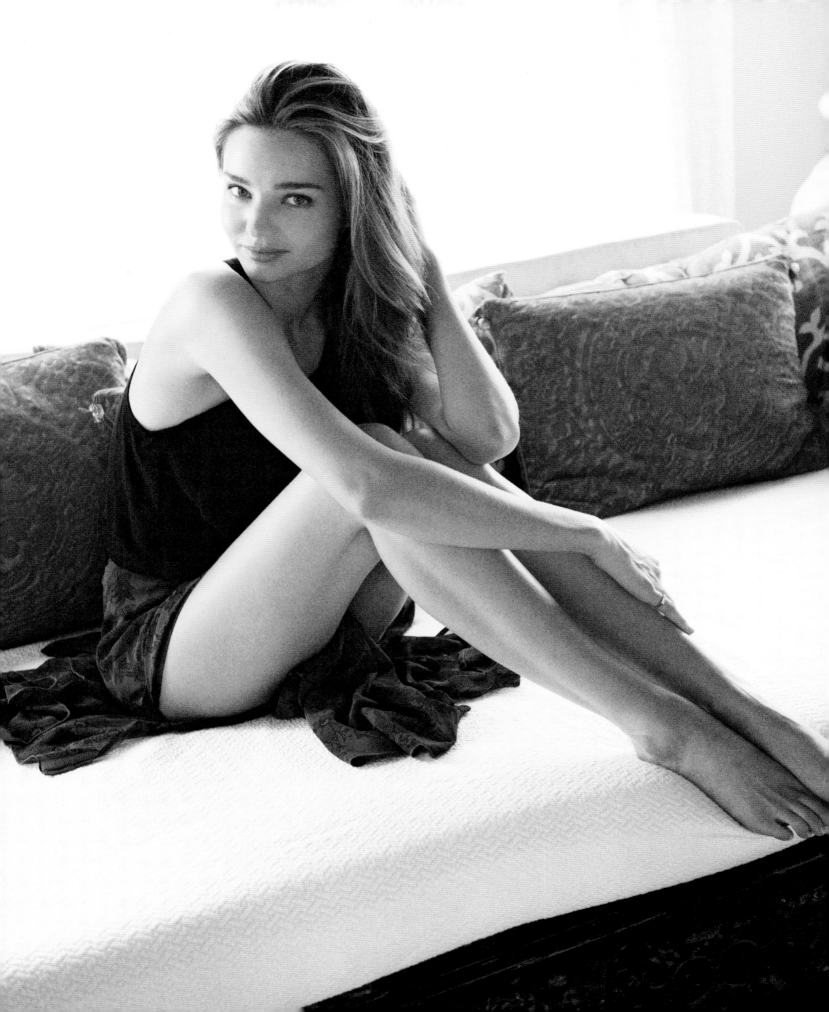

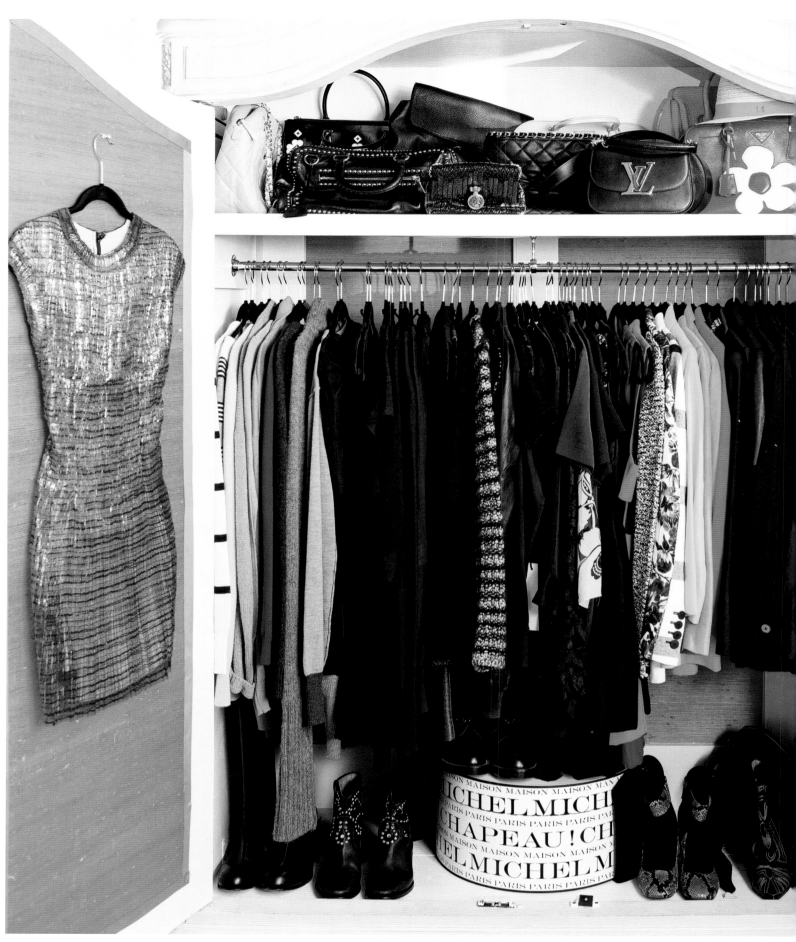

154

"I love delicate, fine jewelry, but I also love chunky rings. I like the mix of masculine and feminine."

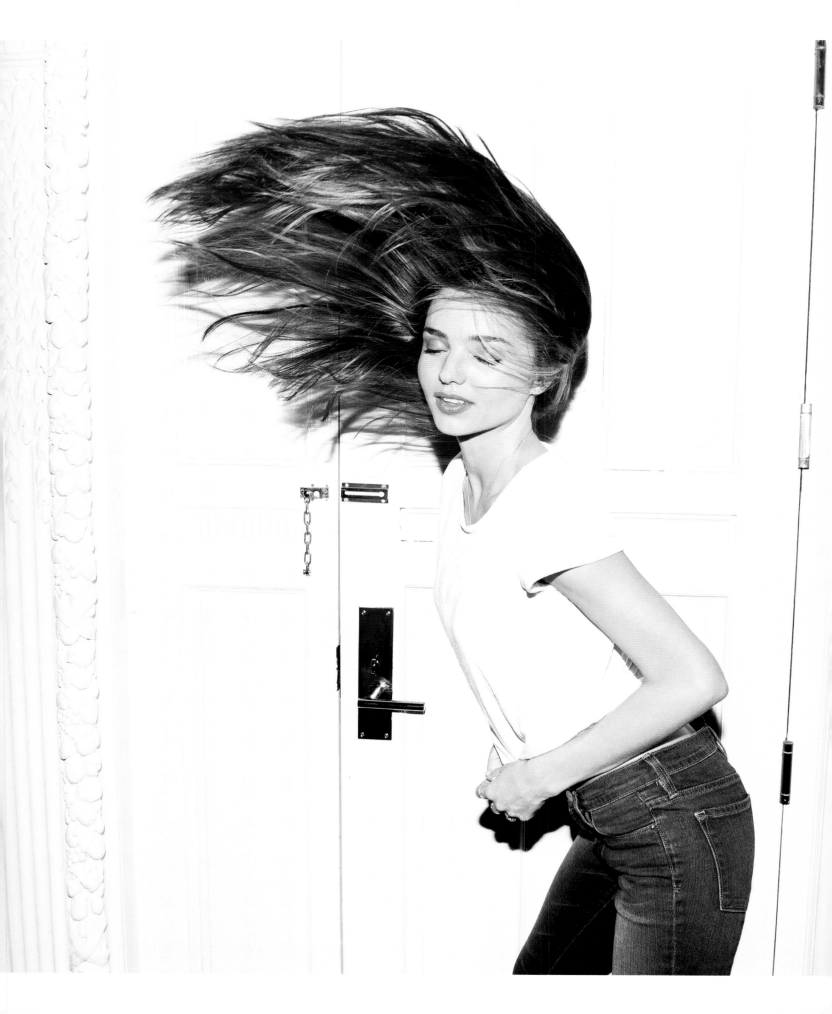

"*I live in New York;
you make
the best of the space
you have.*"

WHEN
October 19, 2013

WHERE
Kloss's then brand-new West Village apartment (her very first) in New York

WHY
Because Kloss has been at the very forefront of ushering in the new, iPhone-powered age of the supermodel—with brains and an entrepreneurial and philanthropic edge, too.

KARLIE KLOSS

MODEL

For some twenty-plus years, insider-y types have been bemoaning the decline of the age of the supermodel. You know the ones—no-last-name-needed types who starred in music videos, dated rock stars, jetted all over the world, lived decadently, and wouldn't get out of bed for less than $10,000 a day (factor in inflation here, guys). Fast forward some half-dozen very crucial, personal brand–building apps later, and we think we may have found this generation's solution to the modern-day supermodel: the social media–savvy one. Swap out the music videos for lip-synching Snapchat uploads, the travel and decadent lifestyle for Instagrammed exploits. The tabloid headlines are still there, but the women behind them supersede them with a tweet more often than not. The new generation of supermodels is very much alive and well, and Karlie Kloss is leading the pack.

For starters, Kloss's rise fits the Cinderella-story narrative all too well: Hailing from Missouri, and one of four sisters (all with the initials KK, too), she made her debut as a Calvin Klein exclusive at the age of fifteen before going on to walk Gucci's, Alexander McQueen's, and Valentino's runways that same season. Some six months later, she'd landed the cover of *Teen Vogue* and the first of her many Meisel-lensed *Vogue* Italia spreads. Fast-forward into adulthood and the impossible-not-to-like Kloss has added collaborations with everyone from Momofuku (her Karlie's Kookies are available at the eatery's Milk Bar and benefit FEED Projects) to Frame Denim (her namesake line boasts forty-inch inseams) and Warby Parker (which benefited Edible Schoolyard NYC) to her résumé. All this while launching a YouTube channel, popping up as the face of a dozen or so campaigns each season, and making her usual stops in a half-dozen or so international editions of *Vogue*. Oh, and she started studying at NYU, too. Exhausted yet?

It would be all too easy for Kloss to buy into a mean-girl, fashion-diva persona—instead, the model/burgeoning mogul is genuinely . . . nice, despite having rubbed shoulders with industry legends (and we do mean legends) on the daily while her peers were worrying about driver's licenses and curfews. Instead of having our interactions chaperoned by a publicist, we spent our afternoon with Kloss getting the grand (and we do mean grand) tour of her brand-new West Village townhouse and raiding her Tamara Mellon– and Coach-filled closet, before running off to the park for an impromptu excursion through Kloss's new 'hood. The model, in a sunny yellow cut-out Reformation dress, GoPro in hand, owned our camera—at least until our spontaneous jaunt was crashed by a pint-size soccer player who took a serious liking to our crew (to put it mildly), even sitting in her lap(!) before running off again. See what we mean about being impossible not to like?

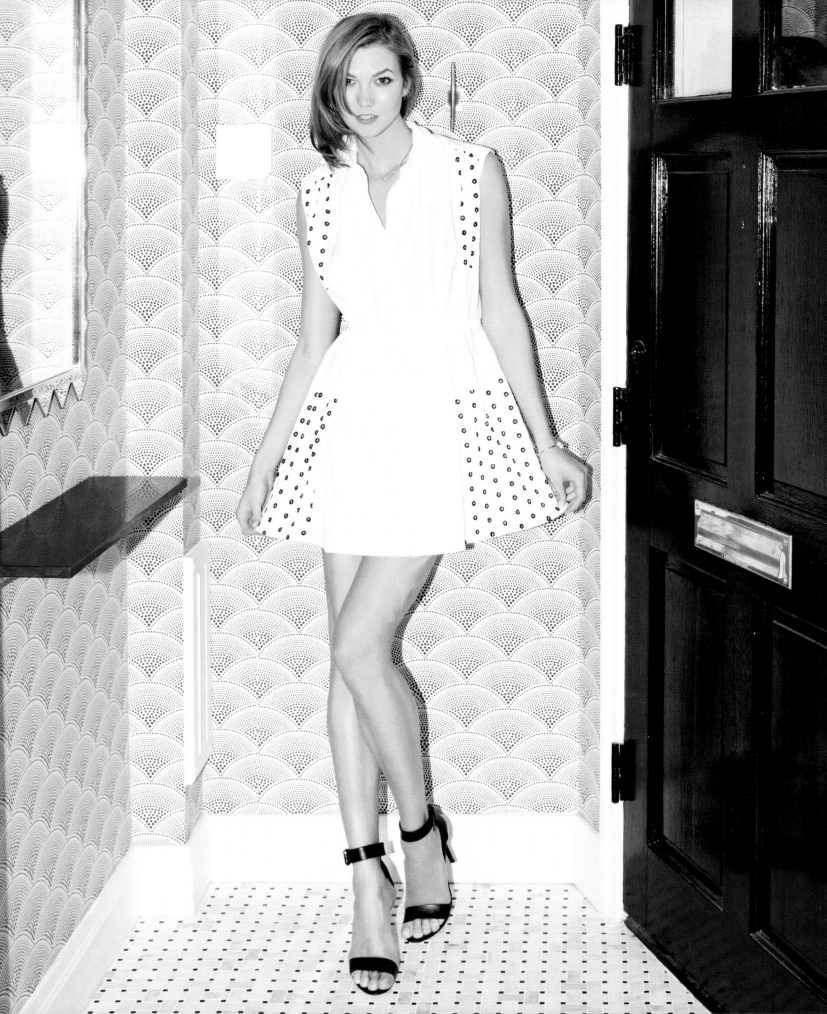

"When I first moved to New York, I scrounged my pennies to buy a Prada bag. It was my first big fashion purchase as a model and my prized possession."

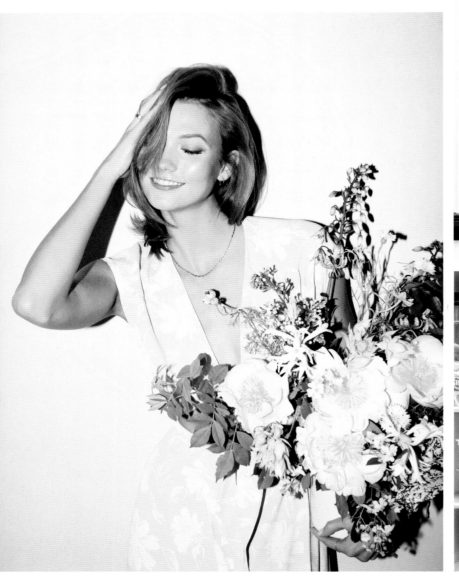

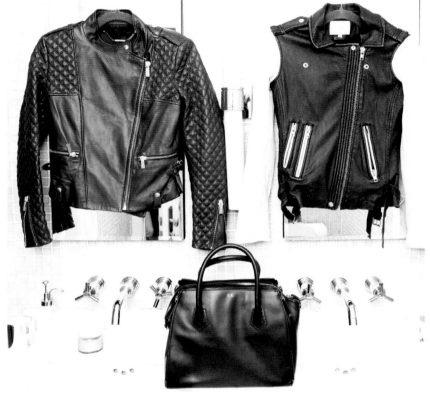

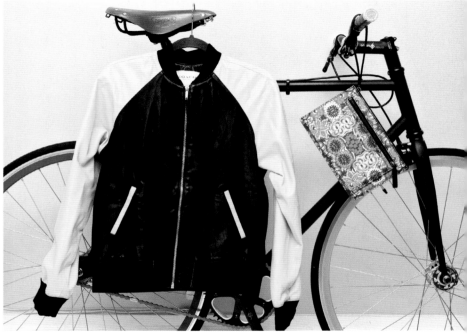

"When I met
Christy Turlington,
I was fifteen and so
awestruck that I
actually burst into tears.
I still am so inspired
by what she
has accomplished—
both personally
and professionally."

163

WHEN
October 3, 2015

WHERE
*Louboutin's
first arrondissement
Paris home*

WHY
*He's the man behind
what are inarguably
the most lusted-after
luxury shoes in
the world, inspiring
countless women
to wear his red soles.
We couldn't not.*

CHRISTIAN LOUBOUTIN

DESIGNER

Ever hear the one about the woman who went to prison for a pair (actually, make that several hundred, give or take) of pumps? Yeah—we hadn't either prior to our afternoon with one of the few footwear designers capable of inspiring grand larceny–like levels of lust.

If we've learned one thing over the years, it's that, for our dear readers, nothing drives real, rabid excitement quite like a closet made up of rows and rows of red soles. The lengths women (and men, too) will go to in order to procure a pair of Louboutins is well documented. And while it would be easy to write off the craze as mere conspicuous consumption, all it takes is one look at the designer's archives to reveal that the bold sole, at its core, really represents something else entirely. Christian Louboutin's work is largely a celebration of the unabashedly, even aggressively feminine via extreme arches, plus-size platforms, and exaggerated embellishments, which include everything from feathers to studs, spikes, googly eyes . . . need we go on? As the man himself told us, "Louboutin women are really pleased to be women. They are pleased with their femininity . . . [by] how much

they can play with it and be powerful, and they are very happy with that."

The designer welcomed us into his home-cum-studio during the throes of Paris Fashion Week. Scouring through designers' closets is always a curious thing—it's nothing short of fascinating to see what he or she chooses for his or her own everyday, and nine times out of ten, they gravitate toward uniforms. Louboutin is no exception—just take a look at his extensive collection of watches, smoking jackets, Lacoste polos, and hats. The one place where he gets crazy? Yup, you guessed it: the shoes. Loafers, brogues, oxfords, smoking slippers, Cuban-heel boots, high- and low-top sneakers . . . Louboutin's own collection of Louboutins run the gamut. It makes sense, too, given that the entire inception of his men's collection came when, after designing his own one-offs for personal wear, word spread and demand quickly grew.

Despite being a household name, it's clear that Louboutin is the kind of designer who genuinely enjoys engaging with the women who wear, well, his wares. In fact, it's one of the main reasons that, despite initially shying away, he's grown to love social media—it gives him direct access to the legions who loyally wear (or fantasize about wearing) his designs.

Need further proof? Just consider his first reaction upon hearing about the woman in Dallas who was jailed for her Louboutin-fueled kleptomania: He sent her shoes.

"The best advice I ever got was from Monsieur Roger Vivier, [via] Christian Dior. He said, 'A shoe has to be able to be visible, and invisible.' It's not advice; it's really a philosophy—which I don't follow all the time!"

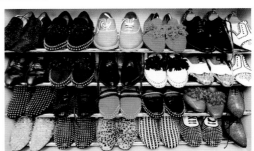

"*I would say that what the Louboutin women have in common is that they are really pleased to be women.*"

WHEN
September 19, 2015

WHERE
*Martelo's townhouse
in the Calle San Lucas
neighborhood of Madrid*

WHY
*Armed with a law degree
and time under her
Givenchy belt at* Vogue
Spain, *Martelo's fueled
the purchases of many
a leather pant and skinny
Balmain blazer, and
she has been behind the
styling of some pretty
epic images, too.*

BARBARA MARTELO

FREELANCE STYLIST AND CONSULTANT

Having photographed stylist Barbara Martelo once before (a few Paris Fashion Weeks ago, while she was holed up at the George V, getting ready for the Dior show), we admittedly had an idea of what we were getting into as we jumped on a flight from Los Angeles to Madrid. After all, given that we were traveling to Spain for a mere twelve-hour stay with the sole purpose of raiding Martelo's closet, we obviously had some inkling, informed in part by the remnants of her suitcase we'd seen for ourselves and in part by her presence on every street-style blog in existence. Truthfully, though? Without getting gushy, the whole thing was so much more than we ever could have imagined. And we can get pretty damn imaginative.

Greeting us at her Calle San Lucas townhouse, we caught up with Martelo over much-needed espresso and a full traditional Spanish breakfast before she lead us to her wardrobe for what's only really fitting to refer to as the big reveal. As Martelo unveiled her dressing room, we had to catch our breath as we were greeted by tiled, glossy white cupboards and a Mondrian-esque island (housing bags, tees, workout gear, belts, sunglasses, the kitchen sink. . .) right in the middle of it all. All of which, mind you, we had to seriously restrain ourselves from flinging open. C'mon. We at least waited for permission. What do you think this is, our first rodeo? Once Martelo gave us the go-ahead, though, all bets were off, and all for the sake of what we get to call work. Organizational obsessives, having gone at it ourselves, we can confidently say this one's all for you: Immaculately lined cupboards of sneakers, sandals, stilettos, and ankle boots; jackets (sorted by fabric for brownie points); miniskirts; blouses; denim (color-coded, because, well, why wouldn't she?)—if there's a category of garment that exists, Martelo has it neatly sorted by hue, length, and material.

As a freelance stylist with a law degree, Martelo's hypercodified nature and method of housing her wares probably shouldn't have been all that surprising to us. It speaks volumes to her buying habits, too—if she likes it, she buys it, and in bulk: sexy booties, ornate and military-inflected miniskirts, tailored blazers, and embellished leather jackets.

With the palm trees just outside the French windows surrounding her home serving as our backdrop, we sort of came to think of it as a lesson in uniform dressing at its finest (and most efficient). Definitely worth the twelve-hour detour (and eleven-hour flight).

*"I collect pieces
and hope that
my daughter, when
she gets older,
will like to wear
them, too."*

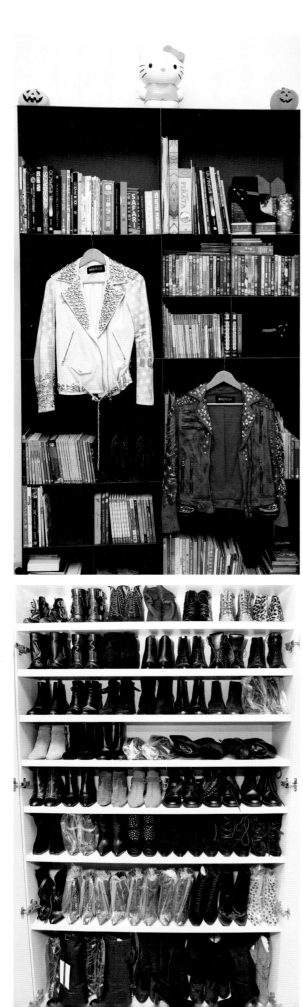

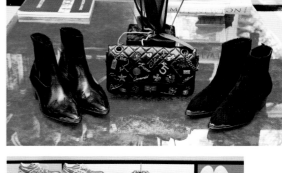
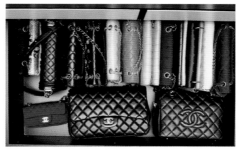

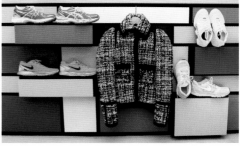

WHEN
June 15, 2015

WHERE
*An elegant, eccentric,
sprawling villa in the
Italian countryside*

WHY
*She's the matriarch
of the beloved cross-
generational family
fashion house that's
redefined knitwear—
none other than Missoni.*

ANGELA MISSONI

CREATIVE DIRECTOR, MISSONI

In case her family's namesake knits didn't tip you off, allow us to spell it out for you, right here and now: No one could ever accuse Angela Missoni of being a minimalist. Upon entering the veritable feast for the eyes that is the Missoni home in Varese, a sleepy city a little over an hour outside of Milan, this much becomes immediately clear. That's not to say, though, that Missoni's assorted tchotchkes and collectibles feel at all chaotic or haphazard: There's a rigorous, exacting method to the Missoni madness. From the elegant (the ashtrays artfully strewn about the living room) to the eccentric (the shelves of porcelain hands and deer figurines in towering glass display cases), we're pretty sure the purposeful styling of every last detail would put even the most grueling of Type A personalities at ease. It's no Grey Gardens, if you know what we mean.

A self-confessed perfectionist, once Missoni had decamped from hair and makeup, she couldn't help but make a pit stop at her closet to get elbows deep with us among her things. She handed us dozens upon dozens of her leather pumps and countless brightly hued babouches (traditional Moroccan slippers) from travels around the globe. From there, it was on to jewelry, as she painstakingly pulled family heirlooms and priceless keepsakes from the drawers bordering her wardrobe. After

handing us the glittering Edie Parker clutch emblazoned with her first name, she even showed us how she repurposes dustbags as impromptu handbags (!) while traveling. Italian mothers: They're nothing if not endlessly resourceful, right?

As Missoni sat for her portraits alongside the indoor pool that sits atop the rolling hills surrounding her home, we got busy propping pieces from her closet throughout the scattered curiosities. And because we know you're dying to ask, yes, precariously hanging a knee-length Missoni coat just so from the edge of a Jenny Holzer installation is every bit as terrifying as you'd imagine. While Missoni told us she doesn't have the time she deems necessary to attend auctions and art fairs that would anoint her a "proper" collector, we beg to differ—and so does the neon Tracey Emin hanging above her family-room sofa, we'll bet. Don't even get us started on the George Condo and Francesco Vezzolis in the mix.

We won't lie—after Missoni brought out a tray (Missoni, duh) with biscotti and cookies to keep us satiated throughout the afternoon, we were starting to, secretly, almost feel as if we were a part of the family. Surrounded by Memphis Group–designed objects, countless antiques, priceless art, oddities . . . we could have really gotten used to it all; but as rain started to fall on the property, we took it as our cue to *partire* and return to Milan for the evening. We do expect an invitation to the next Missoni family reunion, though.

GEORGIA O'KEEFFE for

Greed

BY
FRANCESCO VEZZOLI

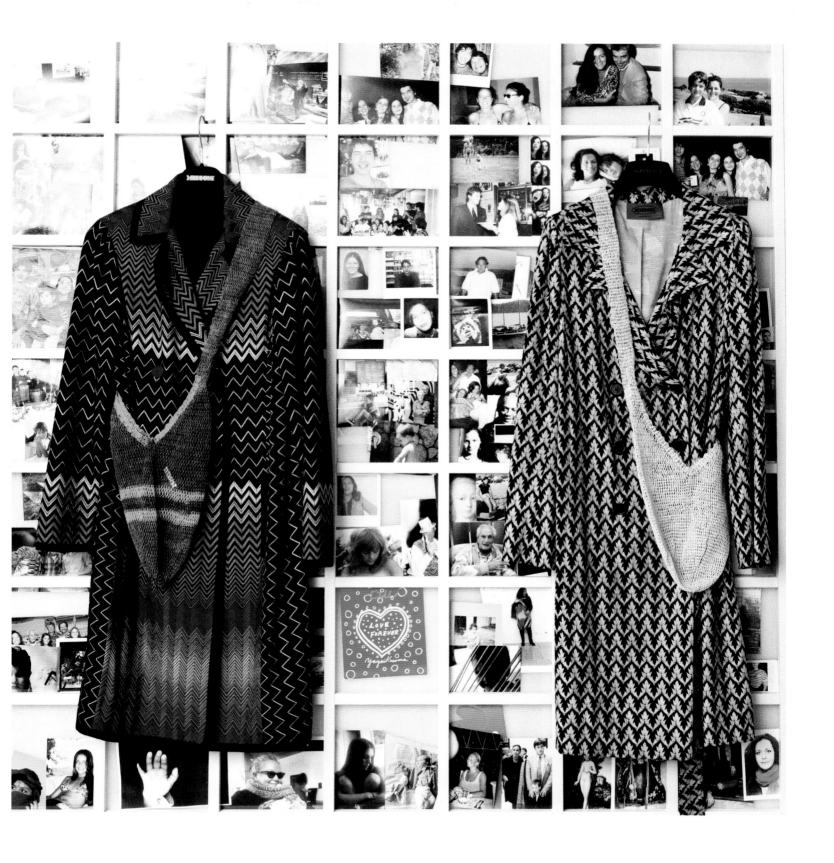

"For sure, all Italians know about quality,
they know about beauty."

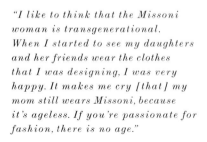

"I like to think that the Missoni woman is transgenerational. When I started to see my daughters and her friends wear the clothes that I was designing, I was very happy. It makes me cry [that] my mom still wears Missoni, because it's ageless. If you're passionate for fashion, there is no age."

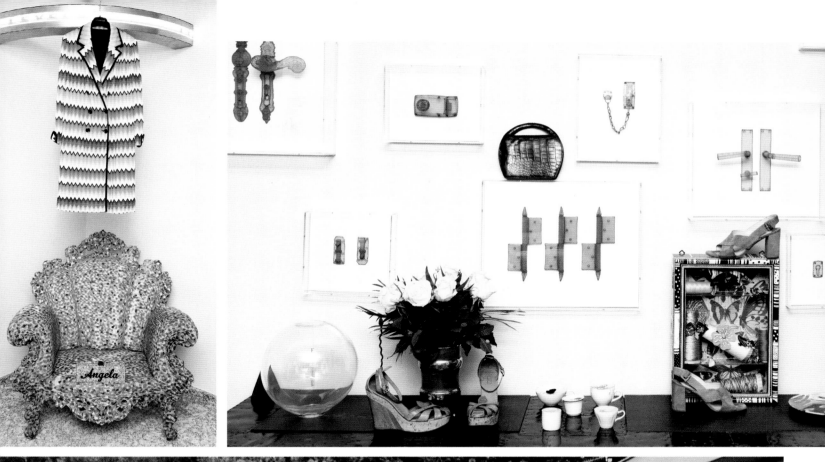

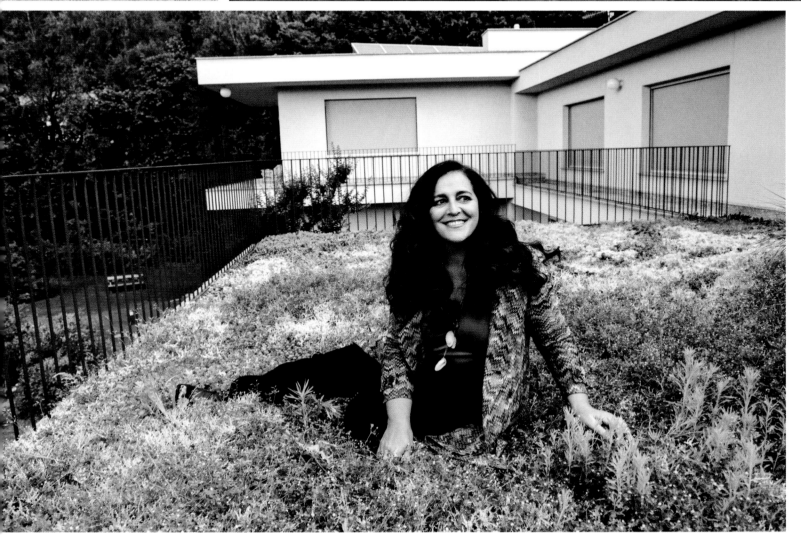

WHEN
November 21, 2014

WHERE
*The model's townhouse
in New York's
Chelsea neighborhood*

WHY
*She encapsulates
everything that is
all-American beauty,
and she basically
owned the modeling
industry throughout
the nineties.*

CAROLYN MURPHY

MODEL

W oman-dom's collective, near-universal appreciation for all things Céline aside, we stand by the idea that there is no single, objective, catch-all sartorial "classic."

Hear us out: While the presence of a good white button-down may have earned a nonnegotiable spot in the closets of some, for others, a sequined slogan tee might be the unassailable equivalent. And even though considerable real estate in the wardrobes of one woman might be dedicated entirely to variations on the same black shift dress, the very sight of such could be enough to send someone else running hysterically in the other direction into the arms of a vibrantly printed, crepe-de-chine Stella McCartney jumpsuit. And yet, despite this, we're fairly confident in our conviction that when it comes to the fabled concept of classic American beauty, we can all agree on one person fitting the bill wholly and completely: Carolyn Murphy.

Arriving at the model's Chelsea townhouse bright and early one recent morning, we were greeted by Murphy and her overwhelmingly cute chocolate Lab, Rupert. Bundled up in an Industry of All Nations sweater and jumpsuit (a girl after our own hearts, clearly) from 6397 Denim, Murphy gave us the grand tour of her place before allowing us free rein to raid her recently

purged closet, our first hint at the model's dedication to constant self-improvement (some inspiration we can all mentally stow away for the next time we're tempted to dedicate an entire Sunday to binge-watching reality television and blearily stalking social media). Aside from her newly avowed commitment to paring down and going back to basics, there's her work with lifestyle brand Shinola (which she succinctly summed up as "the coolest thing since peanut butter") and even dabbling in a creative writing class.

Back to that closet: Murphy being, well, Murphy, the pieces that made the cut and serve as the building blocks of her wardrobe weren't without some seriously juicy anecdotes, either. A pair of Manolo Blahnik slingbacks gifted to her by André Leon Talley, Prada given to her by Miuccia herself ("Miuccia Prada gave me the lace dress as a gift, after the birth of my daughter"; "the leopard hand-bag [was] a gift from Miuccia when I signed on to do the campaign in 1995"), pieces from a Calvin Klein campaign that fell into her lap by way of Carolyn Bessette . . . yeah, you get the idea. "I had no clue Anna Wintour would take me under her wing as she did." Murphy shrugged as she recounted her start as a model, having moved from Virginia to New York to pursue her dream, which eventually lead to her rise as a *Vogue* favorite. What can we say? If anyone knows a real timeless classic when she sees it, it's Anna.

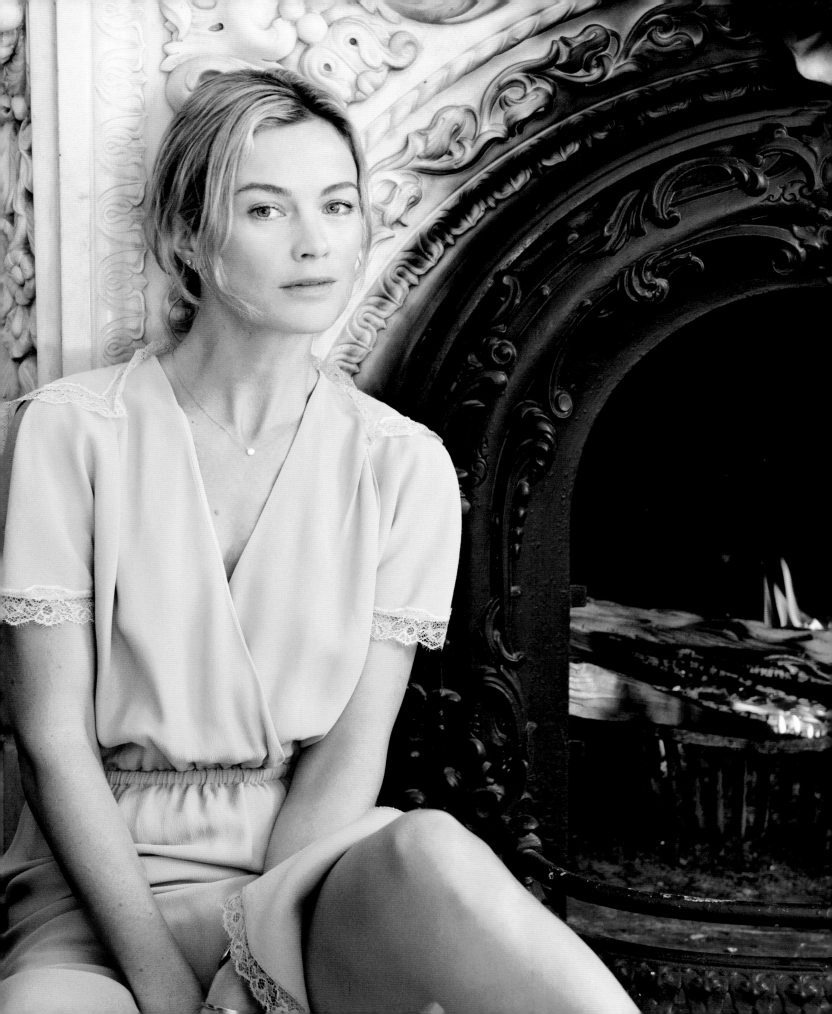

"My first fashion memory is of my nana sitting at her vanity table applying red lipstick, then [pulling on] her white gloves. It was such an elegant moment, and I decided at that moment I would be just like her. But I also started to dive into my father's wardrobe when I was thirteen for his fisherman's sweaters and white Hanes T-shirts. It's a dichotomy of feminine versus masculine!"

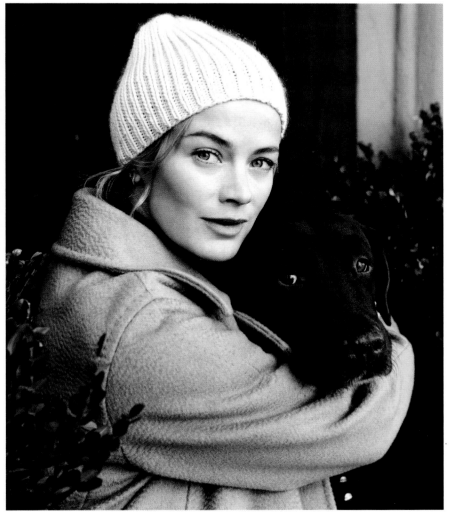

The Monocle Guide to Better Living

"When I first shot for American Vogue, I knew things were about to change, but I had no clue Anna Wintour would take me under her wing as she did."

PETER BEARD

CATSKILLS VS. HAMPTONS

WHEN
November 25, 2014

WHERE
*O'Brien's East Village
apartment in New York*

WHY
From writing for
Interview *during Andy
Warhol's tenure to
directing the creative on
iconic campaigns like
J'Adore Dior, O'Brien's
impact on pop culture
runs* deep.

GLENN O'BRIEN

WRITER; CREATIVE DIRECTOR

A lot of what you see from us is purely driven by our own curiosity and obsession with pop culture and the fashion industry. And a lot of our time is spent pursuing these things—pretty doggedly, we might add—in the hopes that the results will be (at least somewhat) illuminating. So it was with particular glee when, after a few weeks' silence, we received a response to our plea for a few hours of time from one Glenn O'Brien, granting us access to his East Village apartment.

See, O'Brien is pretty much the ultimate example of "persons of influence who also happen to be damn interesting." The man essentially wrote the book when it comes to being creative and innovative in art and fashion. But we'll start at the beginning just in case you're missing some details. O'Brien got his start at Andy Warhol's *Interview*, back when the magazine was in its infancy and being published by Warhol himself out of his infamous Factory. Yes, O'Brien was a charter member of that crew—perhaps the

coolest of all cool-kid gangs ever to exist. After leaving, he held successive positions at *Rolling Stone*, *Oui* (owned by *Playboy*), and *High Times*, all during the seventies. He also hosted a public access show in New York called *TV Party* and welcomed guests like David Bowie and Debbie Harry (yes, this was and is his real life). We'll say this: He has a knack for being in the hottest place at exactly the right zeitgeist-y time—and making an impact on it, too.

You're likely to recognize O'Brien as *GQ*'s former Style Guy (his book should be a bible for boyfriends everywhere) and, well, after getting a firsthand tour of his Basquiat-filled loft (he owns a leather jacket inscribed by the artist himself with his crown motif), we discovered that his onetime column title is indeed apt. But the man is also the creative director behind such everywhere-you-look campaigns as Dior's Charlize Theron–starring J'Adore spot and Dolce & Gabbana's with Scarlett Johansson. In other words, if you're any kind of fan of culture whatsoever (we are, in case you hadn't noticed), there's a good chance, in some very direct way, O'Brien had a hand in it. Just take a glance through these photos and you'll understand what we mean.

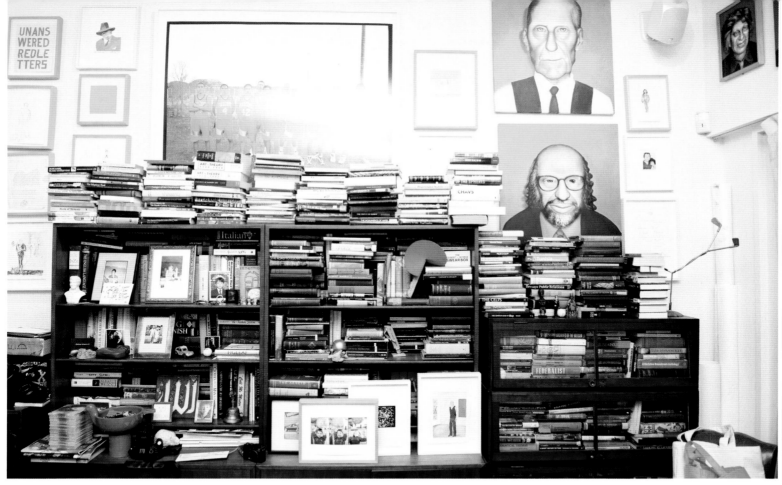

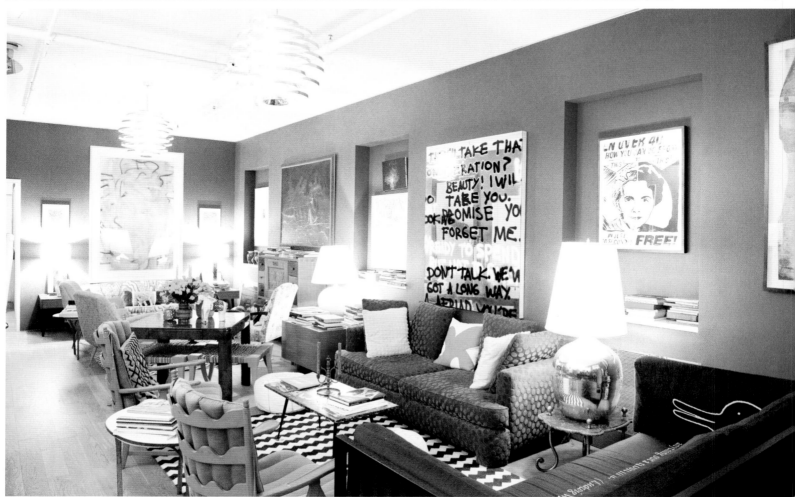

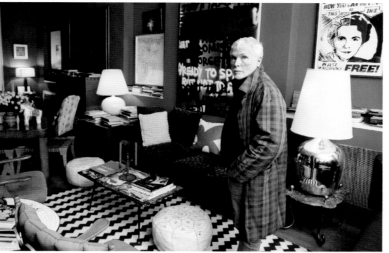

"I wore basic Keds sneakers when I was seven years old, and I still wear them—larger, of course. When I look at old pictures, I am always amazed to see how little my style has changed."

WHEN
November 12, 2015

WHERE
*Perminova's suburban
Moscow mansion*

WHY
*If you've been following
street style at all
in the past five or so
years, we're pretty
sure you know why we
had to make the
trip to Russia, ASAP.*

ELENA PERMINOVA

PHILANTHROPIST AND FOUNDER, SOS BY LENA PERMINOVA; MODEL

Whyen we booked our tickets to Moscow, we had one mission and one mission only: Photograph Elena Perminova for a single, very special project (you're reading it). Scratch that: This mission was born long before we were Moscow bound; it's been priority number one for going on, ahem, five years. (Perhaps, like us, you've noticed Elena in head-to-toe Valentino at nearly every fashion week.) When we finally got word that Perminova was granting us access to her Russian abode, well, that's when we reserved a hotel room on the Red Square, applied for visas, and purchased two round-trip tickets—she virtually snapped her fingers and we were there.

Which explains why our first early morning in Moscow (an eight-hour time difference made that especially trying) saw us driving out of central Moscow, Russian-speaking intern in tow—the latter essential if only to help our driver navigate the unnamed streets in Perminova's neighborhood (and extremely helpful with Elena's excessive Prada— but more on that in a minute). After leaving the highway, we took a drive through a forest before arriving at Perminova's gated enclave. It was secluded to say the least—but you'd better believe we found her!

Although the journey was long, it was well worth it, because as soon as we arrived at the house we were led straight to Perminova's closet—literally the center of her home; and likely the place where a lot of the action happens. When the model and philanthropist greeted us among her racks of next season Versace and Miu Miu, she explained that the space had formerly been the library. Long story short, her collection was abundant (and we're pretty sure there's way, way more where that came from).

Hair and makeup done, it took no time at all for Perminova to get to work, quite literally: The woman really knows what she's doing in front of a camera lens. And, of course, her choice looks (Dior bodysuit, Louis Vuitton one-shouldered dress, mismatched Marni ensemble, and, ahem, a few more), coupled with the massive grandness of her home didn't exactly hurt the whole photo shoot situation.

After we'd had our fill of her piles of Burberry, Gucci, and Dior, we sat down to a lunch prepared by her family's personal chef (who are we kidding? she actually had to drag us away from her closet), where

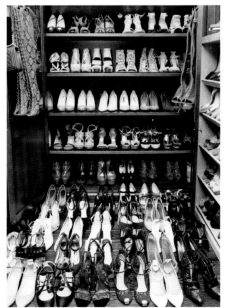

Perminova regaled us with tips for our visit in Moscow (where to eat, who to meet, where to do Pilates) and told us all about SOS by Lena Perminova, her latest project and the first Instagram auction, which donates its proceeds to children in need of health care and education. Suffice it to say, we jumped right on board with all of the above (the woman practically planned the rest of our trip). So, yes, in case you were wondering, our mission was totally accomplished.

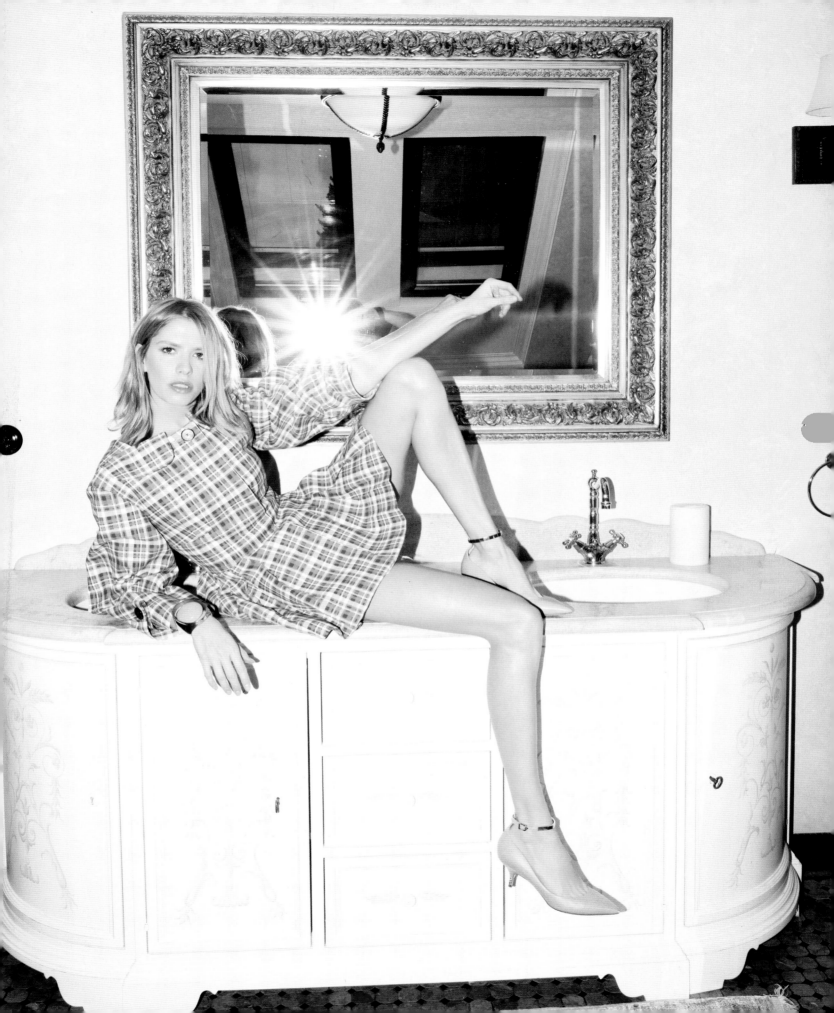

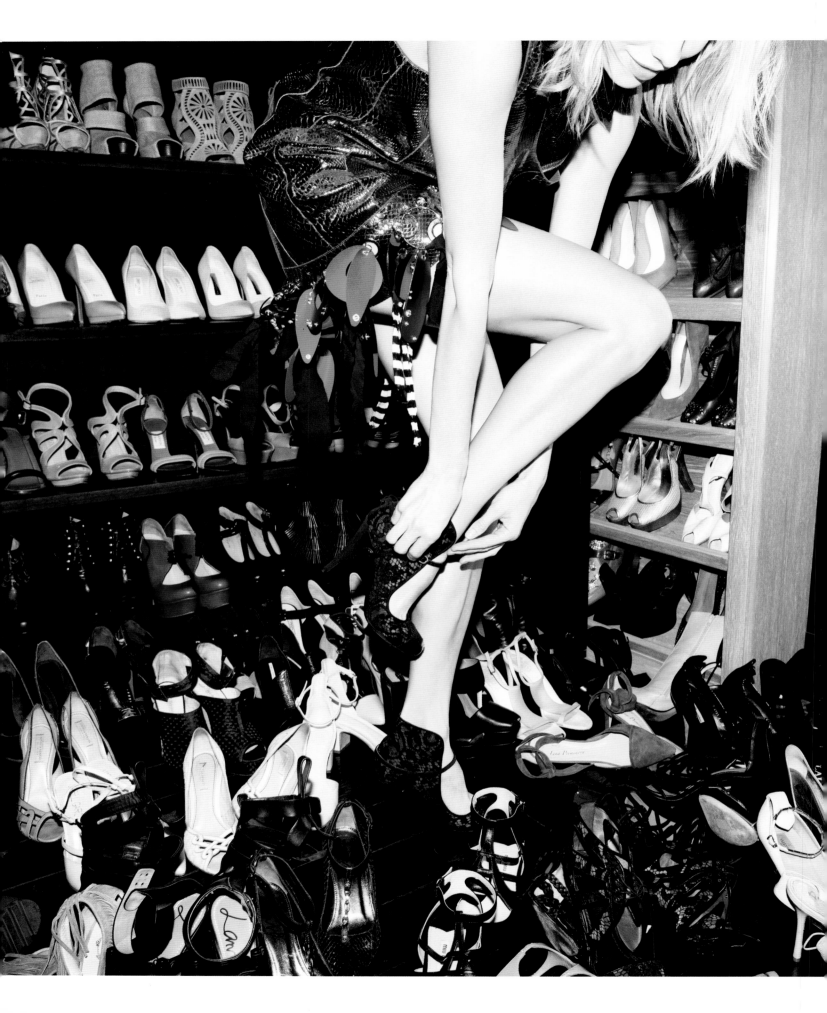

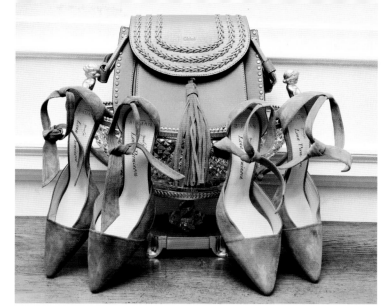

"Even in my early childhood, I wanted to look trendy and different from others. For a Christmas party at school, I wore my older sister's red wedding dress, which looked rather far-out on me."

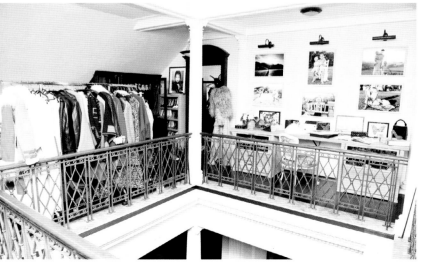

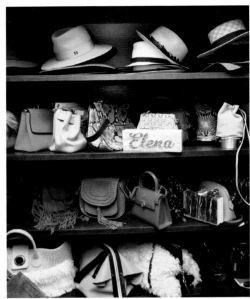

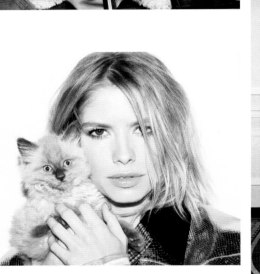
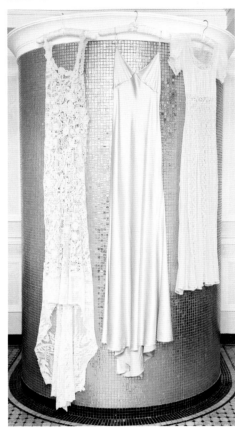
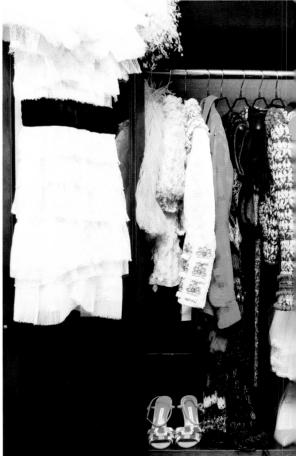
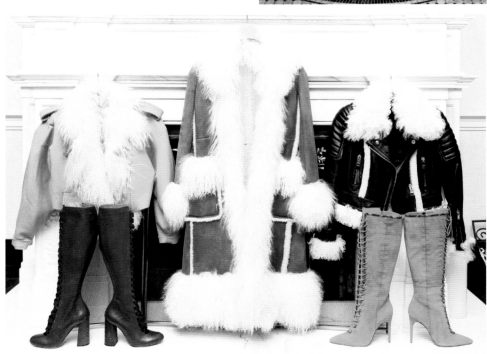

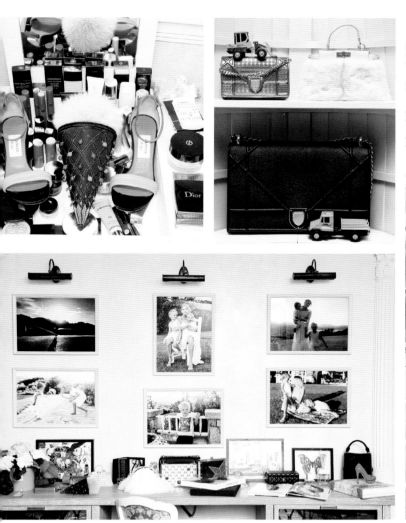

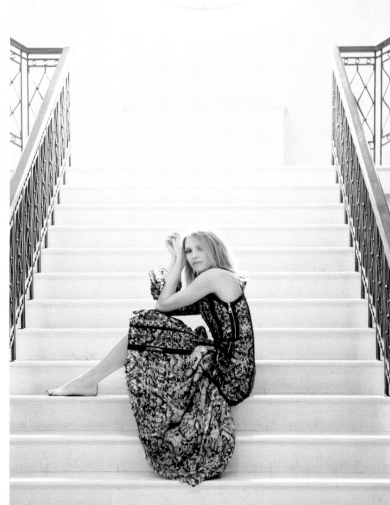

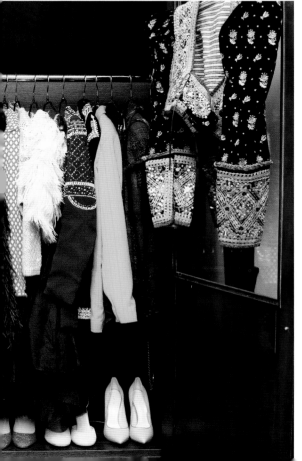

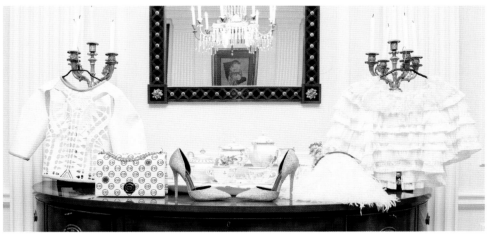

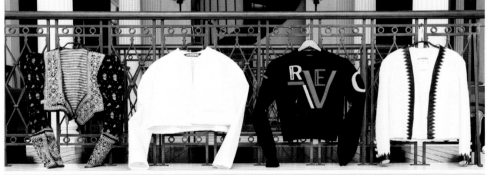

WHEN
February 14, 2013

WHERE
*Her eclectic Chelsea
apartment in New York*

WHY
*She concocted her now-
famous facial oil
on her bathroom floor,
which completely pivoted
her thirty-five-year
career as a stylist to
what it is now.*

LINDA RODIN

FOUNDER AND CREATOR, RODIN OLIO LUSSO

Take one look at the bare-bones minimalism of Rodin's bottle labels and the essential oil–infused libations that lie inside, and you'd expect the woman behind the industry's cultish elixir was just as pared down as the products that bear her name. So you can imagine our amazement, mere seconds after we rang the doorbell of stylist-cum-beauty-exec Linda Rodin's Chelsea apartment, when she swung open the door to unearth what we can only describe as an over-the-top-opulent underwater world. Think teal-tinged everything, layers of leaning gold-framed artwork and photographs, trinkets and thingamabobs piled high, and underwater crustaceans nesting on practically every surface. "I am a Pisces and I have always felt like a mermaid. When I was little, I saw the movie *Mr. Peabody and the Mermaid* and it changed my life." See, get it now?

But here's the thing: Rodin herself is really a juxtaposition of her surroundings. Her sartorial aesthetic, much like her skincare line, is pared back . . . with, you know, the occasional metallic block-heeled boot and

always (ALWAYS) her signature thick-rimmed shades. Let us be clear, Rodin is by no means monotonous (like, at all); her blood runs New York—in understatedly cool form, she always wears her silvery hair loosely pulled back into a knot and never, ever, leaves the house without a pink lip (a habit she credits to her late mother).

As we got to talking, while she sat on her big velveteen teal couch with her "naughty" silvery poodle, Winky, it became pretty obvious Rodin takes after her mother in more than just becoming the apotheosis of graceful aging (since launching her beauty company, Rodin's been lensed for campaigns for The Row, Karen Walker, and J.Crew); her mother was an antique shop owner, which is essentially why Rodin appreciates and has filled her space to the brim with vintage tchotchkes. So, as we do, we rifled through the shell-shaped dishes pouring over with pearl

necklaces and flea-market brooches, and made our way to her closet to uncover all the Prada and Chloé that lay inside. Eventually we ended up in her bathroom—seashell toilet seat included—and headed to the exact spot where she created her first batch of Olio Lusso to do some final portraits. Let's just say, we felt like mermaids after that one, too.

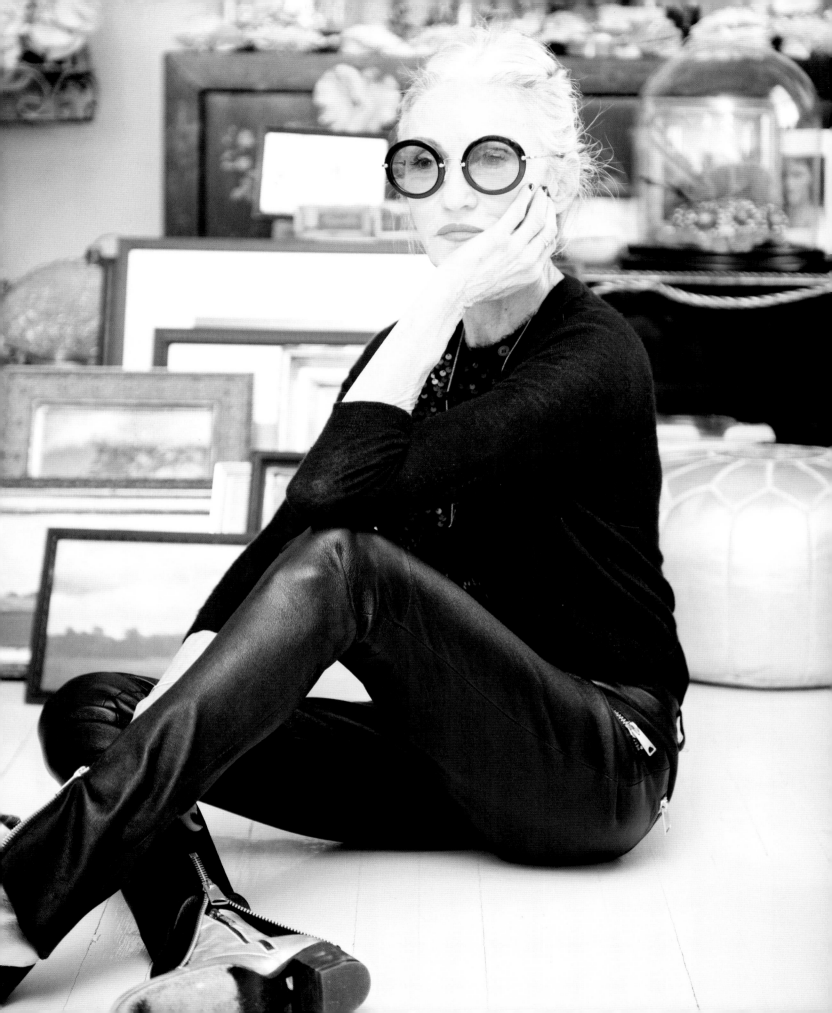

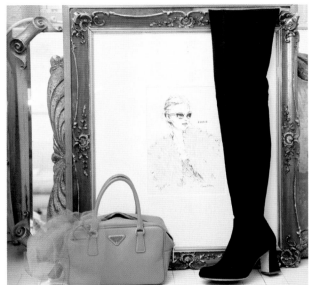

"I am a Pisces, and I have always felt like a mermaid. When I was little, I saw the movie Mr. Peabody and the Mermaid and it changed my fantasy life. Being on a beach and searching for shells is my yoga. Blissful!"

"*My dog is the love of my life, and he's smarter than I am. He is always happy and a bit naughty.*"

WHEN
June 2, 2013

WHERE
*Her palatial
Toronto mansion*

WHY
*Oscar de la Renta
on Mary Katrantzou
on custom Christian
Louboutins. This is the
most OTT Coveteur-
closet situation we've
ever experienced.*

SUZANNE ROGERS

PHILANTHROPIST; FASHION ENTHUSIAST

There are those unexplainable and rare moments when we walk into a home and are hit with a massive wave of déjà vu. As if we'd once walked into that house, at that very moment in time, and had seen all those very things. But once the bewildering (pink, glittery) haze settles, we realize that it's actually just one of our most girlish childhood dreams come to fruition. Nothing quite exemplifies the aforementioned scenario as much as our visit to the home of Suzanne Rogers.

Let us paint a picture for you (in case the photographs here aren't enough): The grandeur of the front foyer, with its fifteen-foot-plus-high ceilings and delicate French Renaissance details, was what we dreamed a grown-up Disney princess would live in. And as we made our way from one room to the next, each decorated with museum-caliber textiles, Louis XV–era furniture, and tchotchkes, we finally found ourselves in the dressing suite. Just like the perfectly tasteful appurtenances of every room in the house, the wardrobe was impeccable. As in, neat freak–level organization (in the best way possible): right-off-the-runway Mary Katrantzou

dresses hung side-by-side and catalogued by kaleidoscopic color palette; current season Chanel; Oscar de la Renta and Balmain organized by rainbow hues. The all-black pieces? Well, those had their own dedicated locale.

We have yet to even mention the accessories—her shoes: Nicholas Kirkwood, Casadei, Saint Laurent, all boxed, photographed, and labeled (we told you she had a method). There were so many pairs that they've even replaced vintage bottles of Merlot and Veuve in spots in the wine cellar. Rogers's shelves were stacked with so many signature orange boxes and Chanel quilted bags and Roger Vivier crystal-buckle clutches, we lost count.

But as much as being a member of Canada's first media-magnate family affords you endless sartorial endowments in the form of archival Alexander McQueen and couture Dior, Rogers's passions go far deeper than fashion's often associated vanity. She merges her dedication to fashion and the relationships she's formed with coveted designers with her philanthropy, often inviting her designer friends to cohost her annual charity gala (the late de la Renta made an appearance for the inaugural benefit) to raise money for a pediatric hospital, which fetched almost $900K in one night. NBD!

To make a long story short: We fell hard.

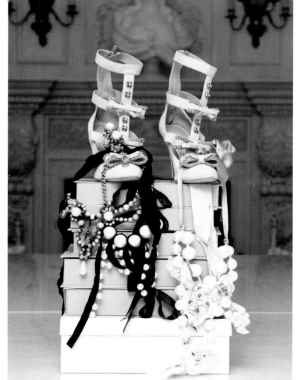

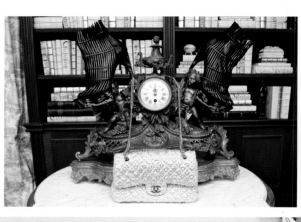
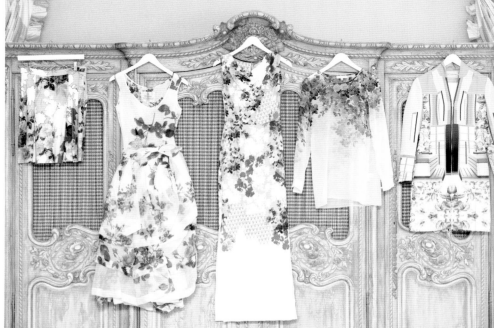
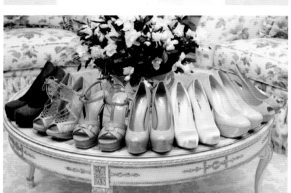

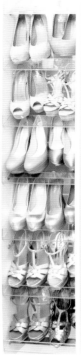
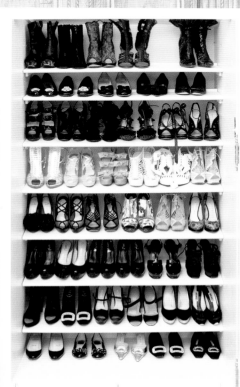
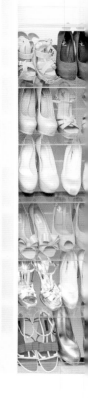

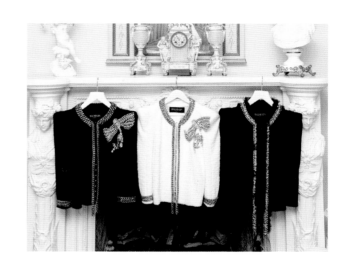

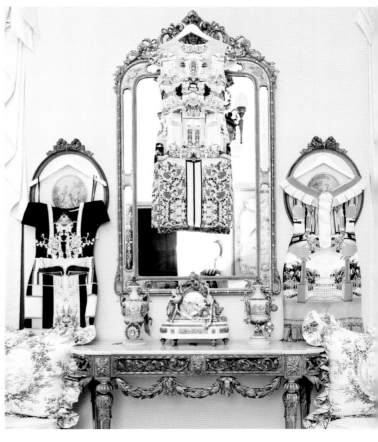

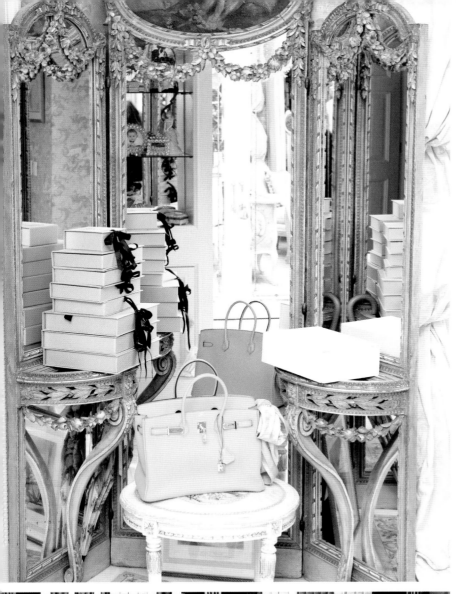

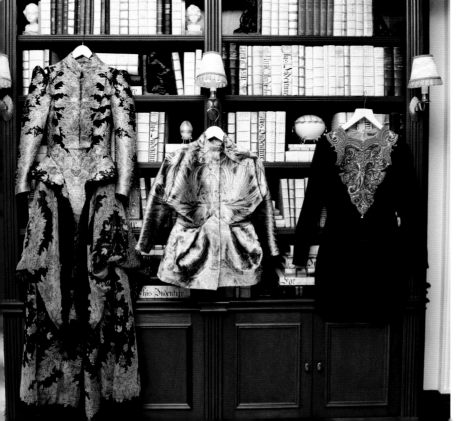

"I love being feminine—even if sometimes it's with a bit of an edge."

207

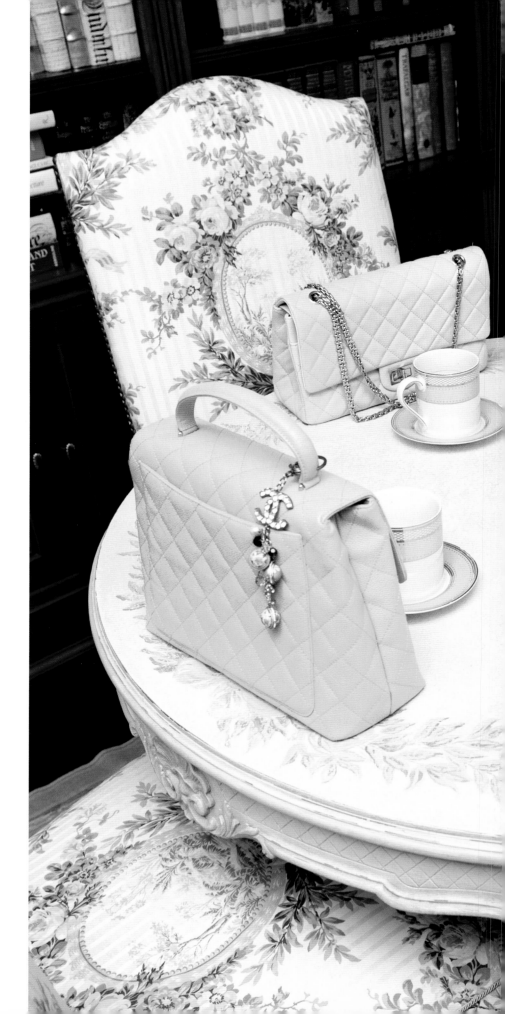

"*Spring/summer
is my favorite season;
my closet becomes
full of color and
my clothes seem to
come to life.
The other half of
my closet is all black—
easy dressing!*"

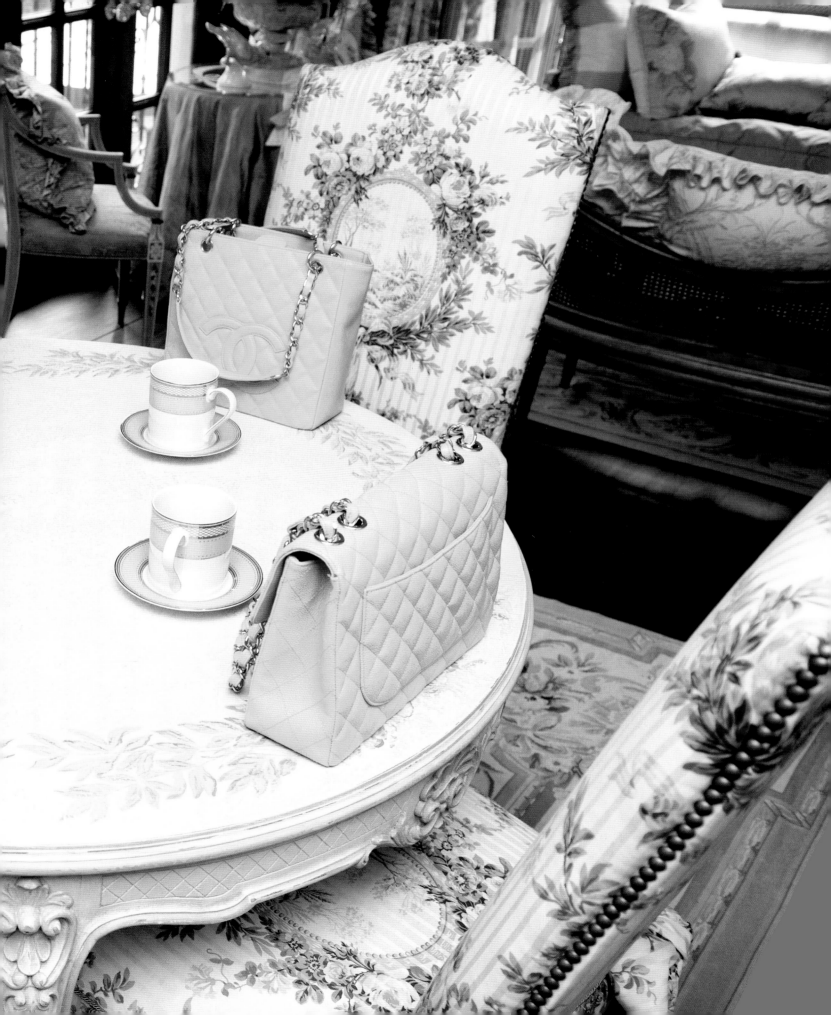

OLIVIER ROUSTEING

CREATIVE DIRECTOR, BALMAIN

The moment a long-standing designer steps down from his helm at a prestigious fashion house and a successor is announced—well before the newly appointed creative director sends down their reimagined looks—there's vacillating chatter among industry vets. As in, will he continue the legacy of his predecessors? Or alternatively, will he mark a certain demise? Such was the scenario (yeah, let's just say people were freaking out) when a not quite thirty-year-old Olivier Rousteing was hired to take over Balmain from Christophe Decarnin in 2011. When it happened, it was a BFD. But if there is one case to reference over and over again, it's that of Rousteing, who, if you've been following his design trajectory since he started at the historic French brand, has pretty much established it as one of the topmost coveted labels. #balmainarmy, anyone?

We mean, aside from creating pieces that are almost too pretty to wear, he's managed to befriend just about every girl of the moment, from the Kardashians in their entirety to Rihanna, Gigi Hadid, and Rosie Huntington-Whiteley, while simultaneously erasing the divide between luxury and popular culture

with every baroque-embellished plunging minidress in a savvy trick of social media promotion. Add that to the fact that Rousteing himself has racked up over a million followers on Instagram, making him just as recognizable as the designs he sends down the runway. You could say he gets it.

When it comes to creative types like Rousteing, we often liken taking a tour through their office or work space to getting a glimpse inside their minds. So when we found ourselves at the Paris HQ of Balmain, where Rousteing hones his creative genius, it was only fitting that we stumbled upon boots adorned with baroque beading and old *Miami Vice* DVDs. We mean, inspiration for those ubiquitous broad-shouldered dresses and wide-lapel suits had to come from somewhere, right?

That's the other thing that almost always tends to manifest when we make our way through a creative's space or personal archives: It kick-starts a veritable game of connect-the-dots. From the trunk of beat-up, boxy black boots he brought from home to the iPod dock that blasts Britney and Rihanna on the regular, all the elements of the French brand's DNA under Rousteing's rule couldn't have been more apparent from our morning with the designer. Oh, and since our visit, we've been toting around boxes of Special K bars, all because Rousteing told us to.

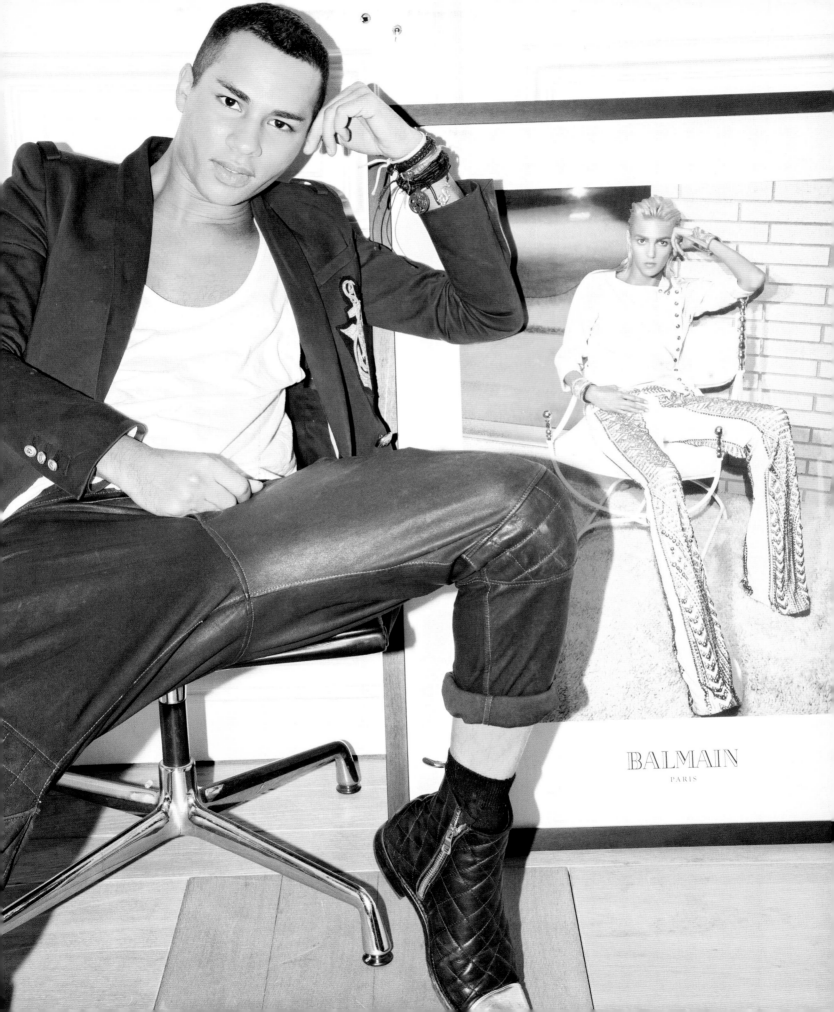

BALMAIN
PARIS

"*I love inspiration from travel. You can go on holidays and fall in love with a town and the people, fall in love on the beach—from this point you can create an entire collection.*"

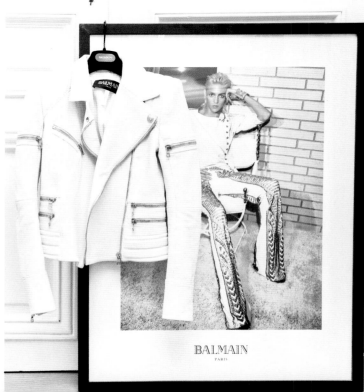

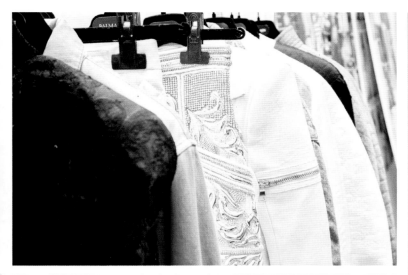

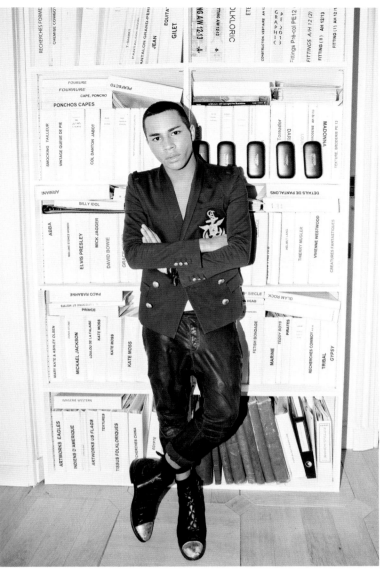

WHEN
December 3, 2015

WHERE
Santisi's Brooklyn Heights apartment, which she shares with her husband, daughter, and a Portuguese water dog named Josie

WHY
She's a legendary American stylist and fashion editor who's worked everywhere from Vogue *to* Harper's Bazaar.

ELISSA SANTISI

STYLIST; FASHION EDITOR

We often run the risk of falling hard for people who are what you might call industry insiders. Ask us for our favorite shoots, favorite interviews, favorite encounters in Coveteur history and they probably involve people like this. Of course, there are more than a few of these industry people whom we'd love for everyone to celebrate, and not just the insular fashion types (hence, um, the entire point of TheCoveteur.com). And one of our very favorites in this category is Elissa Santisi (did you see that one coming?).

For the uninitiated, it's time to get on our level. Santisi is one of those storied stylists who wrote the rules of the game for those of us still coming up in the industry. Her career took off in the early nineties while working under Liz Tilberis at *Harper's Bazaar*, alongside the likes of Tonne Goodman and Paul Cavaco—which, according to Santisi and all the tear sheets we've saved from that period—was essentially ground zero for everything imaginative, fun, and interesting in American fashion. From there, Santisi went on to *Vogue* (NBD) before returning to *Bazaar* as a contributing editor in 2013. Since then, she's also done freelance styling and consulting for brands like Derek Lam and Bottega Veneta. In terms of photographers, she's worked with everyone from Peter Lindbergh

and Craig McDean to Camilla Åkrans and longtime collaborator Raymond Meier. As far as we're concerned, she's worth every ounce of our admiration (and yours).

When Santisi granted us access to her Brooklyn Heights apartment (she's been living in the borough for seventeen years—long before any number of TV and movie tropes made it cool), what greeted us was the ultimate fashion-editor closet (and the epitome of all our style goals ever): a concise, pared-down wardrobe—like a single rack at a shoot—where all of the pieces are perfect and suit Santisi's style precisely. How could we have expected anything less?

This wasn't one of our excessive Chanel and Louboutin shoots. Santisi presented us with three racks in a single closet of some of the best Céline, Derek Lam (Santisi styles the designer's runway shows), Saint Laurent, and Balenciaga we've ever seen. To be honest, we've never been so excited about pants as we were when examining Santisi's impeccable collection (we know, pants); but when you wear button-hemmed Célines as well as you do vintage Levi's, well, we're bound to take interest. Then there were her all-star accessories: more Céline (bags and shoes), Saint Laurent, Tabitha Simmons, and, yes, even a pair of very well-chosen Louboutins. But that was it. It was a sartorial breath of fresh air; with all the extra stuff taken away, only the very best was left. We've got nothing but admiration for someone who can do that.

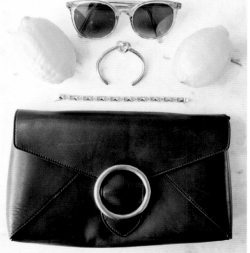

self service

by melanie ward

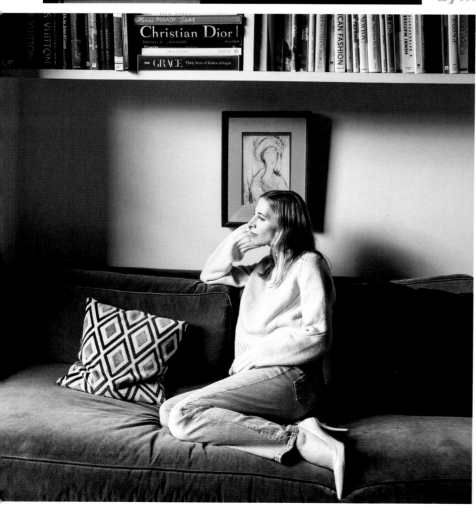

Christian Dior

GRACE

"I did a lot of crazy things at Harper's Bazaar. Once, [photographer] Raymond Meier and I walked around Times Square at night—I had a paper bag full of accessories—and we shot things in a fast-food place, in a phone booth, and on the street . . . a shoe on the floor of a coffee shop."

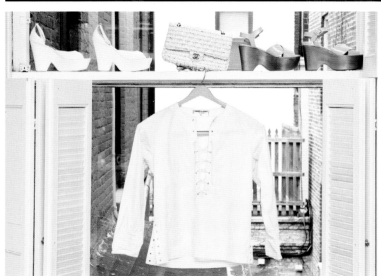

"I remember crying because my mother wouldn't get me these expensive loafers with little chunky heels when I was fourteen. [I remember] really obsessing over them."

WHEN
June 12, 2015

WHERE
Sozzani's studio and archive in Milan—an intellectual, arty haven removed from the hustle of the city below

WHY
She's the visionary founder of 10 Corso Como, a sprawling complex of a boutique that's widely regarded as one of the best in the world. It's spawned spin-offs in Seoul, Shanghai, and Beijing.

CARLA SOZZANI

FOUNDER, GALLERIA CARLA SOZZANI;
CREATOR, 10 CORSO COMO

Nine times out of ten, we try to deny the notion that fashion, for all of its scary tell-all roman à clefs and scandalous *Page Six* items, is in any way intimidating. Sure, there's the occasional fashion assistant or publicist with a sneer near-permanently painted on his or her face, but we're pretty sure those types can be found in just about any industry. Every now and then, though, there's that rare name that, for all of our time spent digging through the underwear drawers of people of prominence, scares us. Just a little.

Like Carla Sozzani. She's the brains behind 10 Corso Como, a store often heralded as one of the best shopping experiences in the entire world. Don't get us wrong: Sozzani was nothing short of lovely, despite us disturbing her in the middle of the workday to raid her stuff. But there's no denying that, as one-half of the most powerful sibling duo in Italian fashion (Carla's sister, Franca, just so happens to be editor-in-chief at *Vogue* Italia), Sozzani is the tiniest bit terrifying.

When we arrived at her store, we were led past the second-floor galleria, and after being ushered through a clandestine side door, there we were, in her studio. Sozzani's space carries off a certain organized chaos, in a way that only true creatives can actually maintain. It's lined by low, overstuffed bookshelves, with more objects to be found in towering piles along the floor; there are various keepsakes

from travels around the world and white corkboards covered in art, magazine tears, and photos of close friends and family. Between the hanging bubble chair suspended from the ceiling in one corner and the Kris Ruhs flower sculptures in another, it felt like a sort of monochromatic, wholly inspiring oasis, completely removed from the bustling superstore below.

In a surprise to absolutely no one, Sozzani's wardrobe mirrors the look and feel of her space: a mix of neutral classics from Alaïa (Carla's lifelong best friends with the designer—the store had thrown the launch party for the designer's first namesake fragrance the night before our shoot) and more boundary-pushing pieces from Comme des Garçons. And then there's her jewelry collection, made up of oversize silver statement pieces almost entirely by Kris Ruhs, Sozzani's partner and frequent creative collaborator (he even designed Corso Como's logo), housed in seemingly endless rows of black filing cabinets adjacent to her office. A beyond appropriate use of otherwise dormant office furniture, if you ask us.

As we cautiously attempted to mix in Sozzani's things with her space—more than a few pushpins may have fallen victim in the process, sending the papers collaging her walls to the floor, which was about as mortifying for us as you'd imagine—she tapped away at her Mac keyboard, peering up to observe us quizzically every so often. Again: terrifying. Good thing we had three massive de-stressing floors of retail therapy at our disposal to peruse after our shoot. We'd like to think Carla would approve.

ADRIAN

GOWNS BY ADRIAN

WALTER ALBINI

COMME des GARÇONS

THE BIBA EXPERIENCE

FUTURE BEAUTY: 30 YEARS OF JAPANESE FASHION

FASHION 2001 LANDED

YOUNG BELGIAN FASHION DESIGN

FASHION 2001 LANDED

MINIMALISM AND FASHION

"[I got my signature look] starting as a child, looking at murals of the great women of Pompeii and Rome. From then on, I chose never to wear makeup or high heels, with the conviction that they are useless to femininity. The rest is contingent upon that."

*"[Azzedine Alaïa
and I] are family
by election.
There is real trust
and understanding
between us."*

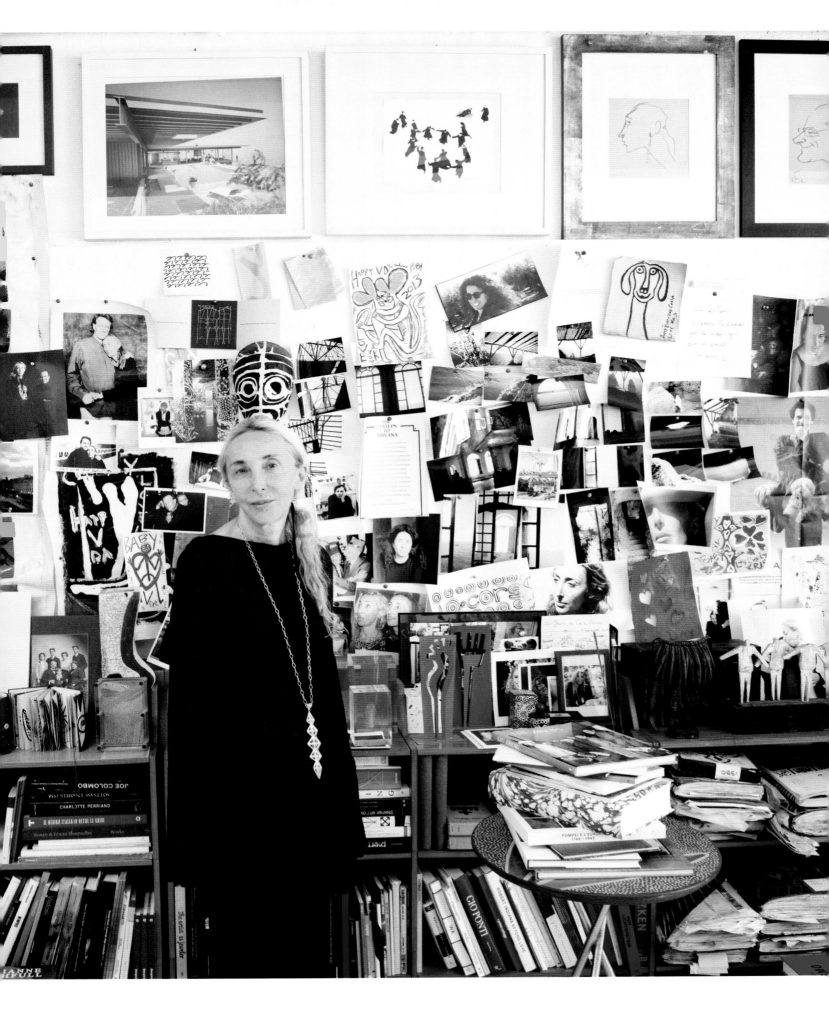

WHEN
September 23, 2015

WHERE
*Stoudemire's family
compound, just
north of Miami*

WHY
*Because Stoudemire
might just be the only
baller who, in his
downtime, covers men's
fashion week (and
interviews Raf Simons
and Rick Owens) for
the likes of* Esquire.

AMAR'E STOUDEMIRE

PROFESSIONAL BASKETBALL PLAYER, MIAMI HEAT

O ccasionally it occurs to us that our job—namely, the whole going-through-people's-stuff-and-then-writing-about-it part—is downright weird. And truth be told, that thought usually first occurs when we find ourselves in situations that are surreal mostly because we're seeing firsthand what defines normalcy in our subjects' lives. It's the everyday, even mundane moments, not necessarily the over-the-top glamorous ones, that strike us—like when we find ourselves watching basketball player Amar'e Stoudemire's four kids zip around on a fleet of scooters and hoverboards while his wife, Alexis, shows us the family's avocado, lemon, and lime trees. This all happened before we pillaged his collection of Lanvin and Givenchy. It's an entirely different workday than if we were accountants, you know?

We were somewhere between Stoudemire's collection of rare, archival Nikes and custom outerwear when the man himself showed up. It's completely cliché but merits mentioning: Amar'e is, well, tall. Six foot ten, to be exact. His height became even more of a focal point when he casually mentioned that given our shoot's coinciding with Yom Kippur, he had been fasting (without so much as a sip of water), all day—that means all through his early

morning practice with the team, continuing through our shoot, and right up until sundown. You'd think (understandably) this would slow things down considerably, but Stoudemire was more than game for just about everything we put him up to. He donned looks ranging from a white tuxedo to a tank and jeans in rapid succession, even pulling his Lincoln out of the garage for a few *Cribs*-like shots out front.

The rest of our shoot went a little something like this: Upon hearing we were in town from Toronto, Stoudemire promptly put on Drake's latest as our soundtrack between shots and setups (and for him, between outfits). Once we wrapped up with the Lincoln, the remaining standouts in his car collection got good use, too—we Coveteur'd his Maybach, with an honorary mention going out to his golf cart (a Floridian must, apparently). His youngest son helped us tow around and find the perfect place for his Goyard suitcase (gray and green, to coordinate with his wife's pink and purple) by the pool. We oohed and aahed over his array of glittering Rolexes, snapped away in the family's at-home movie theater, and got a peek at his array of cigars and Olympic medals, as well as his burgeoning hat collection. After all, what better way to cement just how peculiar your job is than bonding with an NBA All-Star over the trials and tribulations of sunglasses organization after chasing around his Goyard-toting toddler.

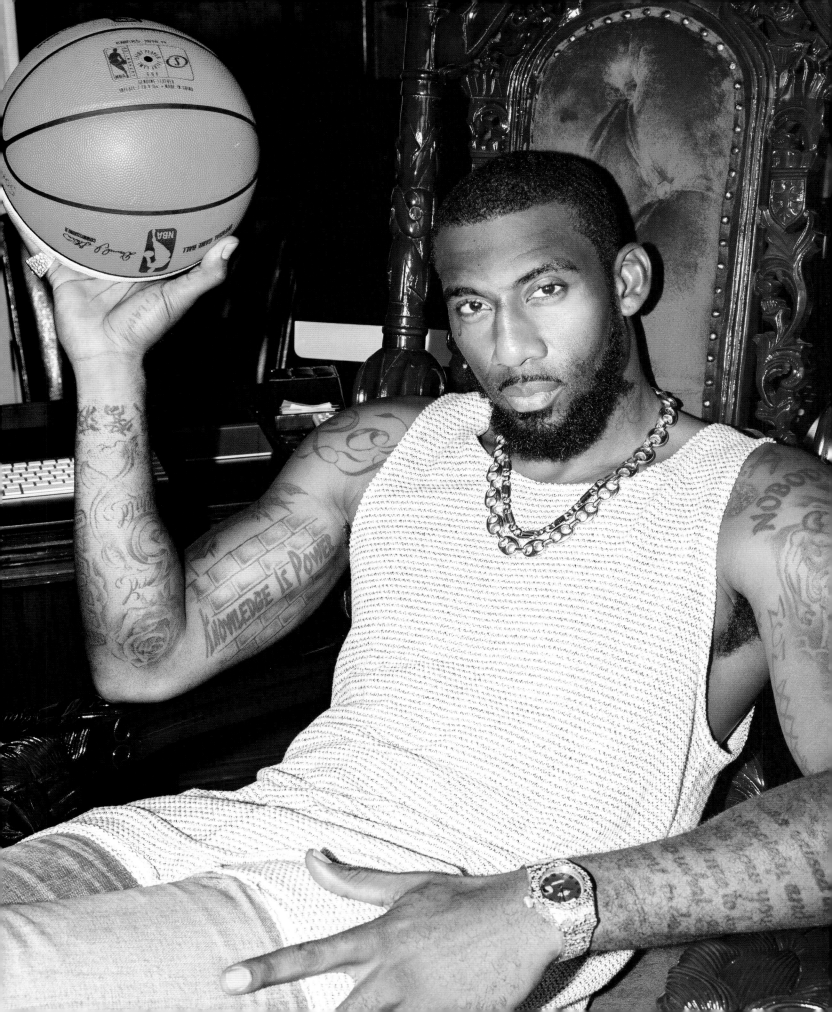

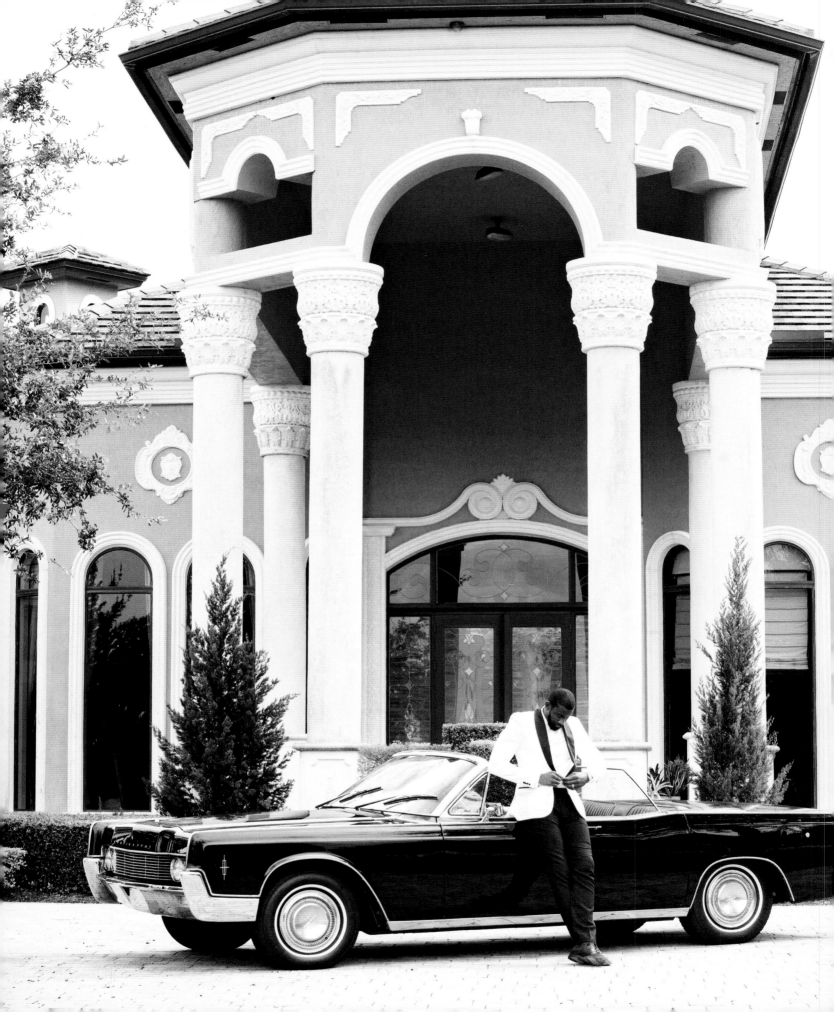

"My style has evolved from
an eighteen-year-old rookie
who wore baggy clothing
to a thirty-three-year-old with a
more mature, tailored look."

*"My favorite pieces are my
Nike 1 of 1 Destroyer jacket,
designed by me; my gold
menorah chain designed by
Shayan Afshar; and my
Saint Laurent hats."*

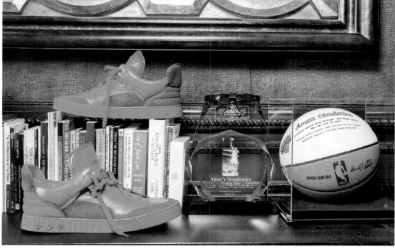

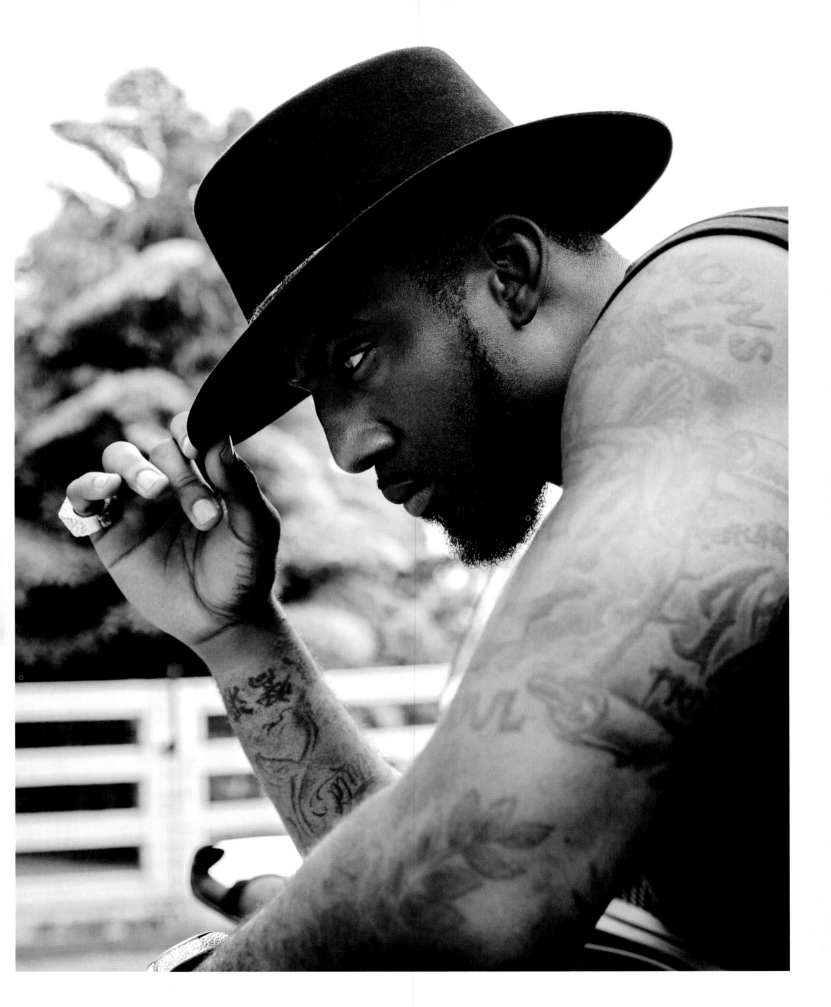

WHEN
July 21, 2015

WHERE
*Her bohemian Somerset
estate in England*

WHY
*Temperley's feminine and
whimsical designs stock
the closets of royalty—as
in, both Beyoncé and
the Duchess of Cambridge.*

ALICE TEMPERLEY

DESIGNER

We like a good story. Especially one that is told to us as we're getting cozy on a velveteen teal couch, strewn with a cavalcade of patterned pillows and throws. A scene that isn't all that surprising when you're sitting on the couch of the storyteller herself (and the woman behind those whimsical dresses that you, Beyoncé, and Kate Middleton have been hoarding), Alice Temperley.

We bet you're wondering how we ended up here, so let's backtrack a teensy bit.

After a three-hour-long train ride to the county of Somerset, and a subsequent cab ride down seemingly never-ending winding roads, interspersed with hundred-year-old willow trees and even more historic estates, we found ourselves outside the Cricket Court mansion. An estate with a long-reaching past—in 1066 William the Conqueror gifted the demesne to his brother—it was eventually purchased by media tycoon Lord Beaverbrook and visited by Winston Churchill and General Eisenhower while they were planning D-Day. Like we said, there's history there. And its front lawn, peppered with Tim Walker props and ruins of a Plantagenet castle in its gardens, shares exactly the juxtaposition

Temperley exemplifies herself: classic and romantic yet artfully offbeat.

The same went for the interior of the house, which, if we had to, we could pretty much only describe as a bohemian paradise. As in, leather couches with a lived-in patina, sitting under the dome of the oak-paneled library, were abandoned for the mammoth pillows that lay on the floor, just calling for us to hang out and chill. Let's just say, the shelves weren't without similarly bohemian sentiments—hand-painted tchotchkes and storied knickknacks lined almost every surface, and Temperley's quintessential disco balls made their casual appearance here. The whole thing was ripped from the pages of *Alice in Wonderland*.

As for the real pièce de résistance—her wardrobe—think copious quantities of floor-length floaty gowns, delicately embroidered sheer lace blouses, Nicholas Kirkwood and Charlotte Olympia heels, and the occasional tutu—yeah, what were you expecting? There were the vintage finds, too, interspersed among her namesake pieces. And as we made our way to her basement, talking summer parties (btw, she's kind of famous for them) and a mutual appreciation for hats, we uncovered racks on racks of Temperley's archival designs even we had never seen before. The only place we didn't explore? The ancient Tudor bear-fighting pen the mansion sits atop—we'll leave that one to the history books.

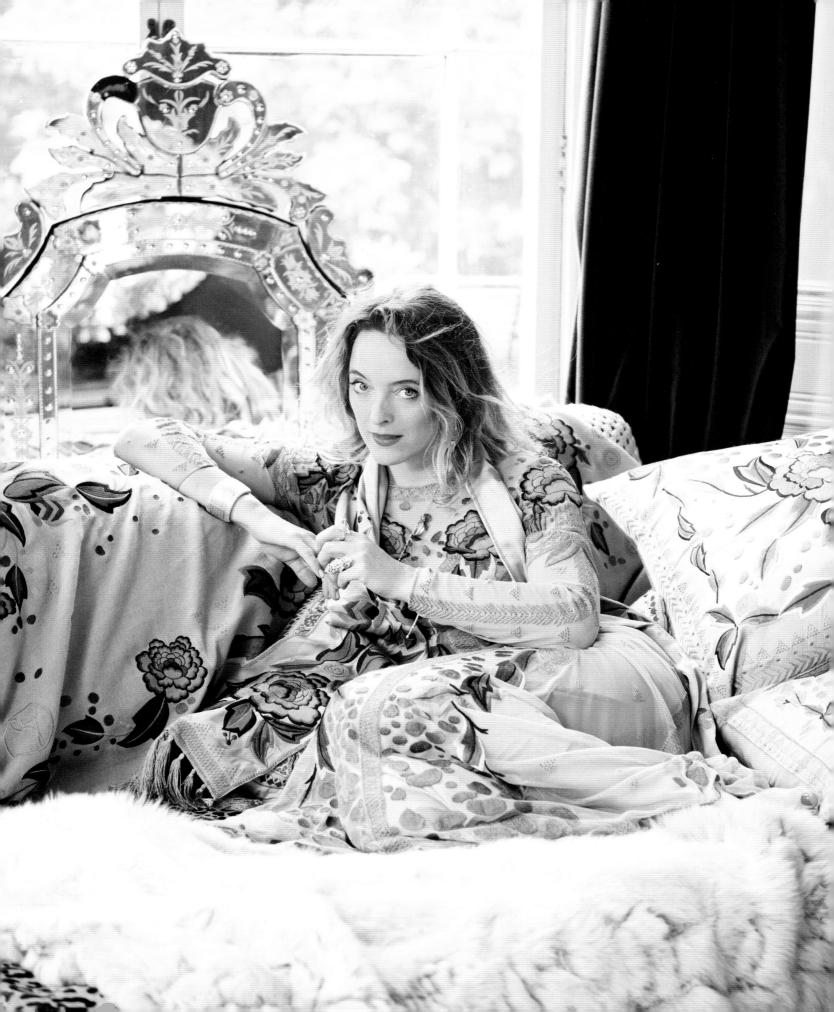

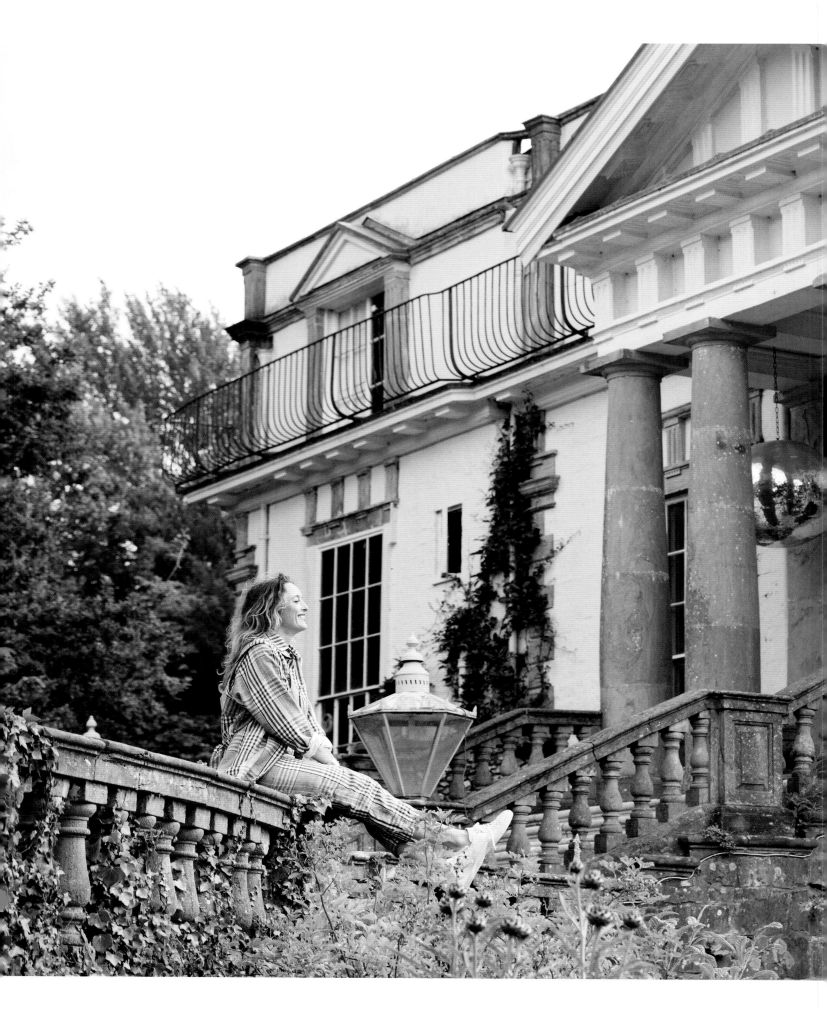

"*I used to try on all my
mother's clothes and cut up
her fabrics and shawls
to make into other things—that
didn't go over very well.*"

WHEN
September 8, 2015

WHERE
*Tilbury's Notting Hill
townhouse in London*

WHY
*Ever coveted Kate
Moss's signature smoky
eye? We thought so.
Tilbury pioneered Moss's
whole Bardot-tinged,
kohl-smeared, morning-
after-eye and nude-lip
thing as her go-to makeup
artist. Her clients, who
include Naomi Campbell,
Rihanna, Adele, and
Amal Clooney, feel the
same way.*

CHARLOTTE TILBURY

FOUNDER AND CREATIVE DIRECTOR, CHARLOTTE TILBURY MAKEUP

Charlotte Tilbury is the kind of woman whose reputation can only be described as preceding her—and we mean that in the very best way possible. She's essentially a legend in the world of backstage beauty. Born and raised in Ibiza, Tilbury speaks in sound bites: She famously sleeps in her makeup, all but delivered her babies in six-inch stilettos, and unapologetically lives by all things that define her brand of Bond Girl–tinged beauty. She speaks, thinks, and acts at miles a minute with nary a strand of her tousled bouffant of Ann-Margret–red hair out of place, and punctuates every sentence with a purred-out "dahhhhhling" (she pulls it off, too).

Despite her youngest being a mere six months old, Tilbury was nothing but true to form when she welcomed us into her Notting Hill home bright and early one fall morning. Sitting us down with proper English tea and plopping coffee-table books illustrating Ibiza life and her latest glossy editorials in our laps, Tilbury got started with hair and makeup (she does the latter herself, duh) before we started sorting through her closet. And yes, we fully realized there was a very real, distinct possibility that, once upon a time, Kate Moss had sat in the exact spot where we were sipping Earl Grey. When we'd regained consciousness, we headed upstairs to raid Tilbury's closet.

When "they" say that behind-the-scenes types—publicists, makeup artists, photographers, anyone who's too busy keeping the pulse of fashion ticking to participate in wearing it—stick to uniforms, they're not kidding. And while the monochrome head-to-toe-black thing is alive and well in Tilbury's wardrobe, you won't quite find her in the same classic button-downs and trousers as some of her contemporaries. The makeup artist's wardrobe is instead ripped directly from the pages of one of the countless sixties-centric coffee-table books she keeps kicking around for inspiration: leggy, bodycon minidresses (she told the *Telegraph* she has some 220-plus LBDs), opaque black tights, towering platforms (pair count: 350 plus). When she goes for color, it's in the form of Ibiza-influenced, tropical-tinged caftans (of course) from Cavalli and Alice Temperley: all of the glamour, with none of the what-the-hell-am-I-going-to-wear-today dramatics.

Having put in her fair share of time on a photo shoot or two, it goes without saying that, by now, Tilbury knows how to take command in front of the camera, nailing her angles and taking peeks and previews between takes. In the name of "getting the shot," she was game for just about anything, too: climbing onto a glossy console to pose with pop art; channeling her inner Stevie Nicks 'round her back garden; taking faux drags from a prop lipstick (her K.I.S.S.I.N.G. Lipstick in Love Bite, to be exact) for the camera. Looks like Tilbury's pal Kate might have taught her a thing or two.

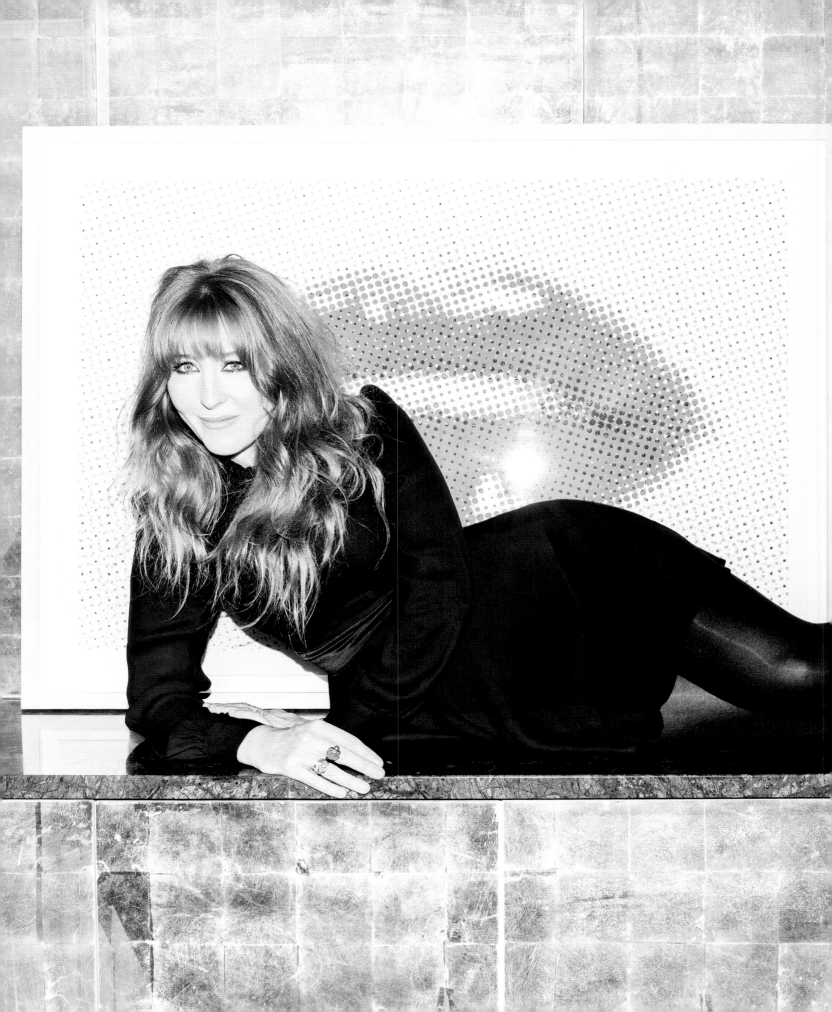

"Makeup can transform not only your face, but your mental attitude. Ever since that epiphany moment, no one has ever seen me without makeup on!"

"I discovered makeup when I was thirteen, and it changed my life. I started wearing mascara, and overnight, people reacted to me in a very different way. I soon realized that makeup is powerful. It's every woman's secret weapon."

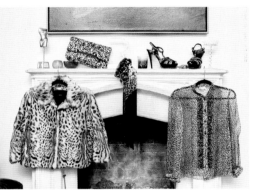

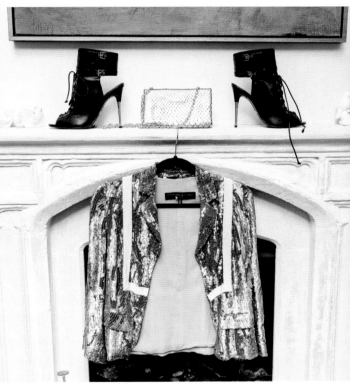

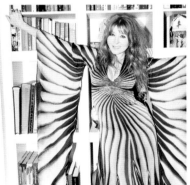

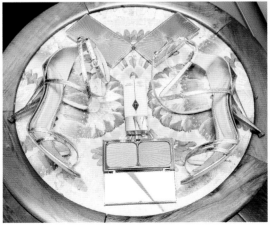

WHEN
November 18, 2015

WHERE
*Von Teese's gothic
Hollywood Tudor
home, high in the Los
Angeles hills*

WHY
*The burlesque queen
is as famous for her
super-feminine, retro-
glamorous style as
she is for her champagne-
flute striptease. Plus,
she counts Christian
Louboutin and Jean
Paul Gaultier among
her closest friends.*

DITA VON TEESE

BURLESQUE STAR; LINGERIE DESIGNER;
AUTHOR OF *YOUR BEAUTY MARK*

If anyone has crafted an aura and image for themselves from the ground up, it's Dita Von Teese. Flick through her social media accounts and it's like she lives exclusively in celluloid. The perfect red lips and sculpted hair (which she famously does herself), the miniature waist and always-impeccable outfit—Von Teese is the straight-up antithesis of the share-everything, social media–famous overexposure that most of her Hollywood compatriots exist within. And despite the fact that for her burlesque performances she is, well, mostly nude, she remains somewhat untouchable.

So, it was with some anticipation that we drove the twisted and vertiginous streets around Griffith Park to arrive at Von Teese's front door. As though a woman famous for her on-point 1940s-inspired style would ever answer the door wearing sweatpants? Yeah, right. In perfect synchronicity with her public image, there was Von Teese, wearing a cropped sweater and vintage embroidered circle skirt, welcoming us into her appropriately Old Hollywood home, complete with a massive art deco pool in the backyard and filled to its soaring ceilings with taxidermy. It was kind of like walking in on a Disney princess and discovering she does, in fact, get dressed with the help of cartoon animals and wear real glass slippers.

But it was only after we got into the depths of Von Teese's two-room closet (with her as our devoted guide, of course) that we came to understand how deep her passion for everything retro and glamorous really goes. We mean, this is no act: The performer is dressed and done all the time (it sounds exhausting, we know, but she makes it seem completely natural). First up was her trove of vintage dresses from Bob Mackie and her museum-quality Christian Dior (including a pristine New Look suit that rests in a tissue-filled box). Then there was her massive collection of Ulyana Sergeenko, whom she considers to be her fashion-world kindred spirit (we get it), and the Jean Paul Gaultier—she treasures a gown of his as her most precious possession, and, yes, it has actually made museum-exhibition rounds.

But the pièce de résistance? Her shoe wardrobe, obviously, which took up the majority of one room, displayed on custom red shelves that perfectly matched Von Teese's overflow of those signature red soles. Indeed, this may have been the most significant collection of Christian Louboutins, ahem, ever. For one thing, it's just massively huge—there are seemingly countless pairs. For another, Von

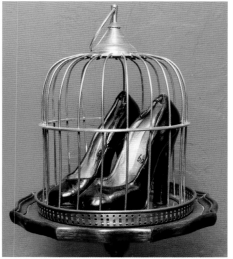

Teese is friendly (as in BFFs) with the designer himself. We mean, this mutual admiration society is so strong that Louboutin even has a cast of Von Teese's ever-so-delicate foot so he can simply send her perfectly fitting stilettos made for her wear only. The Cinderella metaphor has never felt so apt.

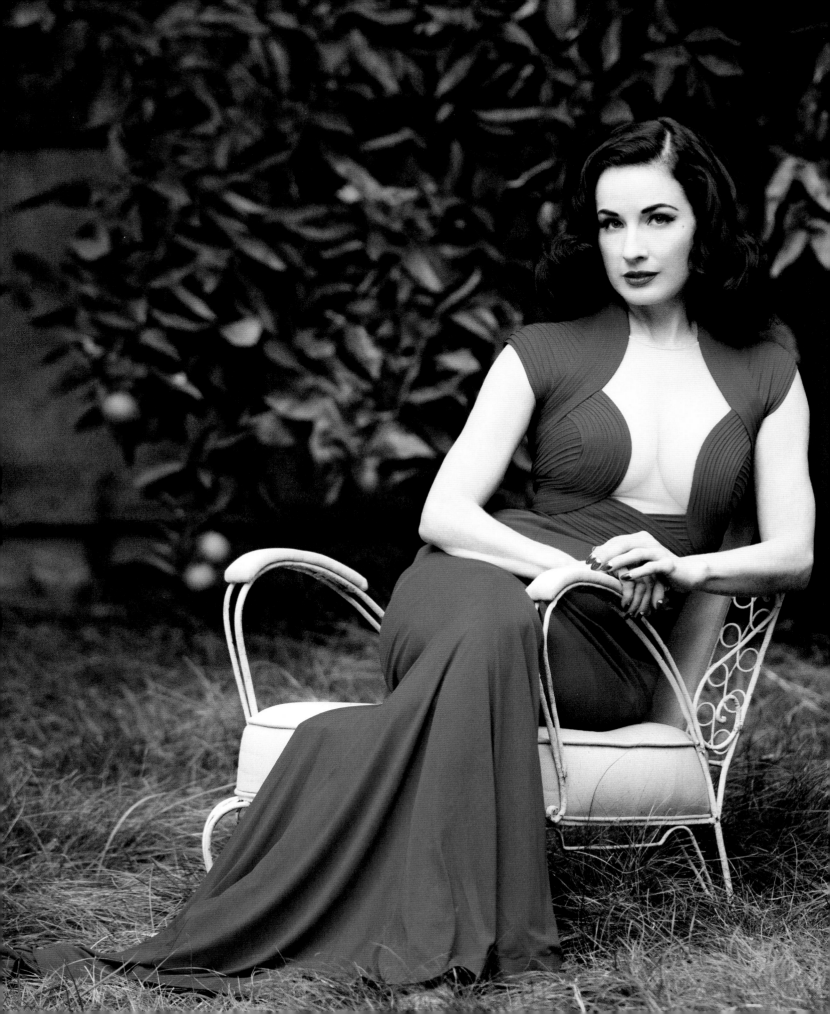

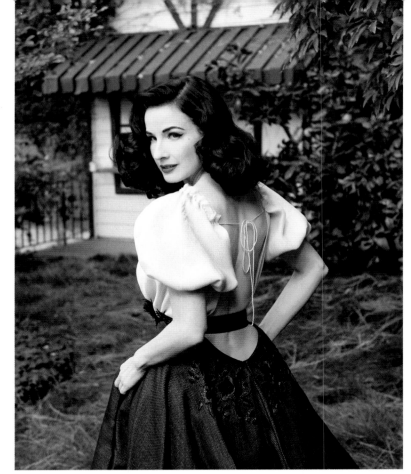

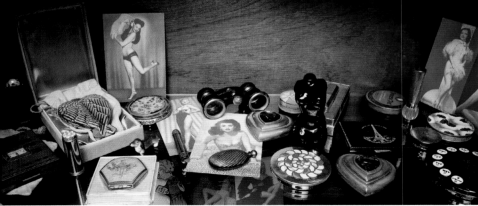

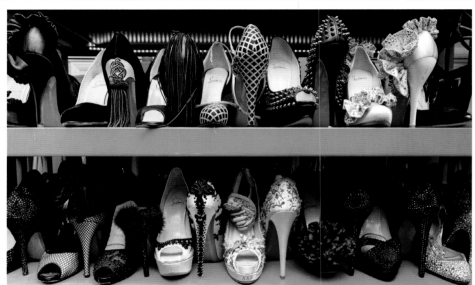
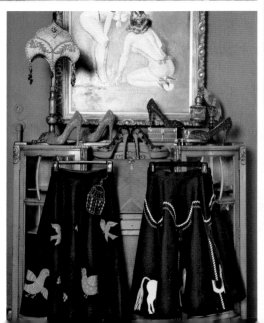

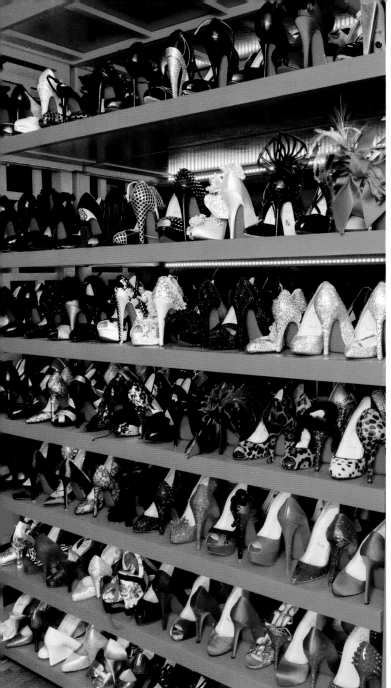

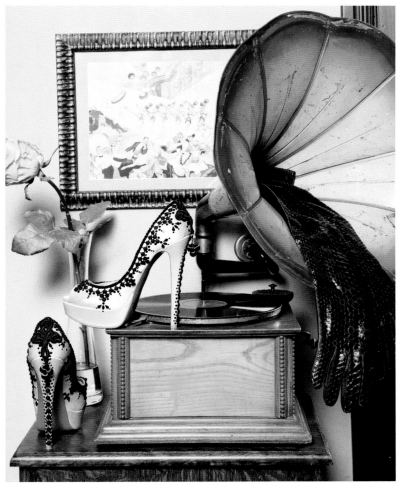

"A lot of my stage costumes [are the result of] many hundreds of hours of custom work and thousands and thousands of dollars worth of Swarovski crystals. The value of some of them reaches $50,000. They're treasured—and they're all insured."

*"I have relationships
with designers
who have the same
kind of obsession
with nostalgic glamour
that I do."*

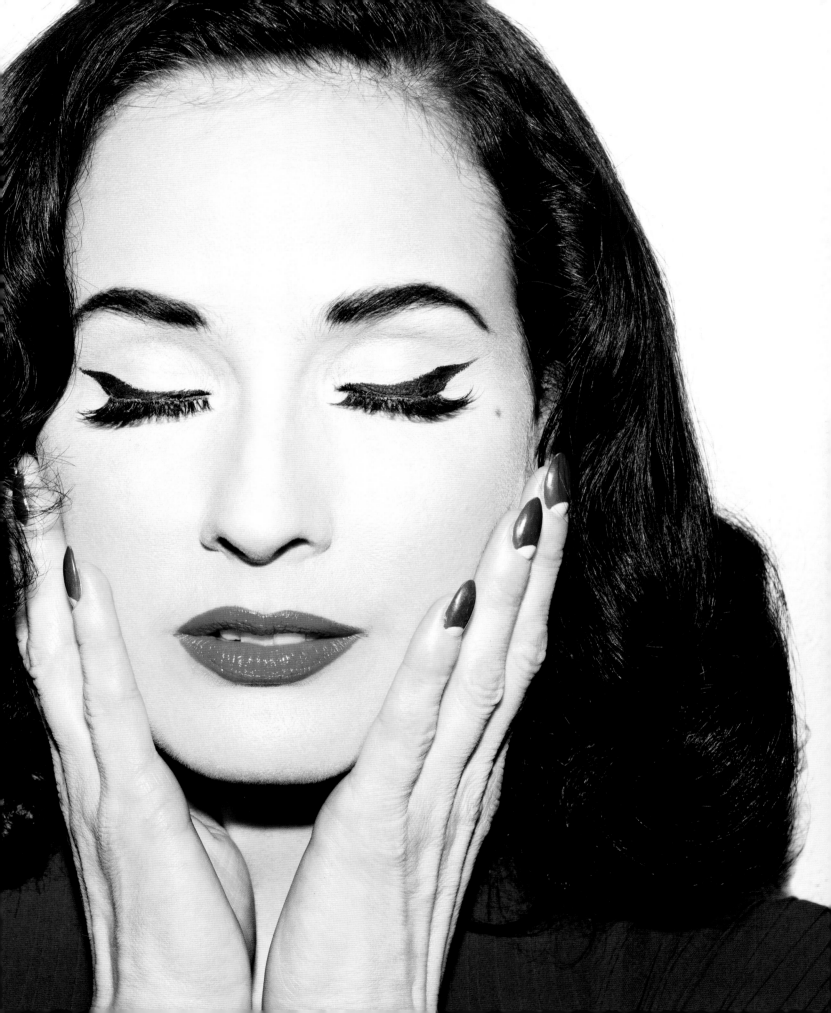

WHEN
April 8, 2014

WHERE
*A memento-packed
apartment in New York's
West Village*

WHY
*He single-handedly made
men's street style a
thing. Here we present
you with one of the
Cov HQ's most squeal-
inducing subjects yet:
Nick Wooster. The day that
his email materialized
in our inbox, granting us
access to his West Village
apartment (and closet),
will forever be known as
the day The Coveteur
office exploded.*

NICK WOOSTER

"FREE AGENT"; CONSULTANT

Just in case you've been living under a rock for the past few years, Nick Wooster (full name: Nickelson Wooster—arguably one of the greatest names in existence) is pretty much the king of men's street style. Ever since he started doing the fashion week circuits, back when he was men's fashion director at Bergdorf Goodman and Neiman Marcus, he's consistently inspired the same kind of frenzied photog scramble outside shows as sartorial institutions like Anna Dello Russo and Miroslava Duma. You can imagine that by the time we walked through the threshold of Wooster's apartment, we had morphed into those heart-eyed emojis. Because on top of the enviable, we-wish-our-boyfriends-would-get-it-together-and-wear-that ensembles, there was that hair, that face, those tatted-up sleeves, that swagger . . . live and in the flesh. (He also happens to be one of the nicest guys whose privacy we've invaded.)

And our excitement was totally vindicated: This is a man who jokingly refers to his wardrobe as his 401k. Thing is, it's not really a joke: There's a reason this guy is street-style gold. One cursory glance in his multiple closets and there's no doubt

Wooster knows what he's doing. He has enough Yohji Yamamoto and Thom Browne and Carven and Mark McNairy to stock the entire men's department at Barneys—not to mention his Rick Owens fashion sweatpants, which, frankly, would do wonders for our travel wardrobe.

But it was his accessories collection that has to be seen to be believed—brogues and boots already displayed Cov-style on his bookshelves (we swear he did half our job for us); a colorful collection of kilt pins that he clasps through the top buttonholes of his many, many oxford shirts; flamboyant brooches and pins that he wears as boutonnieres ("I can find something to buy literally anywhere," he told us as we sorted through them. No kidding); and lastly, his shoes. Oh, yes, he (obviously) knows his shoes. As Wooster had his portrait snapped (a natural in front of the camera, natch), we fawned over his brightly hued Jeffrey Top-Siders and leopard print Célines.

The man admitted he wouldn't swap closets with anyone, which we can understand—but seriously, Nick, consider us! Because for the first time maybe, like, ever, we'd actually trade wardrobes with a member of the opposite sex. Wooster, consider yourself warned.

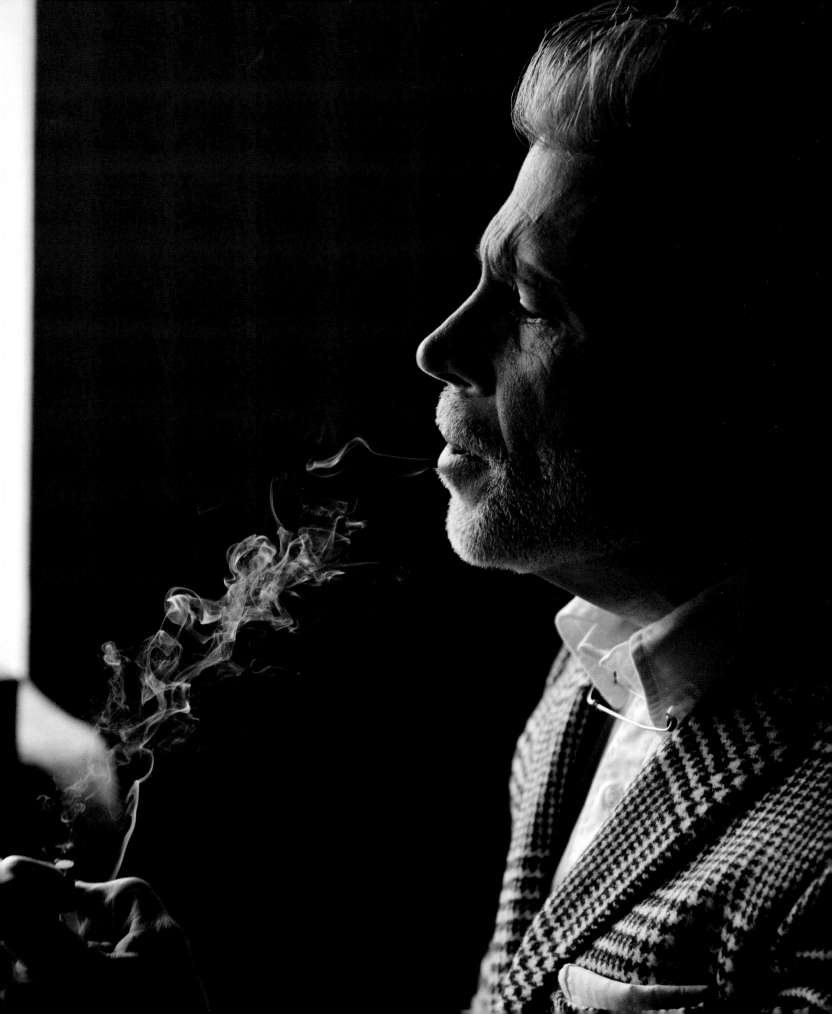

"I jokingly refer to my wardrobe as my 401k plan. I have probably spent what most people would be happy to retire on. Do I regret it? Ask me in 2025."

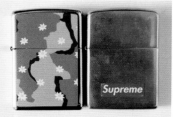

FUCK OFF

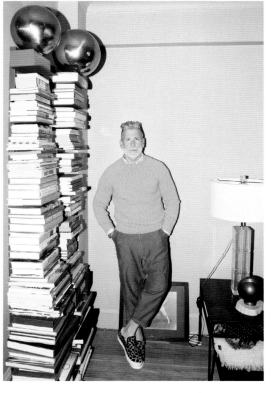

"My earliest fashion memory is telling my mom I didn't like the way certain T-shirts fit. I was in kindergarten."

WHEN
December 12, 2014

WHERE
*At her home in Tokyo—
and all over the city*

WHY
*The DJ-singer-designer
represents the best in
Japanese style: a little
bit romantic and a
whole lot eccentric. Plus,
she hoards Dior, which
is never a bad thing.*

MADEMOISELLE YULIA

DJ; SINGER; DESIGNER

When we flew out to Japan for the first ever time in Coveteur history, our schedule was packed with Dior-centric activities (pre-fall show, private lunches, the Esprit Dior exhibition—not the worst of itineraries), but we did find some time to take in the sights, too, all courtesy of our new Tokyo-based BFF and tour guide extraordinaire, Mademoiselle Yulia. Yulia is essentially Tokyo fashion royalty, showing up on red carpets and in street-style galleries like it's her day job (we guess it kind of is), all while hitting the decks and DJ'ing only the most internationally exclusive parties (but, of course).

To be completely candid, these weren't your typical tourist outings: Our guide showed us around dressed in head-to-toe Dior, for one thing. Our first stop was the imperial gardens—just a Lady Dior's throw away from the Palace Hotel (our newfound home away from home in Japan). Always one to get in on the full experience, Yulia showed us around the gardens dressed in a traditional kimono. Then again, for the DJ-cum-singer, indulging in this particular tradition only makes sense: Her mother is a trained kimono dresser, while her signature blue hair is courtesy of her hairstylist father. A family affair, if you will.

Before heading off to the Dior show that night, we swung by Yulia's home. It was there where we became privy not only to her insane collection of shoes and bags, but also toys. Yes, you read that right. She is a Barbie-loving, My Little Pony–collecting toy aficionado. Let's just say we've seen a lot of kooky collections in our day, but this one takes the top spot. Given her passion and knowledge on the subject, we guess it only makes sense that we met her the following day at a favorite haunt: a vintage toy store. Tucked away in a small alley in the Harajuku district, the shop stocked toy memorabilia straight out of our nineties childhoods: E.T. figurines, collectible Barbies still in their boxes, every Simpson character ever created, Sailor Moon EVERYTHING.

After tearing ourselves away from the toy store, the next stop was (obviously) a place in which we could retreat into the depths of a beverage to calm our over-stimulated nerves. Cut to what could very possibly be the coolest dive bar in the history of all dive bars. Called the Trump Room, the place is filled with red velvet chairs and hundreds of gold mirrors. It was one of those places that might inspire the phrase, "What happens in Tokyo, stays in Tokyo."

According to Yulia, no trip to Tokyo is complete without some good old-fashioned, *Lost in Translation*–style karaoke. While our pipes were more than a bit rusty, Yulia had no problem belting out her favorite Japanese hits (she's a professional though, so no fair). But after a few sakes and three orders of fries, Daft Punk's "Get Lucky" was blasting out of our private room. Finally, after a delicious meal at Gonpachi (aka the restaurant where the epic Uma Thurman versus Lucy Liu *Kill Bill* throw-down took place), where we indulged in more sake (sensing a theme here?) and more carbs than we can comfortably admit, we thanked our most gracious, forever-Dior-clad host and headed back to the Palace. Okay, so the "What happens in Tokyo . . ." rule doesn't exactly hold here, but close.

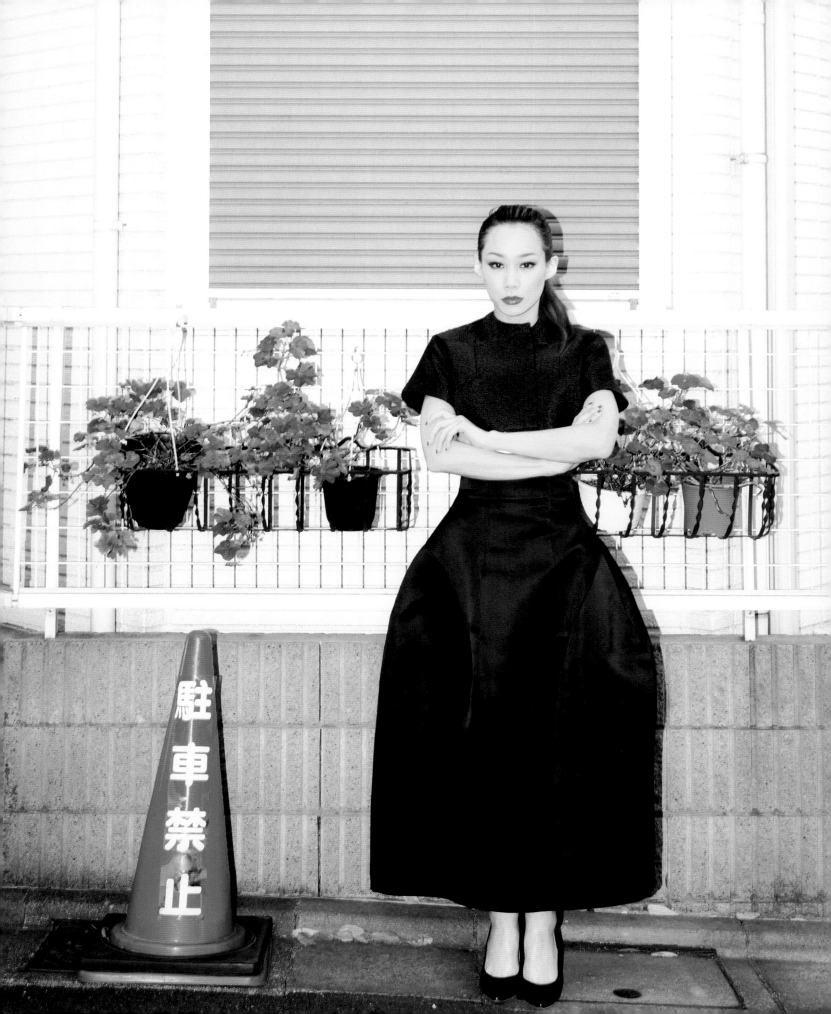

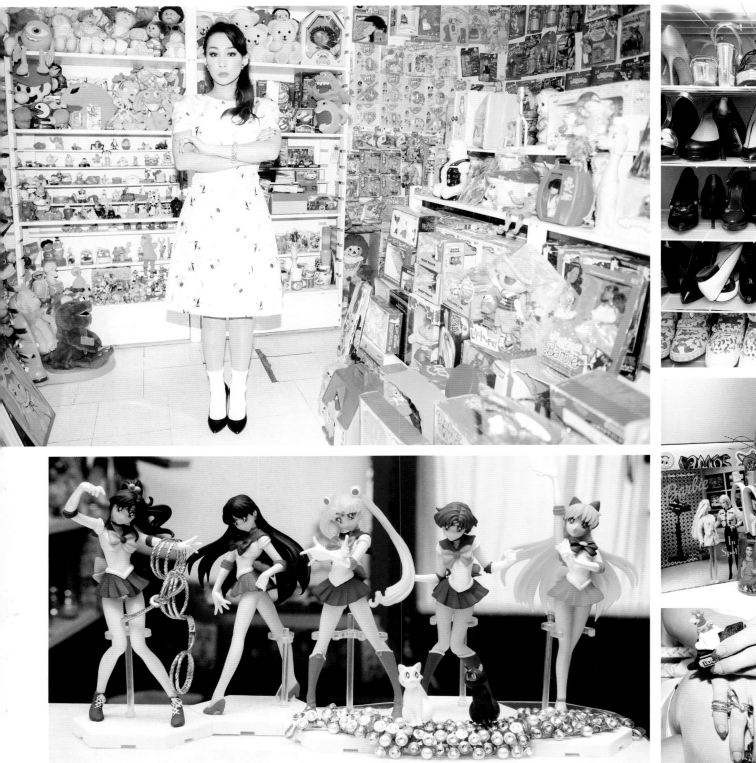

"My mom was also a Barbie collector, so I have been surrounded by the dolls ever since I was born. I now own around two hundred of them."

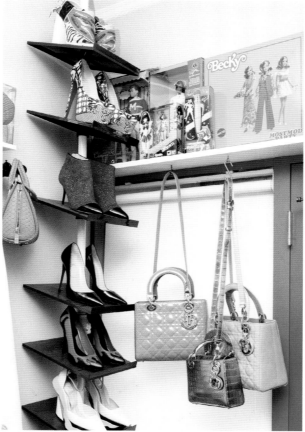

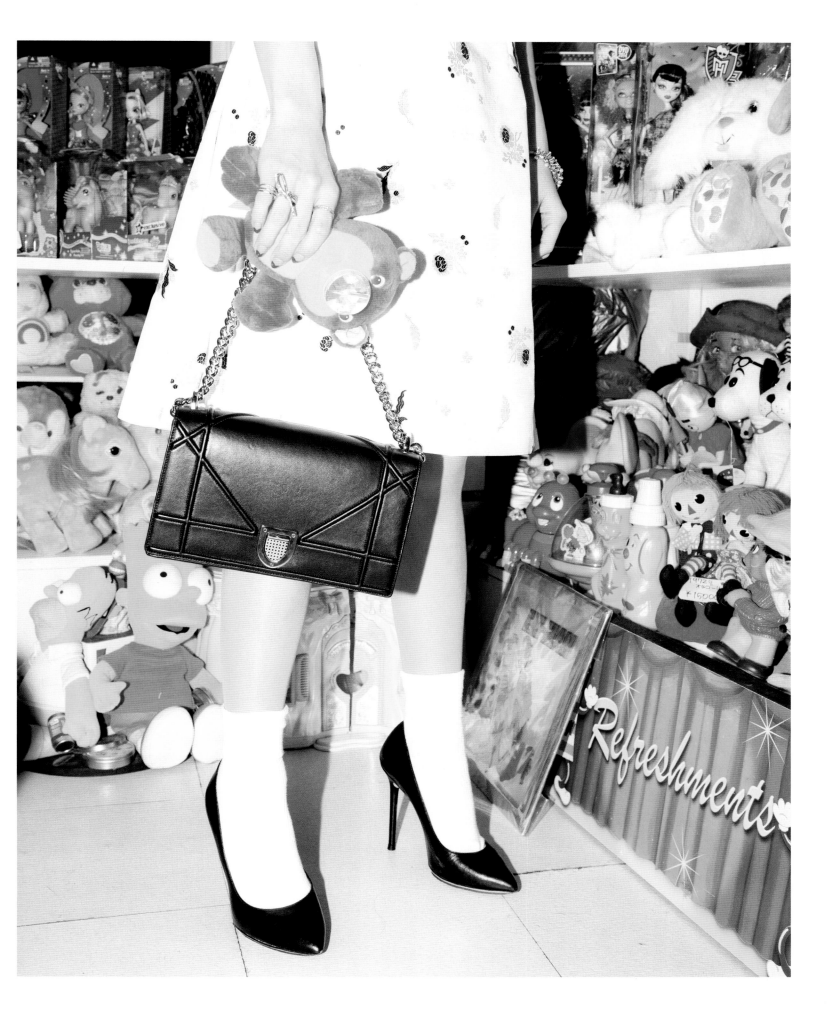

"Even when I wear bright, colorful, and avant-garde pieces, I try not to forget a sense of elegance."

Credits

FOREWORD
photography, Jake Rosenberg

INTRODUCTION
photography, Erik Tanner

JESSICA ALBA
photography, Jake Rosenberg; styling, Erin Kleinberg; writing, Meagan Wilson

JUNE AMBROSE
photography, Jake Rosenberg; styling, Stephanie Mark and Erin Kleinberg; writing, Noah Lehava

ANGELO BAQUE
photography, Renée Rodenkirchen; styling, Emily Ramshaw; writing, Emily Ramshaw

BOBBI BROWN
photography, Jake Rosenberg; styling, Stephanie Mark; writing, Emily Ramshaw

CINDY CRAWFORD
photography, Jake Rosenberg; styling, Stephanie Mark; writing, Noah Lehava

KRISTEN NOEL CRAWLEY
photography, Jake Rosenberg; styling, Meagan Wilson; writing, Meagan Wilson

LAURENCE DACADE
photography, Jake Rosenberg; styling, Stephanie Mark; writing, Emily Ramshaw

CHARLOTTE OLYMPIA DELLAL
photography, Jake Rosenberg; styling, Renée Rodenkirchen; writing, Meagan Wilson

LISA ELDRIDGE
photography, Jake Rosenberg; styling, Stephanie Mark; writing, Emily Ramshaw

MICHELLE ELIE
photography, Renée Rodenkirchen; styling, Meagan Wilson; writing, Meagan Wilson

TAVI GEVINSON
photography, Jake Rosenberg; styling, Kerri Scales; writing, Meagan Wilson

ZAYAN GHANDOUR
photography, Jake Rosenberg; styling, Stephanie Mark; writing, Emily Ramshaw

JAMES GOLDSTEIN
photography, Jake Rosenberg; styling, Erin Kleinberg; writing, Noah Lehava

BEN GORHAM
photography, Renée Rodenkirchen; styling, Noah Lehava; writing, Noah Lehava

KIM HASTREITER
photography, Jake Rosenberg; styling, Stephanie Mark; writing, Emily Ramshaw

HUGH HEFNER
photography, Jake Rosenberg; styling, Erin Kleinberg; writing, Meagan Wilson

VERONIKA HEILBRUNNER and JUSTIN O'SHEA
photography, Jake Rosenberg; styling, Stephanie Mark; writing, Emily Ramshaw

DEE and TOMMY HILFIGER
photography, Jake Rosenberg; styling, Stephanie Mark, Erin Kleinberg, and Stacie Brockman; writing, Emily Ramshaw

ARIANNA HUFFINGTON
photography, Jake Rosenberg; styling, Emily Ramshaw; writing, Meagan Wilson

CAMELIA CRACIUNESCU HULS
photography, Renée Rodenkirchen; styling, Meagan Wilson; writing, Meagan Wilson

ROSIE HUNTINGTON-WHITELEY
photography, Jake Rosenberg; styling, Stacie Brockman; writing, Noah Lehava

CAROLINE ISSA
photography, Renée Rodenkirchen; styling, Meagan Wilson; writing, Meagan Wilson

OLGA KARPUT
photography, Jake Rosenberg; styling, Emily Ramshaw; writing, Emily Ramshaw

LULU KENNEDY
photography, Jake Rosenberg; styling, Stephanie Mark; writing, Emily Ramshaw

MIRANDA KERR
photography, Jake Rosenberg; styling; Erin Kleinberg; writing, Meagan Wilson

KARLIE KLOSS
photography, Jake Rosenberg; styling, Stephanie Mark; writing, Meagan Wilson

CHRISTIAN LOUBOUTIN
photography, Jake Rosenberg; styling, Stephanie Mark; writing, Meagan Wilson

BARBARA MARTELO
photography, Jake Rosenberg; styling, Stephanie Mark; writing, Meagan Wilson

ANGELA MISSONI
photography, Jake Rosenberg; styling, Meagan Wilson; writing, Meagan Wilson

CAROLYN MURPHY
photography, Jake Rosenberg; styling, Renée Rodenkirchen; writing, Meagan Wilson

GLENN O'BRIEN
photography, Jake Rosenberg; styling, Kerri Scales; writing, Emily Ramshaw

ELENA PERMINOVA
photography, Jake Rosenberg; styling, Emily Ramshaw; writing, Emily Ramshaw

LINDA RODIN
photography, Jake Rosenberg; styling, Stacie Brockman; writing, Noah Lehava

SUZANNE ROGERS
photography, Jake Rosenberg; styling, Stephanie Mark and Erin Kleinberg; writing, Noah Lehava

OLIVIER ROUSTEING
photography, Renée Rodenkirchen; styling, Stephanie Mark; writing, Noah Lehava

ELISSA SANTISI
photography, Jake Rosenberg; styling, Stephanie Mark and Emily Ramshaw; writing, Emily Ramshaw

CARLA SOZZANI
photography, Jake Rosenberg; styling, Meagan Wilson; writing, Meagan Wilson

AMAR'E STOUDEMIRE
photography, Renée Rodenkirchen; styling, Meagan Wilson; writing, Meagan Wilson

ALICE TEMPERLEY
photography, Jake Rosenberg; styling, Stephanie Mark; writing, Noah Lehava

CHARLOTTE TILBURY
photography, Renée Rodenkirchen; styling, Meagan Wilson; writing, Meagan Wilson

DITA VON TEESE
photography, Jake Rosenberg; styling, Emily Ramshaw; writing, Emily Ramshaw

NICK WOOSTER
photography, Jake Rosenberg; styling, Stephanie Mark and Emily Ramshaw; writing, Emily Ramshaw

MADEMOISELLE YULIA
photography, Jake Rosenberg; styling, Stephanie Mark; writing, Emily Ramshaw

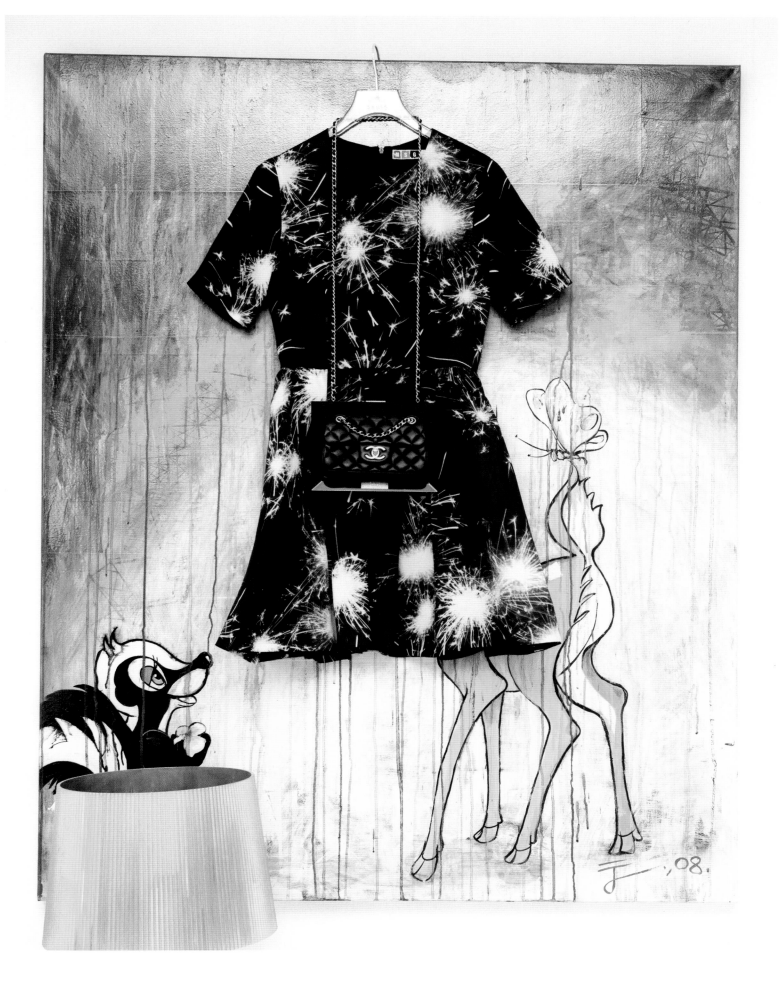

Acknowledgments

So much has happened over the course of creating this book. So much hard work, many late nights, and, of course, tons of fun. We are lucky enough to travel the world and work with amazing talent, and this would not have been possible without the dedication and efforts of our amazing team.

A special acknowledgment must go to our editorial group. Their scheduling, planning, research, and writing made this book possible. We are so grateful to have such remarkable individuals working with us on this team: Thank you to Meagan Wilson, Emily Ramshaw, Noah Lehava, and Alicia Cesaro for telling the stories of The Coveteur.

Photography is a big part of The Coveteur's core. Creating this book meant doing whatever it took to tell the stories of our subjects and create exciting images to share with our readers. Renée Rodenkirchen, our second principle photographer, has taken so many of the images in this book. Thank you, Renée; we could not have done it without you.

While this book was being created, there was still a website to run. Katie Boyle is a huge reason why the site looked its best (and grew!) every day. Thank you, Katie. A special thanks also goes to Kelly McLeod for all of your team support throughout this project.

Erin Kleinberg is a cofounder of The Coveteur, and we are grateful to have had the opportunity to work with her to grow the brand and its team.

To Warren Webster, The Coveteur's chief executive officer: Thank you for making sure the business pushed forward and for helping us bring this book to fruition. We could not have done it without you. We are excited for our next chapter together.

Working on a book has been a new experience for us. Thank you to our agent, Nicole Tourtelot, and our book editor, David Cashion, and the rest of the ABRAMS team for guiding the way.

The design and layout of this book have been done by none other than the fantastic Emily Wardwell. Thank you, Emily, for working with us.

We also want to send a special thank you to Leslie Simitch—her encouragement and support were a huge part in getting this project off the ground.

A special thank you to the beautiful Rosie Huntington-Whiteley for the kind words that you wrote in the foreword for this book. You have always been a true subject of The Coveteur, and we look forward to many more years of fun times together.

Each and every day, we set out to find interesting and exciting subjects. We cannot put into words how much it means to have their support. We would like to thank all of them, as well as our clients whom we have worked with since day one and the teams involved in making what The Coveteur is today. We have become a family of unique, talented, awesome people, and we could not be happier to have you as part of it. Thank you all.

To our friends and family: Without your love and support, none of this would have happened. Thank you for always being there. We are eternally grateful.

And last, but certainly not least, thank you to all of our readers, followers, subscribers, and people who are supporting this book. Truly, without you, none of this would have been possible. We are excited to continue this journey together.

—*STEPHANIE and JAKE*

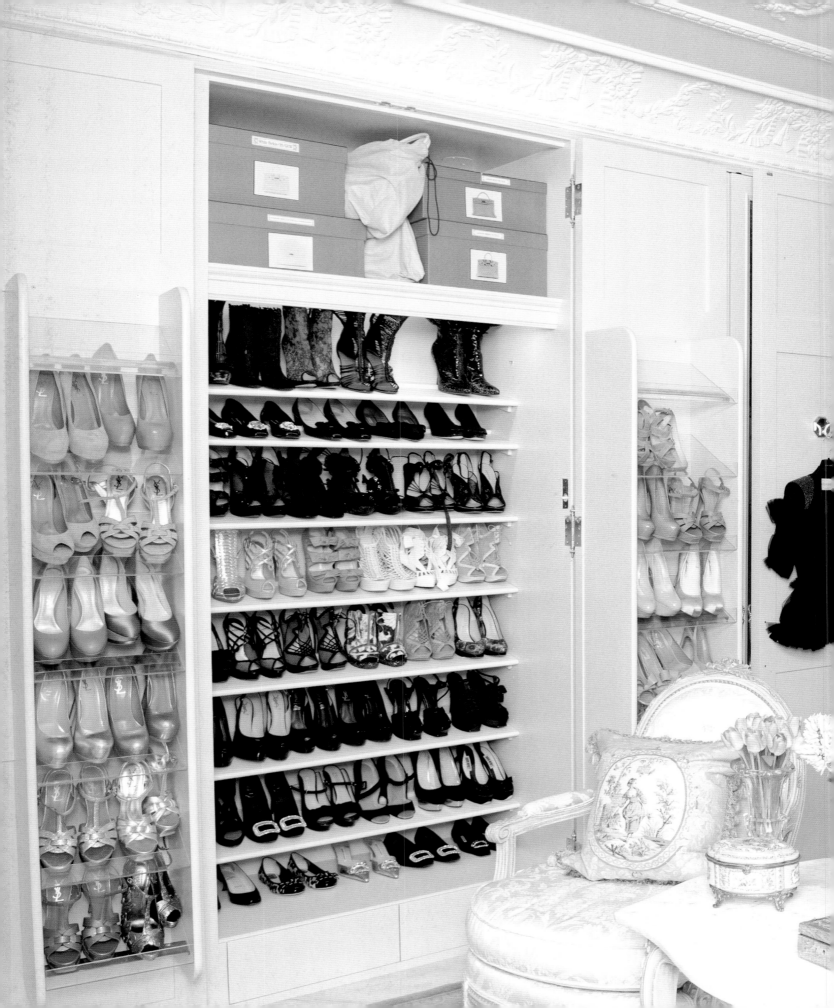

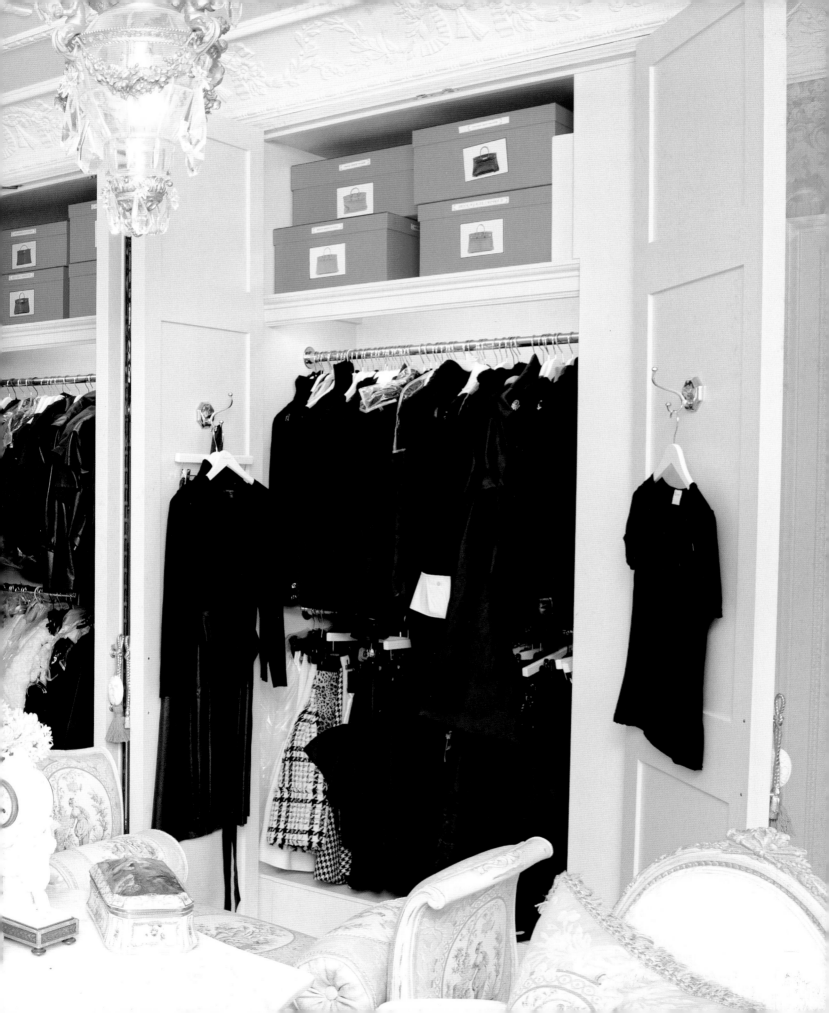